Perspectives on Morisot

Perspectives on Morisot

EDITED AND WITH AN INTRODUCTION BY T. J. EDELSTEIN

ESSAYS BY KATHLEEN ADLER, BEATRICE FARWELL,

TAMAR GARB, ANNE HIGONNET, SUZANNE GLOVER LINDSAY,

LINDA NOCHLIN, AND ANNE SCHIRRMEISTER

HUDSON HILLS PRESS NEW YORK

IN ASSOCIATION WITH THE MOUNT HOLYOKE COLLEGE ART MUSEUM

First Edition

Published in the United States by Hudson Hills Press, Inc.,
Suite 1308, 230 Fifth Avenue, New York, NY 10001-7704.

Distributed in the United States, its territories and posses-
sions, Canada, Mexico, and Central and South America
by Rizzoli International Publications, Inc.
Distributed in the United Kingdom and Eire by Thomas
Heneage & Co. Ltd.
Distributed in Japan by Yohan (Western Publications
Distribution Agency).

Editor and Publisher: Paul Anbinder

Copy Editor: Brenda Gilchrist

Indexer: Gisela S. Knight

Designer: Binns & Lubin/Martin Lubin

Composition: U.S. Lithograph, typographers

Manufactured in Japan by Toppan Printing Company

Library of Congress Cataloguing-in-Publication Data

Perspectives on Morisot : essays /by Kathleen Adler . . .
[et al.]; edited and with an introduction by T.J. Edelstein. —
1st ed.
 p. cm.
Originally presented as lectures at a symposium at Mount
Holyoke College, Apr. 9, 1988, as a complement to the
exhibition Berthe Morisot—Impressionist.
"In association with the Mount Holyoke College Art
Museum."
Includes bibliographical references and index.
1. Morisot, Berthe, 1841–1895—Congresses. 2 Painters—
France—Biography—Congresses. I. Edelstein, T. J.
II. Adler, Kathleen. III. Mount Holyoke College. Art
Museum.
ND553.M88P47 1990
759.4—dc20 90-81567
 CIP

ISBN: 1-55595-049-3 (alk. paper)

Contents

Preface

IN 1987 the Mount Holyoke College Art Museum in association with the National Gallery of Art, Washington, D.C., organized the exhibition *Berthe Morisot—Impressionist.* Both the exhibition and its catalogue received wide critical acclaim.

The catalogue, written by Charles F. Stuckey and William Scott with the assistance of Suzanne G. Lindsay, is a biocritical study of Morisot's life and career. Its authors' chief goals were to provide an overdue assessment of her career as a whole, a revision of the chronology of paintings in the catalogue raisonné, and extensive footnote references. No previous publication on the artist had established this necessary scholarly apparatus.

Using a variety of methodological viewpoints, the present volume serves as a complement to the catalogue. The essays by a distinguished group of art historians long conversant with Morisot's work focus on different issues relating to Morisot as a woman artist—patronage, iconography, sources, and social context. They also treat individual works by the painter in depth, which has never before been done in the scholarly literature. In their original form, they were presented as lectures and at a symposium held on 9 April 1988 while the exhibition was at Mount Holyoke.

The papers could not have been delivered without substantial financial assistance. The exhibition was sponsored at its three venues—the National Gallery of Art, the Kimbell Art Museum, Fort Worth, Texas, and the Mount Holyoke College Art Museum—by Republic National Bank of New York and Banco Safra, S.A., Brazil. Indemnity was received from the Federal Council on the Arts and Humanities, and the exhibition also received substantial support from the National Endowment for the Arts. Linda Nochlin's inaugural lecture for the exhibition at Mount Holyoke was sponsored by the Massachusetts Foundation for Humanities and Public Policy. The symposium was supported by the Amy M. Sacker Memorial Lectureship Fund of the Department of Art, Mount Holyoke College. Other lectures connected with the exhibition were supported by the Monarch Capital Corporation, Aetna Life and Casualty Company, and Sterling Press.

A great many people also made these lectures possible, first and foremost, the late Professor Jean C. Harris who helped select the speakers for the symposium. Thanks are also due to the staff of the Mount Holyoke College Art Museum: Wendy M. Watson, curator; Sean B. Tarpey, registrar; Amy M. Wehle, business manager; and Patricia Keyes, education coordinator. The phenomenal core of volunteers who worked tirelessly during the symposium and other events were of immeasurable assistance, as was the Art Advisory Board of the museum. A number of other people made this volume possible: Paul Anbinder of Hudson Hills Press; Brenda Gilchrist, editor; Martin Lubin, designer. Thanks are due, as well, to all the lenders to the exhibition whose works are a part of this volume.

T. J. Edelstein
Director
Mount Holyoke College Art Museum

Colorplates

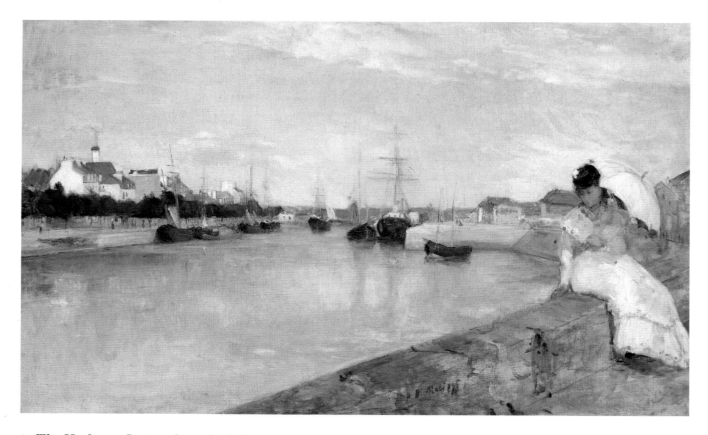

1 **The Harbor at Lorient** [BW 17], 1869

Oil on canvas, 43.5 × 73 cm (17⅛ × 28¾ in.).
National Gallery of Art, Washington, D.C., Ailsa Mellon Bruce Collection 1970.17.48

OVERLEAF, LEFT
2 **Young Woman at a Window (The Artist's Sister at a Window)**
[BW 18], 1869

Oil on canvas, 54.8 × 46.3 cm (21⅝ × 18¼ in.).
National Gallery of Art, Washington, D.C., Ailsa Mellon Bruce Collection 1970.17.47

OVERLEAF, RIGHT
3 **Mme Morisot and Her Daughter Mme Pontillon (The Mother and
Sister of the Artist)** [BW 20], 1869–70

Oil on canvas, 101 × 81.8 cm (39½ × 32¼ in.).
National Gallery of Art, Washington, D.C., Chester Dale Collection 1963.10.186

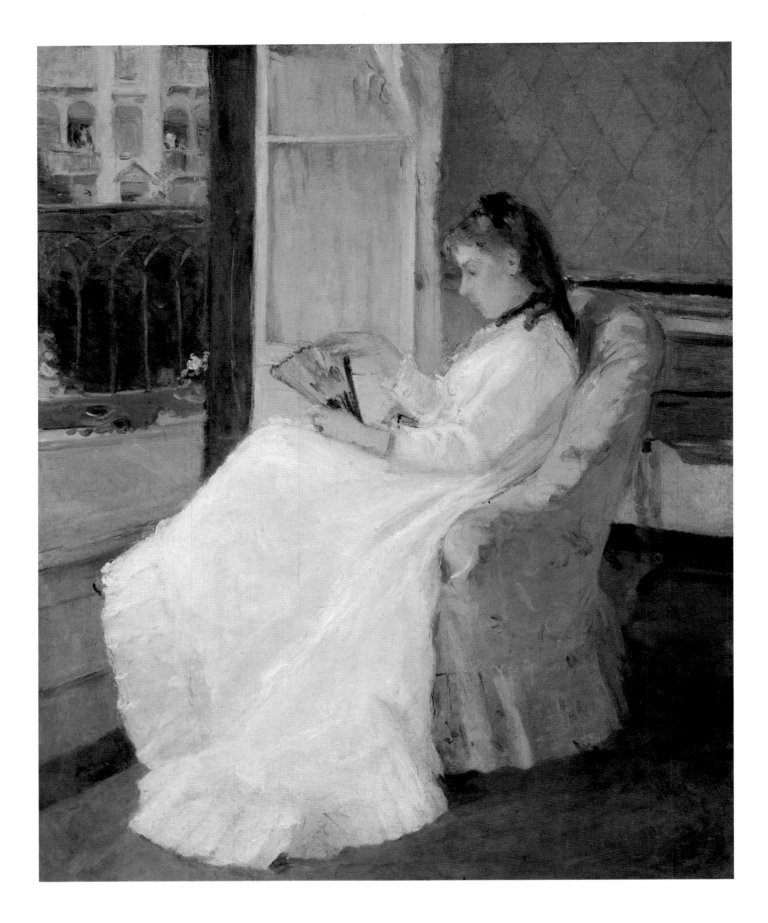

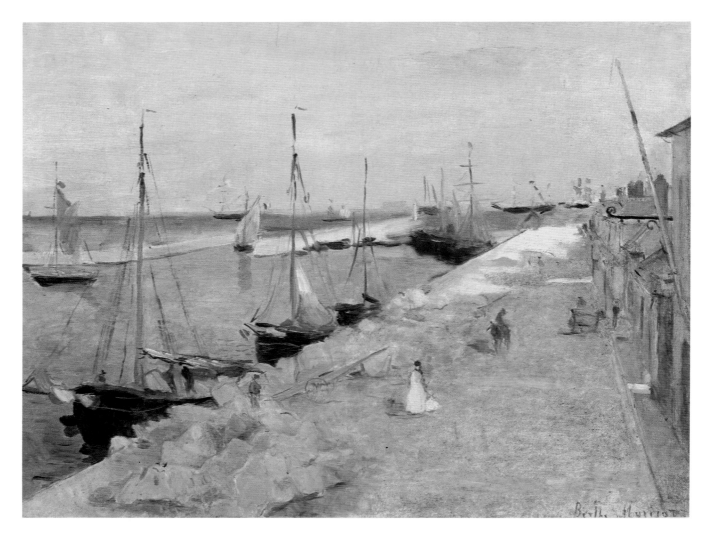

4 *The Harbor at Cherbourg* [BW 16], 1871
Oil on canvas, 41.9 × 55.9 cm (16½ × 22 in.).
From the Collection of Mr. and Mrs. Paul Mellon, Upperville, Virginia

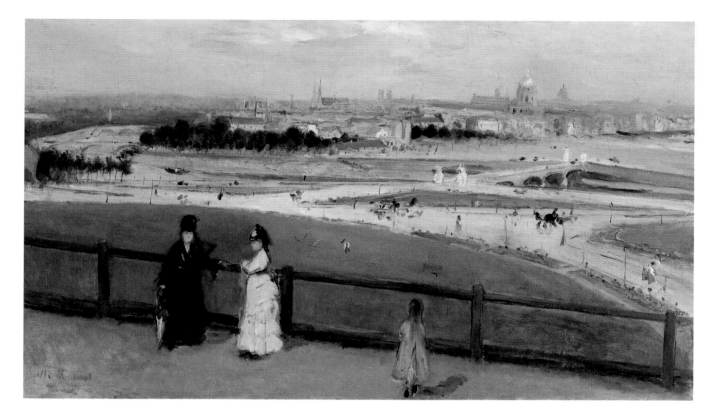

5 View of Paris from the Trocadéro [BW 23], c. 1871–72

Oil on canvas, 46.1 × 81.5 cm (18¹/₁₆ × 32¹/₁₆ in.).
Collection of the Santa Barbara Museum of Art, California, Gift of Mrs. Hugh N.
Kirkland

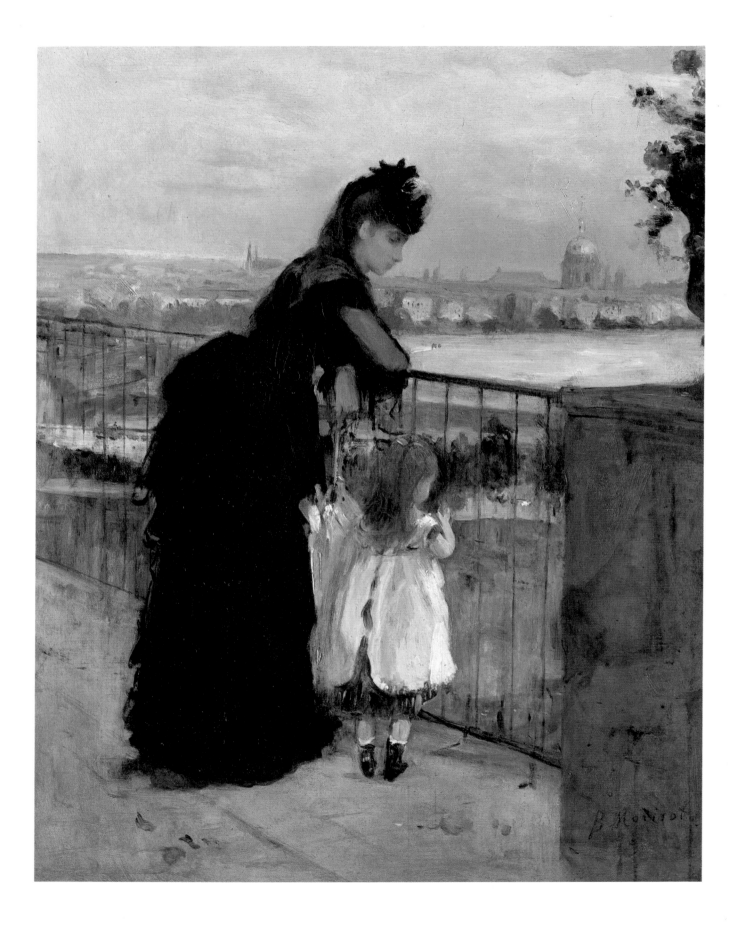

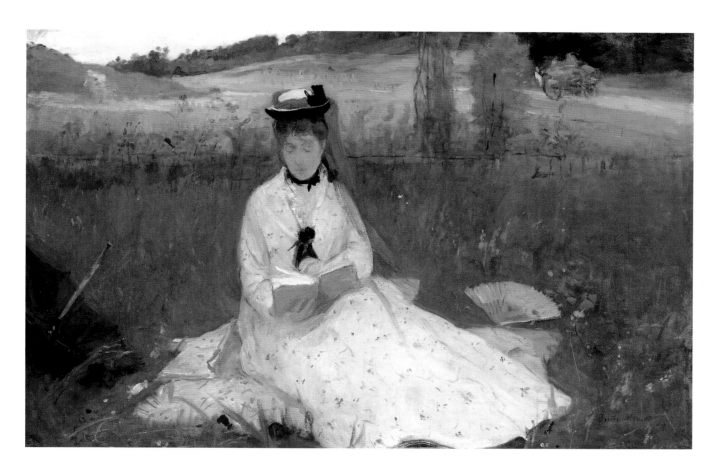

7 *Reading* [BW 14], 1873
Oil on canvas, 45.1 × 72.4 cm (17¾ × 28½ in.).
The Cleveland Museum of Art, Gift of the Hanna Fund

6 *On the Balcony* [BW 24], c. 1871–72
Oil on canvas, 60 × 50 cm (23⅝ × 19⅝ in.).
Private collection

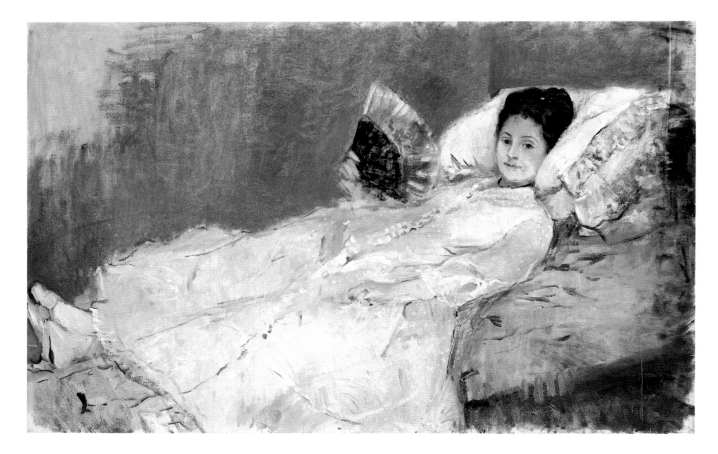

8 *Portrait of Mme Marie Hubbard* [BW 33], 1874
Oil on canvas, 50.5 × 81 cm (19⅞ × 31⅞ in.).
The Ordrupgaard Collection, Copenhagen

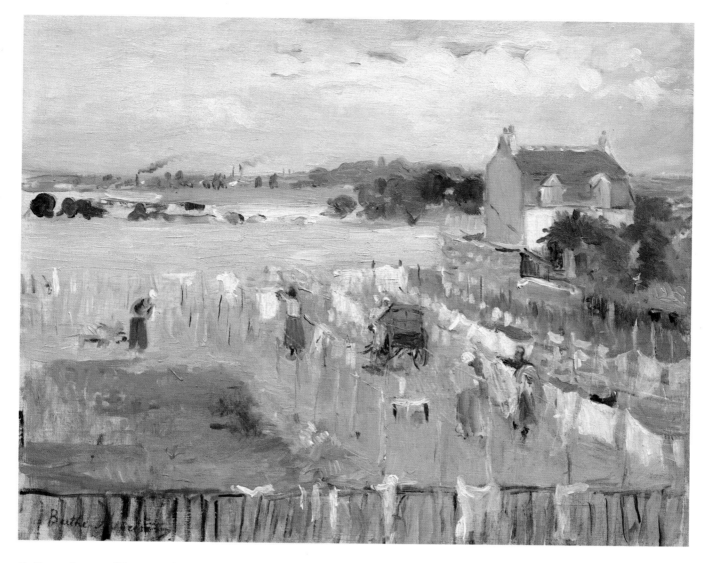

9 *Laundresses Hanging Out the Wash* [BW 45], 1875
Oil on canvas, 33 × 40.6 cm (13 × 16 in.).
National Gallery of Art, Washington, D.C., Collection of Mr. and Mrs. Paul Mellon
1985.64.28

10 Figure of a Woman (Before the Theater) [BW 59], 1875–76

Oil on canvas, 57 × 31 cm
(22½ × 12³⁄₁₆ in.).
Courtesy of Galerie Schröder und
Leisewitz Kunsthandel, Bremen,
Federal Republic of Germany

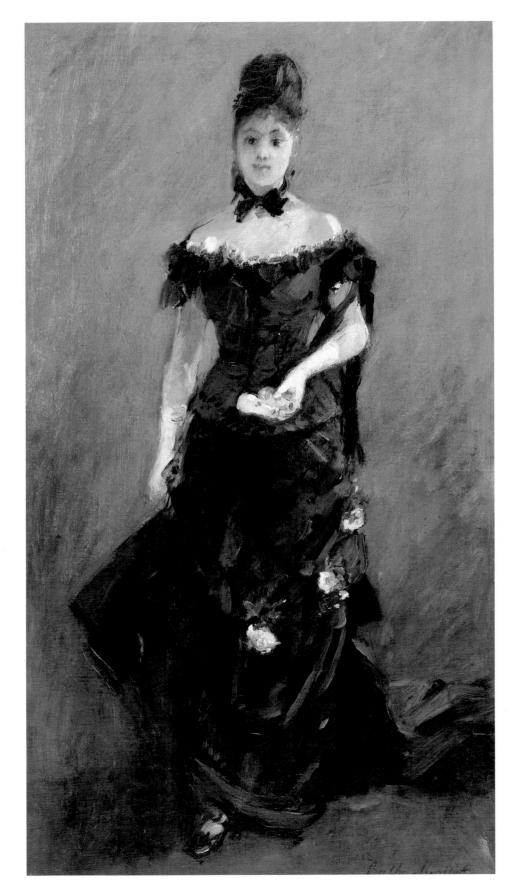

11 *The Black Bodice* [BW 74], 1876

Oil on canvas, 73 × 59.8 cm (28¾ × 23½ in.).
The National Gallery of Ireland, Dublin

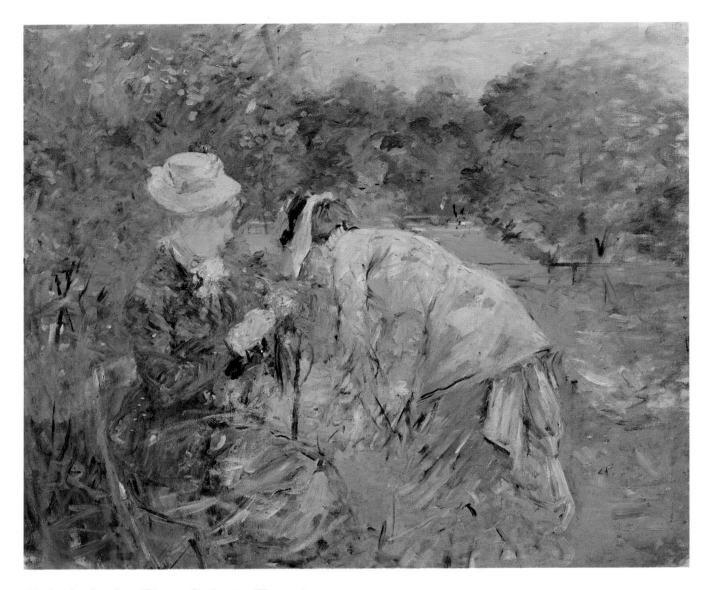

12 *In the Garden (Women Gathering Flowers)*
[BW 80], 1879
Oil on canvas, 61 × 73.5 cm (24 × 29 in.).
Nationalmuseum, Stockholm

13 *Winter* [BW 86], 1879–80
Oil on canvas, 73.5 × 58.4 cm (29 × 23 in.).
Dallas Museum of Art, Gift of the Meadows Foundation
Incorporated

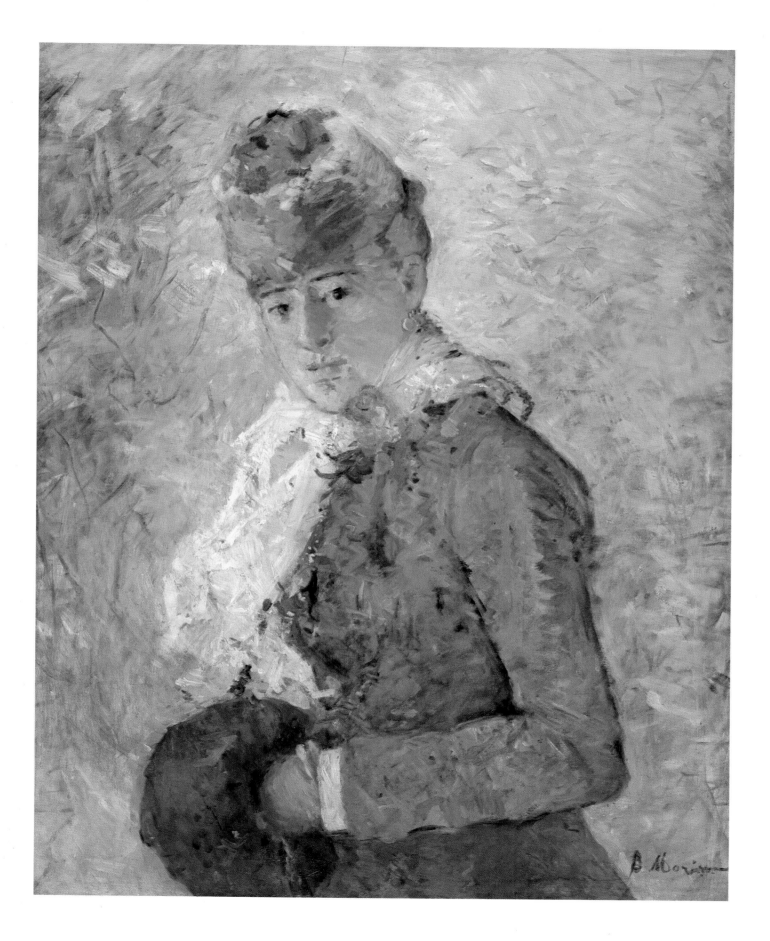

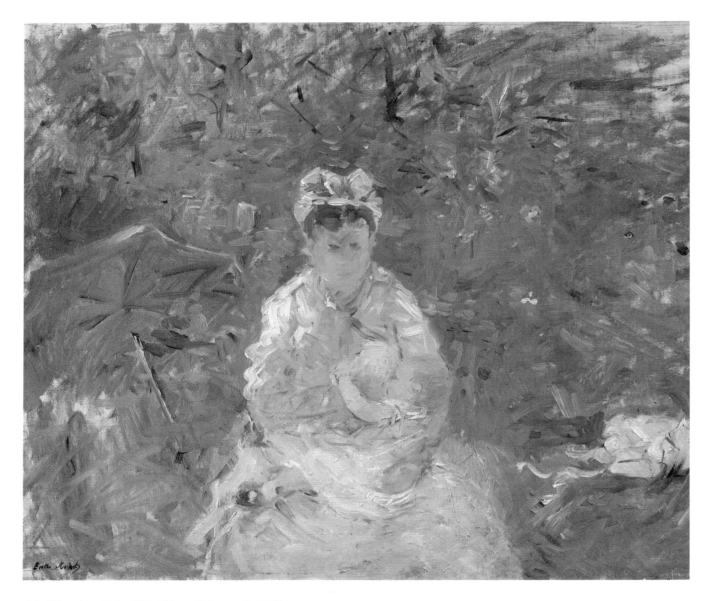

14 Nursing (The Wet Nurse) [BW 94], 1879
Oil on canvas, 50×61 cm (19¾×24 in.).
Private collection, Washington, D.C.

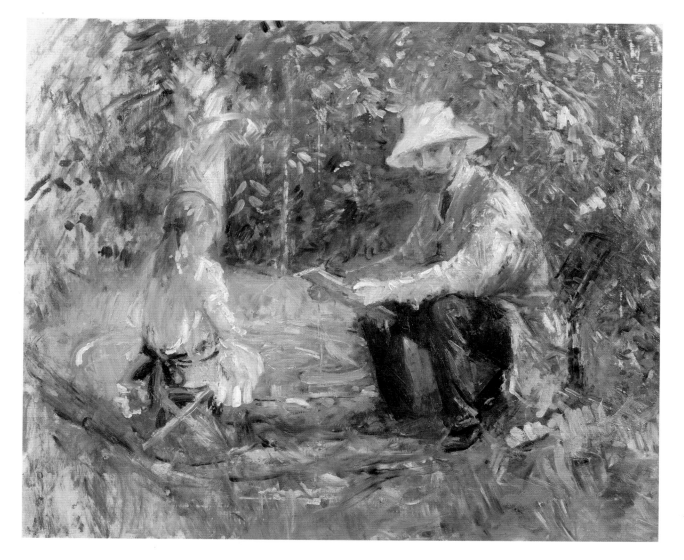

15 *Eugène Manet and His Daughter in the Garden* [BW 137], 1883

Oil on canvas, 60 × 73 cm (23⅝ × 28¾ in.).
Private collection

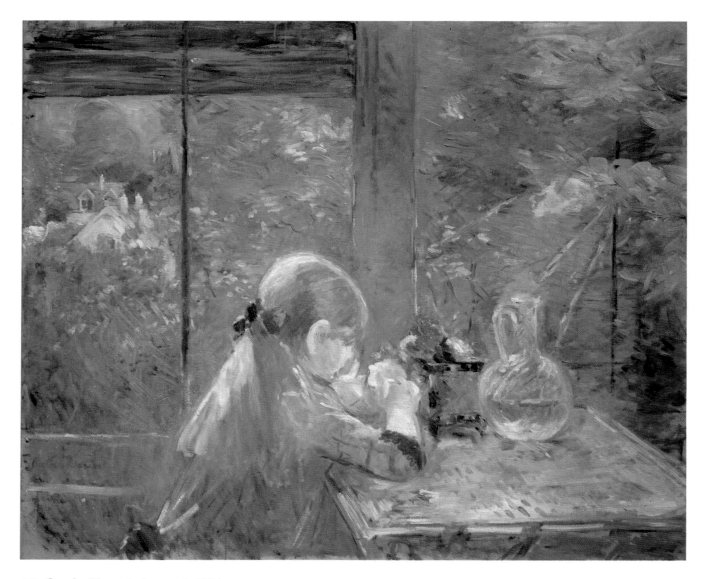

16 *On the Veranda* [BW 160], 1884
Oil on canvas, 81×100 cm (31⅞ × 39⅜ in.).
Collection of John C. Whitehead

17 *Self-Portrait* [BW 479], c.1885
Pastel on paper, 47.5 × 37.5 cm (18¾ × 14¾ in.).
The Art Institute of Chicago, Helen Regenstein Collection

18 *Self-Portrait with Julie* [BW 167], 1885
Oil on canvas, 72×91 cm (28⅜×35¹³⁄₁₆ in.).
Private collection

19 *The Bath (Girl Arranging Her Hair)* [BW 190], 1885–86
Oil on canvas, 91.1×72.3 cm (35⅞×28⁷⁄₁₆ in.).
Sterling and Francine Clark Art Institute, Williamstown, Massachusetts

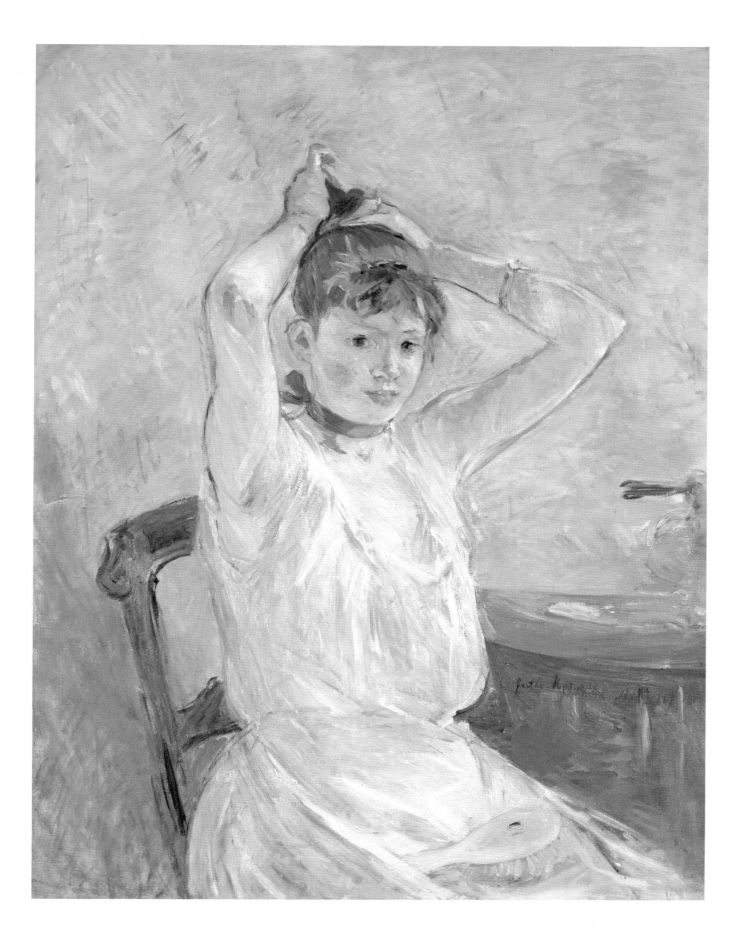

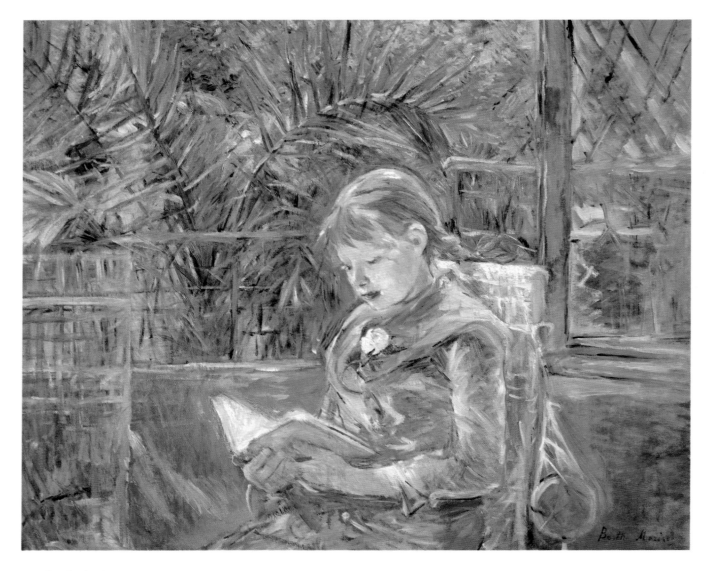

20 *Little Girl Reading* [BW 219], 1888

Oil on canvas, 74.3 × 92.7 cm (29¼ × 36½ in.).
Museum of Fine Arts, St. Petersburg, Florida. Gift of Friends of Art in memory of
Margaret Acheson Stuart

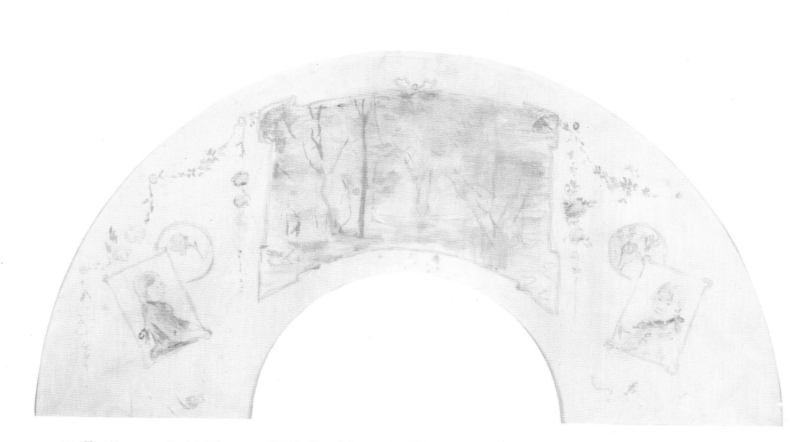

21 *Fan Decorated with Vignettes (Médaillons)* [BW 750], 1887
Watercolor on silk, 50 cm (19⅝ in.) [diam.].
Private collection

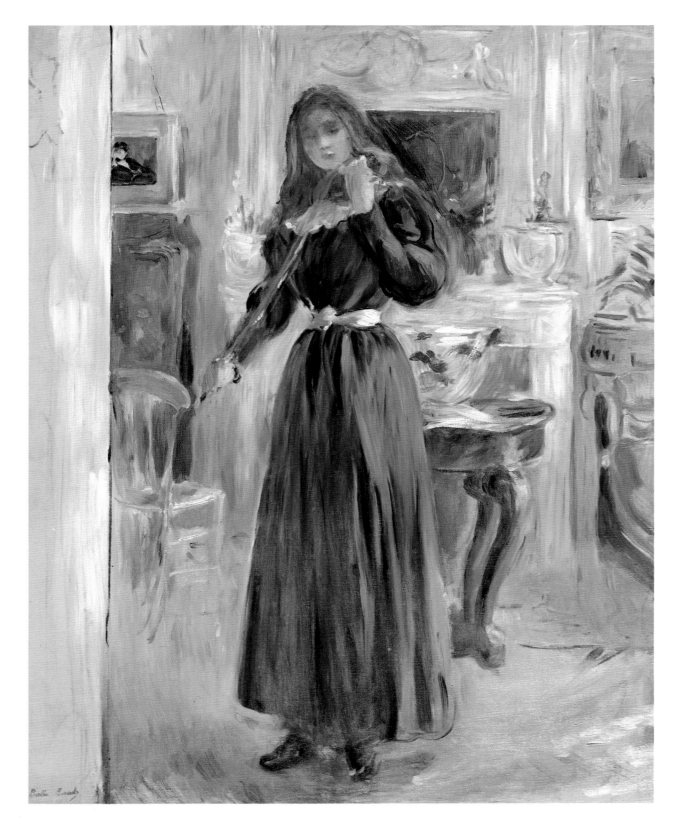

22 *Julie Playing the Violin (Julie au Violon)* [BW 354], 1894
Oil on canvas, 65 × 54 cm (25⅝ × 20¼ in.).
Mr. Hermann Mayer

23 *Portrait of Jeanne Pontillon* [BW 338], 1894

Oil on canvas, 116 × 81 cm (45⅝ × 31⅞ in.). Private collection, Switzerland

OVERLEAF
24 **Edouard Manet, *Repose,*** 1870

Oil on canvas, 148 × 113 cm (58¼ × 43¾ in.). Museum of Art, Rhode Island School of Design, Providence, Bequest of Mrs. Edith Stuyvesant Vanderbilt Gerry

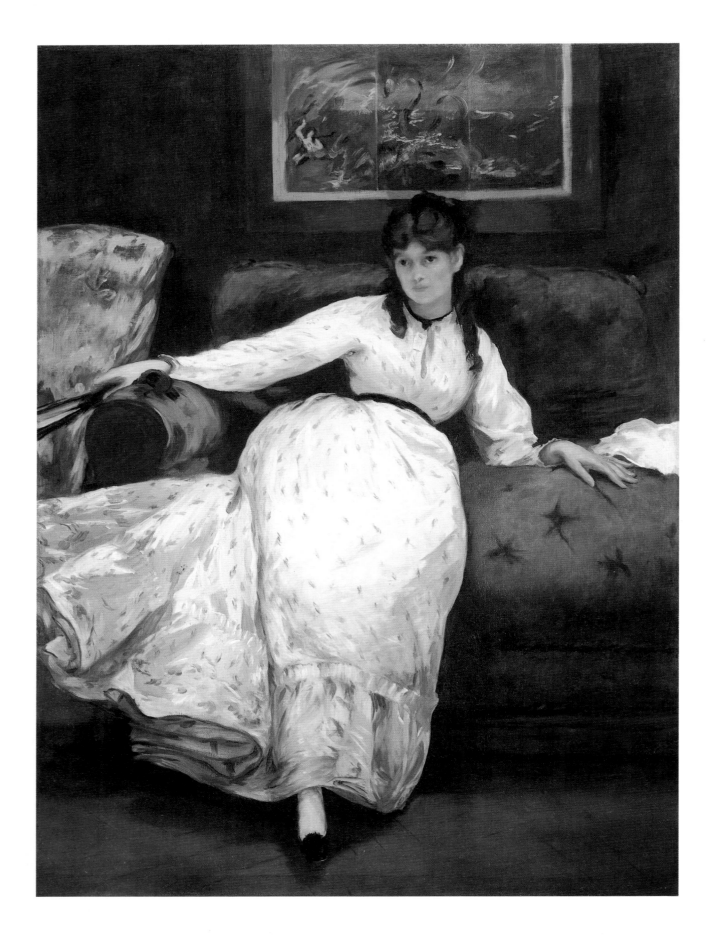

T. J. EDELSTEIN

Introduction

THE WORLD of Berthe Morisot is often a world of boundaries—of balconies or verandas that are both inside and outside, of a parapet at the edge of a harbor, of the natural world of the Bois de Boulogne that is nevertheless part of one of the greatest cities in the world, Paris, which, significantly, we see only in the distance.

This sense of edges, of limitation, is imposed upon a vision of spatial ambiguity, a visualization of ambivalence, which continues throughout her oeuvre. The most common theme of her art, it is prevalent in her earlier career in paintings such as *The Harbor at Lorient* of 1869 (colorplate 1), its loosely painted harbor wall placed at an oblique angle and jutting out of the canvas into our space. The handling of the stones of the wall with watercolor-like washes subverts expectations of atmospheric perspective because the background of the painting is painted in sharp detail. Morisot's sister Edma perches on a wall in a landscape of modernity. *On the Balcony* of 1871–72 (colorplate 6) contains a similar sense of separateness.

Little Girl Reading, 1888 (colorplate 20), reprises the composition of *On the Veranda,* 1884 (colorplate 16). In both, the heavy impasto and brilliant color of the background create a spatial conflation with the foreground. Yet the suggestion of the isolation, of the encapsulation, of the figure in the foreground remains dominant. The concentration of the protagonists on their tasks and the strong horizontals and verticals lock them into their own space. Equivocation might almost be said to be the subject of many of Morisot's paintings—and, in some sense, of her life.

Berthe Morisot achieved renown as an artist in an age when women were not even granted admission to the official art school, the Ecole des Beaux-Arts in Paris. She attacked a canvas with a confidence, rapidity, and power that astonish us even after our experience with twentieth-century art. Remarkably for a woman of the nineteenth century, she pursued a professional career and raised a family. But in spite of these achievements, she sometimes doubted her own accomplishments. In 1885 she wrote to Edma: "I am working with some prospect of having an exhibition this year: everything I have done for a long time seems to me so horribly bad that I should like to have new, and above all better, things to show the public. . . . It seems to me that I am about the only one [of the Impressionists] without any pettiness of character; this makes up for my inferiority as a painter."[1]

The authors in this volume touch upon this ambivalence. The world of Morisot is a suburban existence removed from the arena of modernity. Morisot's women are often dressed in a manner appropriate solely for the home. Edouard Manet, her great mentor, portrays

her hovering on the gray line between courtesan and proper young lady. Her self-portraits record both her image filtered through the prism of Manet's gaze and her independent existence as creator. Creator in more than one sense, as the ramifications of her painting *Nursing (The Wet Nurse)* convey. Even in the world of commerce, one in which presumably success or failure can be precisely measured, the definition of achievement remains ambiguous. And within the context of contemporary art theory, her work was perceived by her contemporaries as the perfect exemplar of woman's natural vision, a denial of its very radicalism.

In its iconography and its style, Morisot's art is an expression of these dichotomies. The vivacity of her brushwork creates a tension between the two-dimensional plane of the canvas and three-dimensional space which is heightened by her frequent use of unprimed canvas. *The Bath (Girl Arranging Her Hair)*, 1885–86 (colorplate 19), expands these ambiguities by adding a schism between the lower half of the figure, with its prototypically painterly strokes, and the upper half, in which Morisot begins to model the figure with

line, drawing with her brush. It is almost as if she has purposefully set out to confound the theorists of *couleur* versus *dessin*. What had been a tension between surface and depth, abstraction and mimesis, becomes a contrast between line and color, tradition and modernity. But yet another ambiguity is expressed by the interiority of the figure, emphasized by the spatial constriction created by the back of the chair and the table. The horizontal lines of this chair and its placement echo Morisot's recurring compositional and iconographic theme.

This volume, which places Morisot within a broader context than has been done in the previous literature, examines some of the critical issues that confronted Morisot as a woman and as a woman artist. The essays do not resolve the contradictions of her art but perhaps these very contradictions are what make her work so pertinent to us today.

1. Denis Rouart, ed., *The Correspondence of Berthe Morisot*, trans. by Betty W. Hubbard (London, 1959), 143.

KATHLEEN ADLER

1. The Spaces of Everyday Life: Berthe Morisot and Passy[1]

*Everyday life has always weighed
heavily on the shoulders of women.*
　　　　　—Alice Kaplan and Kristin Ross, 1973[2]

THIS PAPER focuses on one painting by Berthe Morisot, *View of Paris from the Trocadéro* (color-plate 5), painted in about 1871–72.[3] The painting represents two women and a child, with a distant view of Paris in the background. It is taken from the Trocadéro Gardens, at the intersection with the rue Franklin, close to the Morisot family home on that street. Purchased from Morisot by the dealer Paul Durand-Ruel in 1873, it was sold first to Ernest Hoschedé in 1873 for 750 francs, and then to the Rumanian collector Georges de Bellio in 1876 a few days after the second independent exhibition; it later entered the collection of Jacques Doucet and is now in that of the Santa Barbara Museum of Art, California (Gift of Mrs. Hugh N. Kirkland).[4] I intend to read this painting in ways that run counter to the existing discussions of it. I shall start, in relation to its subject matter, by emphasizing the place *from which* it was painted and what that place signified to Morisot and other women who lived there in the 1870s, rather than stressing the background of the painting—the view of the city of Paris.

Morisot lived in Passy, the sixteenth arrondissement of Paris, from about 1853[5] until her death in 1895. During this period of a little more than forty years, she moved several times, but always within the boundaries of the arrondissement. Since the place, Passy, was ob-viously of great significance to her, I shall consider what kind of place it was in the latter part of the nineteenth century and how it is accommodated in the discourses of urbanism of this period. First, it is necessary to examine what was meant by the term "suburb" in nineteenth-century France.

The concepts of "suburbs" and suburban development in Paris were closely linked with the growth of the railway system, particularly after 1856. The word *suburbain*, although used in ecclesiastical contexts since the fourteenth century, in its modern sense was a neologism for an area adjacent to, but distinct from, the city. By 1872 it is rather loosely defined in dictionaries such as the Hachette *Dictionnaire de la langue française* as: "That which surrounds a town; that which is almost in the town." It was accepted as a new word by the Académie in 1878. The definition of "suburb" relies on its differences, on establishing its separate and specific qualities that make it recognizably distinct from both the country and the city.

During the 1860s various writers attempted to define the particularities of the "suburban." Important among them was César Daly, the editor of the *Revue générale de l'architecture et des travaux publics* from 1840 to 1890, and editor of a series of illustrated books that he described as his *Bibliothèque de l'architecte*. This series contained four volumes of illustrations of historic ar-

chitecture, *Motifs historiques d'architecture* and *De sculpture d'ornement*, as well as several volumes on contemporary architecture. The largest section of the contemporary architecture volumes, *L'Architecture privée aux XIXe siècle,* was devoted to modern houses in Paris and its suburbs. This appeared in three series: three volumes in 1864, three in 1872, and the final two in 1877.[6] Daly repeatedly defined "suburban" in these volumes in terms of its particular characteristics as opposed to both the urban and the rural. In 1860 he wrote:

In our age of a modern, industrial and commercial society, there are in the city elegant houses to rent, glittering shops and hotels . . . and in the country, modest but pretty farmhouses and occasional châteaux. In addition, on the *faubourgs* of the large cities and along the railway lines, there is born a new category of private architecture, which one might perhaps call suburban.[7]

By 1864 Daly was emphatic that the simple classification of architecture into two groups, of city and country, was no longer admissible because it failed to account for "that new branch of our art" that he had named suburban architecture. This new architecture, he said, resulted from the rising importance of a rich and enlightened bourgeoisie in contemporary society and manifested its desire to satisfy its taste for luxury. He described the suburban home as "the clothing of the family," which revealed the ways and uses of the domestic foyer and the character of social relations among the bourgeoisie.[8]

Daly was not alone. In 1864 Léon Isabey and E. Leblan's *Villas, maisons de ville et de la campagne* described a "kind of revolution in taste," in which people were seeking to escape the tumult of the city and were developing a preference for the villagelike (*villégiature*).[9] And in 1875 and 1877 Eugène-Emmanuel Viollet-le-Duc and Félix Narjoux in their *Habitations modernes* illustrated selected examples of the new genre of suburban architecture. English commentators in publications such as the *Builder* also referred to the new phenomenon of suburban architecture in France. Already in 1855 an English visitor reported in the *Builder* that he "was much pleased with some newly erected villas and cottages ornés . . . at Passy and Auteuil, in which a highly picturesque effect was produced by the employment of black and red brick and stone without

any elaborate decoration. Some of these were in the Late Domestic French Gothic style."[10] The house that Daly illustrated most frequently in *L'Architecture privée* was in south Passy. Designed by the architect Edmond-Jean-Baptiste Guillaume, it was a mixture of Renaissance ornament, seventeenth-century forms, eighteenth-century planning, and nineteenth-century technology and attention to convenience, and, while noteworthily lavish, was typical of suburban architecture in both its location and its eclecticism.[11] For commentators like Daly and Isabey, the suburb was unequivocally the domain of a wealthy class. Isabey noted: "Everyone now wants to be a property owner, and those who aren't today will be tomorrow."[12]

Passy appears again and again in discussions of the suburban as the epitome of the new suburb. It had been created in emulation of London suburbs, as a place where men might "set up the home of the family in the good air and in the semi-country, while keeping their offices in the central part of the city."[13] Its growth, like that of other suburbs, was made possible by the development of the railway network, particularly by the frequent connections established between it and Auteuil and the Gare Saint-Lazare.[14] Passy's expansion began in the 1850s, at just the time Morisot and her family settled there after moving from Bourges. Although it still had a semirural aspect, it speedily acquired examples of that category of architecture Daly was defining as "suburban." By 1858 the *Builder* reported that the roads to the Bois de Boulogne and Saint-Cloud had been "lined, with Aladdin-like rapidity, with little rural retreats,—nests, as it were, sheltered under the leafage of the wood."[15] Passy was, nonetheless, the least densely populated of the twenty arrondissements constituted in 1860, and its population density was such that it could still be called a rural area.[16] By 1872 its density was unquestionably urban, the population having risen to more than forty-three thousand, in comparison with a little more than seventeen thousand in 1856.[17] Because of the constitution of its population, many of whom were *rentiers*, people of independent means, it was relatively far more powerful politically than working-class areas.[18] It was also an area, as I shall discuss below, closely associated with the Versaillais and the quelling of the Commune in 1871.

Passy occupied a special place between the city and the country and was able to draw on what were per-

ceived as the most desirable characteristics of both: it was situated on a hill at something of a remove from the city but close enough to central Paris to be convenient for traveling to work. Already in 1836 the view from the hill and the purity of the air attracted comment,[19] and this continued to be the refrain in writings on Passy during the remainder of the century and into the twentieth. Adolphe Joanne, for example, noted in his *Paris illustré* in 1870 and in 1877 Passy's fine view over the valley of the Seine, healthy atmosphere, and proximity to the Bois de Boulogne.[20]

Passy had been a village since at least the thirteenth century. By the eighteenth century, the Château of Passy, home of Le Riche de la Pouplinière, was known as a meeting place and a retreat for painters (including Jean-Baptiste Chardin, Jean-Baptiste van Loo, and Maurice-Quentin de La Tour), musicians, and writers, and there were other fine mansions and gardens in the Passy district. During the reign of Louis-Philippe, much of the area to the north and west of the Champs-Elysées had come to be dominated by waste grounds, market gardens, and storage buildings. At that time the Bois de Boulogne could be described as "so ugly by day and so dangerous by night that the less there is to be said about it the better."[21] Until well into the twentieth century, Passy residents clung to the notion of it as a village of a very particular kind, but in its mixture of the urban and the rural it conforms exactly to contemporary definitions of the suburban. Despite its village-like aspects, it was also irrevocably Parisian, as Jacques-Emile Blanche, long-time Passy resident, indicated when he wrote: "Passy, so pretty, so comme il faut, it is still Paris."[22]

It was crucial to the establishment of the concept of the suburb that it be separated from what was regarded as the "tumult" of the city and from the mix of social groups that characterized the city. Donald Olsen points out that the absence of a rich community life and the avoidance of contact with other classes were precisely what constituted the appeal of suburban living.[23] This was so, however, for men only. For women, as I shall discuss, the situation was markedly different. Writers like Daly, Isabey, and Viollet-le-Duc were concerned only with a specific kind of wealthy suburb: they were not interested in the suburban development of a very different sort to the northeast of Paris. As Louis Lazare noted in 1870, Paris had been fragmented

by the development of luxurious bourgeois suburbs to the west, such as Passy, and the growth of workers' suburbs to the east, such as Belleville: "Two very different and hostile cities have been constituted in Paris: the city of luxury blocked by the city of misery."[24]

In the literature of urbanism, and especially in the considerable body of art-historical writing that emphasizes the significance of the city center, with its boulevards, arcades, and cafés—the haunts of the flaneur—the nineteenth-century Parisian suburb has tended to be either ignored or conflated with areas along the Seine, such as Argenteuil, in the interests of setting up a dichotomy between the city/work and the suburb/leisure. But as T. J. Clark has observed: "To use the word 'suburban' to describe these stamping grounds —to apply it to resorts like Asnières or Chatou, Bougival, Bois-Colombes, or, pre-eminently, Argenteuil, was on the whole misleading, and remains so."[25] This is because a suburb like Passy was not a leisure area, with the exception of the Bois de Boulogne at its northern boundary, which occupied a special place in the lives and routines of Passy inhabitants.[26] One could not describe Passy in the terms Clark employed for Argenteuil: "Parisians were looking for somewhere to act naturally, to relax and be spontaneous; people took pleasure in Argenteuil; they did what they wanted there, they left the city behind."[27] Passy was a place where closely observed rituals of social behavior prevailed; spontaneity and relaxation were not greatly important in these codes.[28] Instead, it was intended to be a structured and ordered place, where women could devote themselves to being *femmes au foyer*, ready to provide that domestic bliss that writers like Jules Michelet regarded as their paramount function, more important even than the bearing of children.[29]

During weekdays especially, a suburb like Passy was primarily a women's place, a total contrast to the center of the city that, with the constraints imposed on her by the need for chaperonage and by male expectations about her in the city, allowed no space for the bourgeoise. As Susan Buck-Morss aptly comments: "The popular literature of flanerie may have referred to Paris as a 'virgin forest,' but no woman found roaming there alone was expected to be one."[30] For some of its inhabitants, Morisot among them, the suburb was a world of its own, with its own codes and practices and a rich community life. Blanche noted that Morisot

and her circle, whom he called *"les dames de Passy,"* were "a very formal society of bourgeoises for whom their area is like a sub-prefecture, and who seldom 'descend' into Paris."[31] Within the ordered structures of their "sub-prefecture," which had definite constraints and limits, upper-bourgeois women were able to act from a position of some strength. For this to occur, however, the frameworks had to be understood and retained. Far from attempting to rebel against, or even to subvert, the ideology of the separate spheres, women like Morisot and her circle worked within these structures and used them to their advantage. This meant that Morisot saw no need to ally herself with the growing feminist movement of the 1870s or with the emergence of a separate women's art world in the same decade.[32]

From a feminine position, Passy was very different from that same place viewed from a masculine position. As "muted" groups in society, women may map their social spaces in ways that bear little correlation to the ways the dominant group perceives them.[33] That mapping is a mental process, but it is closely connected with the physical properties of the space. Human geographers have emphasized how spatial relations are "themselves social, socially produced and socially reproducing"[34] and have stated emphatically that "space is not a 'reflection of society,' it is society."[35] In these discussions space is understood as one of society's fundamental material dimensions, which cannot be considered independently from social relationships.

The space that was Passy and the everyday lives of women in that space constitute the subject matter of Morisot's paintings. Instead of the "ebb and flow" of the life of the boulevards, that heroic modern life Baudelaire had exhorted painters to look to, her work represents the ebb and flow of other kinds of lives: those of women and children in the suburbs. Her paintings indicate the temporality of immediate experience, the continuous flow of day-to-day life. In them the suburb is neither heroic nor epic, but the site of small-scale daily rituals and occurrences. Anthony Giddens has called these daily rituals the *durée* of activity, in distinction to Fernand Braudel's term, the *longue durée* of institutional time.[36] Giddens considers that social life consists in regularized, eminently predictable social practices. The routinization of day-to-day life is the basis of the relations between practical consciousness and the properties of social systems, so that daily life

continues as a matter of routine, rather than of "directly motivated" phenomena. These day-to-day routines operate hegemonically to establish and maintain relations of power and control. In a nineteenth-century bourgeois suburb such as Passy, elaborate social rituals and forms of protocol were of paramount importance in establishing and maintaining "social life."

Henri Lefebvre, in his analyses of everyday life, which in his view is synonymous with social space, also emphasizes the significance of the routine and the familiar.[37] Kristin Ross and Alice Kaplan have argued that this concept of everyday life, which in Lefebvre's terms is only *modern* (i.e., born in the nineteenth century) everyday life, is important because it introduces a third term into the opposition between the phenomenological and the structural. "Everyday life is situated somewhere in the rift opened up between the subject, phenomenological, sensory apparatus of the individual and reified institutions. Its starting point is neither the intentional subject dear to humanist thinking nor the determining paradigms that bracket lived experience."[38]

For Morisot, everyday life was suburban life, with its rituals and repetitions. The range of her subject matter encompasses both the modes of repetition identified by Lefebvre: the cyclical, which dominates in nature, and the linear, the repeated gestures of work and consumption that tend to mask the cycles.[39] She represented women's rites of passage: pregnancy, birth, childhood, adolescence, maturity, the cycles of life and death; and the monotony of everyday recurrences: the ritual of the toilette, reading, playing with children, dressing in a variety of ways appropriate to different social functions, such as going to a ball.

While these themes may be equated with the subject matter of women's albums and amateur paintings, since they represent women's shared everyday lives,[40] it is important to emphasize that Morisot was not an amateur, but a professional painter. Her work is not a simple "record" of suburban life, and thus cannot be used as "documentation" of it, but must be located in the discourses on art and its institutions of the time—as well as in the realm of women's lived experience.

View of Paris from the Trocadéro may be examined in relation to contemporary artistic debates both about landscape painting and about "sketch" and "finish." Its horizontal format, almost twice as long as it is high, had been extensively used in landscape sketches by many artists, Charles-François Daubigny, Théodore

Rousseau, and Jules Breton among them. The format had its origins in Netherlandish landscape and enabled the inclusion of a considerable amount of topographical information.[41] Morisot's colleagues Claude Monet and Camille Pissarro were also employing a markedly horizontal format in some of their landscape paintings at this time, although in none is the ratio of width to height exactly as in *View of Paris from the Trocadéro*. In these panoramic landscape paintings the viewer is encouraged to perceive the vista as extending beyond the frame, in contrast to the Italianate compositional structure favored in Salon landscapes by artists like Camille Corot where the eye is directed to the center of the painting through some form of *repoussoir* device. Even within this mode, Morisot's painting is exceptional in the simplicity of the composition, with its foreground, middle ground, and horizon bands, and in the emphasis on the figures, which are larger in relation to the overall size of the canvas than was customary.

The debates about what constituted an appropriate degree of finish for a painting are also pertinent to Morisot's work. Like many examples from the early 1870s, *View of Paris from the Trocadéro* reveals a loose, freely worked facture with very little if any preliminary drawing or defined structure, even in the architectural forms on the horizon. The sketchiness of her work was often commented on by critics.[42] Such comments reflect the prevalent, often expressed view that drawing was superior to painting, and that drawing could be perceived as "masculine" while the use of color could be considered "feminine."[43]

The sketchiness and simplified compositional structures of Morisot's work may also be attributed in part to her relative freedom from the pressures exerted by the dealer/critic system: unlike Monet or Pissarro, she was not in a position where the overtures of a dealer were hard to resist.[44] This particular example is unusual in having a history of purchase by Durand-Ruel and resale to two well-known collectors. Although Morisot did sell her work regularly, often to fellow-artists,[45] she did not aim to please dealers. Her mother's comment in 1871 is perceptive: "If one must do bad work in order to please the public . . . she will never do the kind of work that dealers buy in the hope of reselling it."[46]

View of Paris from the Trocadéro was not exhibited in public until 1892, at Morisot's first solo show at Boussod and Valadon, so there is no record of the responses it elicited in the 1870s. In recent literature, however, considerable attention has been devoted to it. Two themes recur: the first is a seemingly inevitable comparison of Morisot's painting with Edouard Manet's *Universal Exhibition* of 1867 (Oslo, Nasjonalgalleriet). Even where Morisot's painting is acknowledged to be different from Manet's, not only in viewpoint but in intent, it appears that a connection needs always to be made in order to reinforce the polarity artist/woman artist. The second refrain is the assertion that it was "natural" for Morisot to paint this view.[47] The implication that for a woman artist, considerations of judgment and choice play less of a role than the supposed "naturalness" of painting the view of Paris from the end of the street in which she lived reveals that here, once again, within the seeming "neutralness" of the scholarly writing of catalogue entries, what is being constructed is the polarity culture/nature. Here, once again, woman is proposed as being to nature what man is to culture.[48] As in all such oppositional frameworks, the intention is the reinforcement of the dominant term, "culture." This binary opposition is as fundamental to the discussion of women and the city as are the other habitual oppositions of city/suburb, production/reproduction, public/private.[49]

These constructed oppositions determine most readings of the painting, privileging the city center in the background over the women in the foreground. Theodore Reff, for example, states that it is "a modern urban landscape, a panorama of the city and its major monuments, and the figures are merely incidental."[50] I want to argue, however, that the figures are far from incidental, as they might have been had this been simply a painting in a topographical tradition. Within that tradition, an image celebrating a noteworthy view of Paris, such as guidebooks agreed this to be, would have employed staffage figures, which often made gestures such as pointing to direct attention to the view. Neither in *View of Paris from the Trocadéro* nor in the closely related *On the Balcony* (colorplate 6) are the women represented looking at the view or gesturing toward it. In *On the Balcony*, in both the oil and the water-color versions, the woman looks at the child at her side, while in *View of Paris from the Trocadéro* one figure has her back to the view, and the other, in profile, faces her companion. In both paintings only the child faces the cityscape.

In the two paintings, a barrier marks a physical divide between the space in which the women are situated and the city beyond. In *View of Paris from the Trocadéro*, the barrier is formed by a railing, by the sweep of lawns of the Trocadéro Gardens, and by the river and the Champ de Mars. In *On the Balcony*, presumably painted from the Morisot family home in the rue Franklin, it is formed by a balcony railing and jardinière. The separation and sense of distance between the foreground figures and the view of the city are notable. It is a distance concerned not only with physical space but with social space.

In asking what the figures and their physical and social space with the city as their background signify, it is important to consider when they were painted. Whether *View of Paris from the Trocadéro* dates from the summer of 1871 or that of 1872, the Trocadéro Gardens and the view of Paris they commanded were presumably still charged with memories of the Commune of Paris and the events of May 1871. In mid-May of that year, the Communards were in control of the Trocadéro; Passy was suddenly no longer a peaceful suburb but a place under siege, with constant fire exchanged between the Communards and the Versailles forces in the Bois de Boulogne.[51] On 21 May the Versaillais seized the Trocadéro and Marshal MacMahon made his headquarters there. Morisot herself was no longer in Paris, but her mother wrote on 23 May:

One thing that is certain is that the gunboat is firing upon us continually; the reason is that the headquarters are in the rue Franklin, MacMahon is in the Guillemet house, Vinoy [General Vinoy, commander-in-chief of the army in Paris] is at the Cosnards', and the *intendant générale* is in our house. Tiburce [Morisot's brother] has invited these gentlemen to dinner. It seems that it is not easy for them to get provisions. . . . He has put the cellar at their disposal, as well as the linen, the china, etc. However, they sleep on mattresses on the floor, and almost in the open, since not a windowpane is left.[52]

Two days later, she wrote again: "Paris on fire! This is beyond any description. . . . A vast column of smoke covered Paris, and at night a luminous red cloud, horrible to behold, made it all look like a volcanic eruption. There were continual explosions and detonations; we were spared nothing."[53]

In *View of Paris from the Trocadéro*, any sign of these recent events is erased and the scene is one of tranquility and order. The heights of the Trocadéro have been reclaimed by the residents of Passy, the lawns and flower beds of the gardens have been perfectly restored, and the buildings on the skyline are visible proof of the city's survival. The buildings that are identifiable include the Palais de l'Industrie, Sainte-Clotilde, Notre-Dame, Saint-Sulpice, Les Invalides, and the dome of the Panthéon; the Tuileries Gardens appear in the left background.[54] No marks of damage are visible, no trace of chaos remains. Morisot's choice of viewpoint, far from being natural, reinforces the strength of an ideology that decreed that the bourgeoise should exist in a protected sphere, isolated from the man's world of business and of war.

The process of reclamation emphasizes the separateness of city and suburb. In Morisot's paintings, the women are, significantly, on the other side of the barrier from the city. They are in a space that is transitional, neither city nor country, and which may be described in terms of the stages of the rites of passage defined by the Dutch anthropologist Arnold van Gennep in 1903. He identifies three phases in the rites of passage: separation, transition, and reintegration.[55] In the phase of transition, the protagonists are in a "no-man's-land."[56] I want to apply these phases to the spaces of the city and to suggest that the suburb is not only geographically transitional, but also, within the ideology of "separate spheres," socially transitional. In such suburbs as Passy, women acted out rites of transition in the longer term—in the transitions from childhood to adulthood, for example—and in the shorter term, on an everyday basis. Daily, the suburb served its function to provide a safe space for bourgeois women and children, while men separated from and returned to them. Daily, the "no-man's-land" was not the nonspace that term implies, but a "woman's-land."

For the suburb to operate as it was intended, as a secure haven, the city had to be maintained as different from it, as "other." Saying this inverts the usual relationship between the city and the suburb in which the suburb, the feminine in the polarity, is constructed as the other. This is not to suggest that the suburb was the center: rather, it is an attempt to identify the role of a peripheral space in relation to the space defined as central. The opposition of the public sphere, the do-

main of men, and the private sphere, the domain of women, the gendering of the city, is obviously at the core of this discussion, but I wish to extend it by considering the suburb also as a social and public domain. Although it was within their homes in suburbs like Passy that bourgeois women played out their allotted roles of wife and mother, it was both within and without their homes, in the rituals of visiting, of playing with children and walking with them in parks and gardens like those of the Trocadéro, that their social life, their everyday life, was constituted. The suburban space was not just a container for a multitude of private homes. The intersection between these homes and the lives of their occupants had a real existence that needs to be defined not only in relation to the city center.

The construction of the relationship between the city and the suburb in Emile Zola's *Une Page d'amour*, published in 1878, is representative of the usual polarizing of city and suburb, in its emphasis on the primacy of the city. Here the main character, Hélène, who comes to Paris from Marseilles, is forced to rest in her Passy home after an accident. She "takes in the city in an idle glance," but has no idea what she is looking at. Her daughter's queries about what various buildings are receive only one answer: "I don't know." Zola describes Hélène as having ventured into the city only three times during the eighteen months she has spent in Paris, returning on each occasion agitated and distressed. Her view of the city is one of confusion and lack of knowledge, and she, like all the female characters in the novel, is represented throughout as ignorant. Each male character, on the other hand, possesses some form of prestigious knowledge, and the author himself retains power and control by imposing on the reader his detailed description of the view of Paris, acting as guide or interpreter. The gendered divisions of the city are sharply made, with the suburb acting as a foil to the dominant city,[57] the women's ignorance as a foil to the men's knowledge.

Morisot and her circle did not share Hélène's ignorance of the city. In part, the infrequency of their "descents" into it was because their class and gender made it uncomfortable for them to move into a "masculine" preserve. In part, too, their separation from the city was a deliberate decision, the result of being empowered within their own sphere, the woman's sphere of the suburb. *View of Paris from the Trocadéro* is not a painting of the city. It is a painting whose foreground and main interest are women and the "woman's-land" they occupied: the modern suburbs of Paris.

Notes

1. This is a much-revised version of the paper I originally presented at the Berthe Morisot symposium, Mount Holyoke College Art Museum, in 1988. Another version, "The Suburban, the Modern and 'une Dame de Passy,'" appears in the *Oxford Art Journal* 12, no. 1 (1989), 3–13. I am grateful to Teri Edelstein for her invitation to participate in the symposium, and to Tamar Garb, Tag Gronberg, Marcia Pointon, Briony Fer, and Richard Thomson for their comments. Special thanks to Jo Creed-Miles and, once again, to Malcolm Baker.

2. Alice Kaplan and Kristin Ross, "Introduction," *Everyday Life, Yale French Studies* 73 (Fall 1987), 3.

3. There is no real evidence that makes it possible to date the painting exactly. Charles F. Stuckey points out (Stuckey and William P. Scott [with the assistance of Suzanne G. Lindsay], *Berthe Morisot—Impressionist*, exh. cat., Mount Holyoke College Art Museum and National Gallery of Art, Washington, D.C. [New York, 1987], 44) that the letter in which Morisot refers to "doing Yves with Bichette" (1871) could refer to any of at least three paintings. There is no agreement about who the models for *View of Paris* were. Theodore Reff suggests her sisters, Yves and Edma, and her niece Paule (Bichette) (*Manet and Modern Paris*, exh. cat., National Gallery of Art [Washington, D.C., 1982], 38), and dates the work 1872. Mary-Louise Bataille and Georges Wildenstein (*Berthe Morisot: Catalogue des peintures, pastels, et aquarelles* [Paris, 1961], 24) identify the models as the Carré sisters, Valentine and Marguerite. Since one may assume that at this date Morisot worked at least in part from nature, it is clearly a summer painting. Morisot was not in Paris in the summer of 1871 until the end of July at the earliest, and she spent most of the summer of 1872 away from Paris. These absences do not, however, preclude the possibility of the painting's having been executed in either of these years.

4. The painting is no. 23 in Bataille and Wildenstein, *Berthe Morisot: Catalogue des peintures, pastels, et aquarelles*. There is additional information about its provenance in Sophie Monneret, *L'Impressionnisme et son époque*, 4 vols. (Paris, 1978–79).

5. The exact date of the family's move is not clear. Charles Stuckey accepts Armand Fourreau's date of 1852 in *Berthe Morisot* (Paris, 1925).

6. Daly has recently been discussed by Simon Jervis in his introduction to *César Daly: Interior Designs of the 19th Century*

(London, 1988), 3–8, a facsimile edition of plates from the third series of *L'Architecture privée au XIXe siècle*.

7. César Daly, *Revue générale de l'architecture et des travaux publics*, 1860, 34.

8. César Daly, *L'Architecture privée au XIXe siècle sous Napoléon III* (Paris, 1864), 11.

9. Léon Isabey and E. Leblan, *Villas, maisons de ville et de la campagne composées sur les motifs des habitations de Paris moderne dans les styles des XVIe, XVIIe, XVIIIe et XIXe siècles* (Paris, 1864), i.

10. *Builder* 13 (1855), 428.

11. Some aspects of this house are illustrated in Jervis, *César Daly: Interior Designs*, pls. 1, 2, 13, 20, 30–33.

12. Isabey and Leblan, *Villas, maisons de ville*, i.

13. A. Doniol, *Histoire du XVIe arrondissement de Paris* (Paris, 1902), 226.

14. Ibid.

15. *Builder* 16 (1858), 757.

16. Jacqueline Beaujeu-Garnier, *Atlas et géographie de Paris et la région d'Ile-de-France* (Paris, 1977), vol. 1, 215.

17. These population statistics are quoted from Doniol, *Histoire du XVIe arrondissment*, 27. In 1841, the year of Morisot's birth, Passy had a population of 6,704. By 1901 it had risen to 117,087.

18. For example, the Versailles Assembly in 1871 decreed that Passy have the same number of deputies as Popincourt, a working-class area with a population four times as great. Cited by Edith Thomas, *The Women Incendiaries* (London, 1967), 105.

19. P.-N. Quillet, *Chroniques de Passy et de ses environs* (Paris, 1836), 3.

20. Adolphe Joanne, *Paris illustré en 1870* (Paris, 1870), 244; *Paris illustré en 1877* (Paris, 1877), 254. Baedeker's guides make similar observations; for example, the 1903 guide in describing Passy uses the phrase *"grâce à sa situation des plus saines et au voisinage du bois de Boulogne,"* Karl Baedeker, *Paris et ses environs* (Leipzig and Paris, 1903), 237.

21. Victorien Sardou, preface to Georges Cain, *Nooks and Corners of Paris* (London, 1907), 1i.

22. Jacques-Emile Blanche, *Passy* (Paris, 1928), 9.

23. Donald J. Olsen, *The City as a Work of Art: London, Paris, Vienna* (New Haven, 1986), 164. The section of Olsen's book entitled "Villa Suburbia" has been an important source of ideas for this paper.

24. Louis Lazare, *Les Quartiers de l'est de Paris et les communes suburbaines* (Paris, 1870), 142.

25. T. J. Clark, *The Painting of Modern Life: Paris in the Art of Manet and His Followers* (London, 1985), 147.

26. Under Napoléon III, Adolphe Alphand had transformed the Bois de Boulogne into a simulacrum of a "natural" park by dint of elaborate planting and engineering programs. Many leisure activities, including ice-skating, riding, and boating could be enjoyed there. From the 1850s it was evident that Passy and Auteuil residents tended to use the Bois de Boulogne on weekdays as an extension of their private gardens, and to shun it on weekends.

27. Clark, *The Painting of Modern Life*, 198.

28. For a discussion of the significance of social rituals in women's lives, see Carroll Smith-Rosenberg, *Disorderly Conduct: Visions of Gender in Victorian America* (New York, 1985).

29. Michelet's description of the man's arrival home after a day in the city lays bare the ideological underpinnings of the "separate spheres": "In the evening, he arrives tired out.... But he finds at his home so much goodness, such harmony, that he is able to suppress the cruel realities of the day.... The mission of the woman (more so even than reproduction) is to refresh the heart of man." (*L'Amour* [Paris, 1858], 65.) For a detailed discussion of Michelet in relation to ideas about women's roles, see Thérèse Moreau, *Le Sang de l'histoire: Michelet, l'histoire et l'idée de la femme au XIXe siècle* (Paris, 1982).

30. Susan Buck-Morss, "The Flaneur, the Sandwichman and the Whore," *New German Critique* 39 (Fall 1986), 119. On the constraints imposed by the need for chaperonage, see also *The Journal of Marie Bashkirtseff*, introduced by Rozsika Parker and Griselda Pollock (London, 1985), especially the entry for January 2, 1879, 347. On the gender specificity of the concept of the flaneur, see Janet Woolf, "The invisible *flâneuse*: Women and the literature of modernity," *Theory, Culture and Society* 2, no. 3 (1985), 37–48. Griselda Pollock discusses the flaneur as "an exclusively masculine type" and the omissions that mark a history of art that gives its attention to the artist/flaneur, in "Modernity and the Spaces of Femininity," *Vision and Difference: Femininity, Feminism and Histories of Art* (London and New York, 1988), 50–90. Tamar Garb and I considered the exclusively masculine emphasis of the Baudelairean injunction to depict the "heroism of modern life" and what the feminine equivalent of this directive might be, in our *Berthe Morisot* (Ithaca, N.Y., 1987), particularly in chapter 3, "The Painting of Bourgeois Life."

31. Blanche, *Passy*, 44. Writing in the 1920s, Blanche was looking back at the Passy of the early years of the Third Republic with nostalgia. Louis Vauxcelles noted this in his chapter on "Les Femmes peintres d'aujourd'hui," in *Histoire générale de l'art français de la Révolution à nos jours* (Paris, 1922–25): "Ce fut vraiment une créature d'élite que 'cette dame de Passy,' comme la définit un jour M. Jacques Blanche, en un bien joli article, où le peintre-critique évoquait le vieux Passy de la villa Fodor, de la rue Guichard et de la rue

des Eaux, avant l'invasion des immeubles de la rue du Colonel-Bonnet, ex-avenue Mercedes" (315). I am grateful to Tag Gronberg for pointing this out to me.

32. For a detailed discussion of this, see Tamar Garb, "'L'Art Féminin': The Formation of a Critical Category in Late Nineteenth-Century France," *Art History* 12 (March 1989), 39–65.

33. Shirley Ardener, *Women and Space* (London, 1981), 11–12.

34. John Urry, "Localities, Regions and Social Class," *International Journal of Urban and Regional Research* 5 (1981), 458.

35. Manuel Castells, "Crisis, Planning, and the Quality of Life: Managing the New Historical Relationships Between Space and Society," *Environment and Planning D: Society and Space,* 1, no. 1 (1983), 4. See also Castells's *The Urban Question: A Marxist Approach* (London, 1977).

36. Anthony Giddens's theory of structuration is developed in his *A Contemporary Critique of Historical Materialism,* vol. 1, *Power, Property and the State* (London, 1981). The idea of the *durée* of everyday existence is discussed particularly on pages 64–65 and 150.

37. Henri Lefebvre, *Critique de la vie quotidienne,* 3 vols. (Paris, 1958–81). See also his "The Everyday and Everydayness," *Yale French Studies* 73 (Fall 1987), 7–11. Here Lefebvre states that "Modernity and everydayness constitute a deep structure that a critical analysis can work to uncover."

38. Kaplan and Ross, "Introduction," 3–4. See also Kristin Ross, *The Emergence of Social Space: Rimbaud and the Paris Commune* (Minneapolis, 1988), especially the Introduction, 3–31.

39. Lefebvre, "The Everyday and Everydayness," 10.

40. Anne Higonnet has discussed the "feminine imagery" of women's albums and paintings in "Secluded Vision: Images of Feminine Experience in Nineteenth-Century Europe," *Radical History Review* 38 (1987), 16–36.

41. See the discussion of this format in Michael Clarke, *Lighting Up the Landscape: French Impressionism and Its Origins,* exh. cat., National Galleries of Scotland (Edinburgh, 1986).

42. Morisot did not employ a standard canvas size for this painting: the format conforms neither to portrait nor to landscape nor to marine standardized formats.

Monet used a format that is twice as long as it is high in some paintings of 1871–73, for example, *Green Park,* painted in London in 1871; *Les Bords de la Zaan* and *Marine (Hollande),* painted in Holland in 1871; and *La Seine à Argenteuil* of 1872/73. He used a format that is almost exactly twice as long as it is high in *Bateaux sur La Zaan.* Pissarro used an exaggeratedly horizontal format, 55 x 130 cm, in his Seasons paintings of 1872.

43. On this, see Tamar Garb, in Garb and Adler, "The Painting of Bourgeois Life," and "'Soeurs de pinceau': The Formation of a Separate Women's Art World in Paris, 1881–1897," Ph.D. dissertation, University of London (in preparation). See also, Tamar Garb, "Berthe Morisot and the Feminizing of Impressionism," in this volume, pp. 57–66.

44. Although *View of Paris* was purchased by Durand-Ruel, Morisot's works were not significant in Durand-Ruel's bid to establish a market for Impressionist painting, which her virtual absence from Lionello Venturi, *Les Archives de l'impressionnisme,* 2 vols. (Paris, 1939), indicates. On Durand-Ruel's strategy, see Nicholas Green, "Dealing in Temperaments: Economic Transformations of the Artistic Field in France During the Second Half of the Nineteenth Century," *Art History* 10 (March 1987), 59–78.

45. See, for example, Merete Bodelsen, "Early Impressionist Sales 1874–94 in the Light of Some Unpublished 'procès-verbaux,'" *Burlington Magazine* 110 (June 1968), 333–36, for details of the auction sale at the Hôtel Drouot in 1875, where works by Morisot were purchased by Henri Rouart and by Ernest Duez, as well as by her brother-in-law Gustave Manet. See also, Suzanne Glover Lindsay, "Berthe Morisot: Nineteenth-Century Woman as Professional," in this volume, pp. 79–90.

46. Denis Rouart, ed., *The Correspondence of Berthe Morisot,* trans. by Betty W. Hubbard, introduction and notes by Kathleen Adler and Tamar Garb (London, 1986), 83.

47. See, for example, Richard Brettell, Scott Schaefer, et al., *A Day in the Country: Impressionism and the French Landscape,* exh. cat., Los Angeles County Museum of Art (Los Angeles, 1984), 118: "The site was a natural one for Morisot to choose."; Reff, *Manet and Modern Paris,* 38: "It was, moreover, a perfectly natural place for Morisot to choose, . . . so natural, in fact, that in the same year she painted another view of the same scene."

48. Sherry Ortner, "Is Female to Male as Nature Is to Culture?" in Michelle Zimbalist Rosaldo and Louise Lamphere, *Women, Culture and Society* (Stanford, 1974).

49. Linda McDowell discusses these polarities in the discourses of urbanism in "Towards an Understanding of the Gender Division of Urban Space," *Environment and Planning D: Society and Space* 1, no. 1 (1983), 60.

50. Reff, *Manet and Modern Paris,* 38.

51. A letter from a Passy doctor, Jules Rafinesque, describes vividly the changes in the habitual tranquility of Passy: "I am writing to you above the shells which are whistling over our heads. One fell five minutes ago in a garden next to ours, but it did not explode. . . . For the moment I watch the number of the sick diminish without regrets; for the streets of Passy are not safe, and I am the only doctor left." (Quoted in Alistair Horne, *The Fall of Paris: The Siege and the Commune 1870–71* [London, 1965], 347.)

52. Rouart, *Correspondence*, 71.

53. Rouart, *Correspondence*, 72–73.

54. Of these, the Palais de l'Industrie, built from 1852 to 1855, is the only modern building.

55. Arnold van Gennep, *The Rites of Passage* (London, 1960). I was introduced to van Gennep through Laura Mulvey's essay "Changes: Thoughts on Myth, Narrative and Historical Experience," *Visual and Other Pleasures* (Basingstoke, 1989), 159–76. Mulvey notes that transitional rites may be marked literally by a particular relationship to place.

56. Mulvey, "Changes," 171. The "no-man's-land" is also, in Alice Jardine's terms, the space over which the master narrative has lost control, a space that is coded as feminine, as woman. See Jardine's *Gynesis: Configurations of Woman and Modernity* (Ithaca, 1985), 25.

57. I have considered Zola's representation of the gulf between the city and the suburb of Passy at greater length in "The Suburban, the Modern, and 'une Dame de Passy.'" Naomi Schor discusses *Une Page d'amour* in chapter 2, "Smiles of the Sphinx: Zola and the Riddle of Femininity," in *Breaking the Chain: Women, Theory, and French Realist Fiction* (New York, 1985), 29–47.

BEATRICE FARWELL

2. Manet, Morisot, and Propriety

A T THE SALON OF 1873 Edouard Manet showed two works, *Le Bon Bock*, his first real success with both public and critics, and *Repose* (color-plate 24), a portrait of Berthe Morisot, which was greeted with a new storm of abuse. Ever since the scandal of the *Déjeuner sur l'herbe* ten years earlier Manet had been considered fair game for adverse criticism, so that what was new here was the favorable reception of *Le Bon Bock*. To modern eyes, *Repose* seems not only harmless, but a delicious portrait. Critics then, however, called it a "horror," an "indecent and barbarous smear," and a "challenge to good taste."[1] It was attacked for its "unfinished" appearance, an expected criticism leveled at much of Manet's work, and for the "mournful" expression of the sitter.[2] Cartoons ridiculed it as "A Lady Resting After Having Swept the Chimney Herself," and as "The Goddess of Slovenliness" (figure 2-1).[3] Some critics objected to the casualness of the pose, and it is this remark, and the implications of the cartoons, that I find interesting, particularly in view of the one favorable review by Manet's good friend the poet Théodore de Banville, who described it as imposing on the spirit "an intense character of modernity."[4] Banville recalled how Charles Baudelaire had esteemed Manet's work, and proposed that Manet was the only painter in whom one could recognize the "refined sentiment of modern life" that constituted the "exquisite originality" of *Les Fleurs du mal*.[5]

In nineteenth-century vanguard painting, if the vanguard literati love it while the bourgeois critics hate it, it is a safe bet that it contains elements of the "counter-discourse," as Richard Terdiman calls it—the continuous flouting of bourgeois values—that was carried on over many decades by the intellectual opposition in France.[6] The "counter-discourse" opposes the dominant discourse, that of the Establishment, and in the case of art, that of the Salon, with its state support and official recompenses to those who met with its approval. What was the element that triggered the automatic response? The painting was seen as "dirty," "slovenly," in "bad taste." The only clue to why it seemed so is the too-casual pose. I shall return to this problem after a short excursion for background information.

It is possible that Manet and Morisot had met many years earlier, but their two families had become socially intimate by 1868, the same year that *The Balcony* (figure 2-2) was painted, Manet's first monumental portrait of Morisot. Mme Morisot regularly accompanied her two painter-daughters, Berthe and Edma, to the weekly salons at Manet's home, where they listened to Manet's wife Suzanne's accomplished piano playing and engaged in witty conversation. The Morisots were equally familiar with Edgar Degas, and it has been remarked that Manet, Degas, and Morisot all belonged to the same upper-bourgeois class and socialized with one another far more than any of them did with the

45

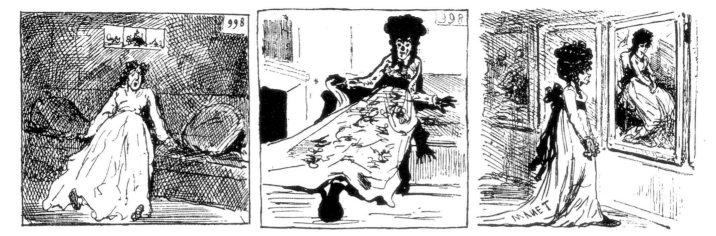

Figure 2-1

a. Bertall, "Seasickness," *L'Illustration*, 24 May 1873; b. Cham, "A Lady Resting After Having Swept the Chimney Herself," *Charivari*, 23 May 1873; c. Cham, "The Goddess of Slovenliness," *Charivari*, 8 June 1873.

other Impressionist painters, who were the sons of grocers and artisans.[7] Professional socializing at the Café Guerbois or the Nouvelle Athènes was different: it was an aspect of the painter's life in which Morisot could not participate because of social restrictions imposed more by gender than by class.

Morisot learned a great deal about painting from Manet, whose art she esteemed perhaps more than that of any other contemporary. Nevertheless, she consistently showed with the Impressionists, as Manet did not, and manifested professional solidarity with them as a group. It must be said, however, that Morisot's painting is more concerned with the figure than with landscape, a feature she shared with both Manet and Degas. And when one considers the range of modern subject matter the two men treated—the races, orgiastic picnics, backstage at the Opéra, nude women bathing—compared with the basic domestic *intérieur* and garden of Morisot's repertoire, one can get a quick take on the limitations under which she worked as a professional painter. Propriety was observed in every respect in her circumscribed life, and there was nothing even remotely bohemian about it.

I suppose that every art historian has wondered what emotional undertones reverberated beneath the ostensibly proper relationship between this married man and the disturbingly attractive, still young, unmarried colleague who sat for him so often and who ended up

Figure 2-2

Edouard Manet, *The Balcony*, 1868
Oil on canvas, 169 × 125 cm (66½ × 49½ in.).
Musée d'Orsay, Paris.

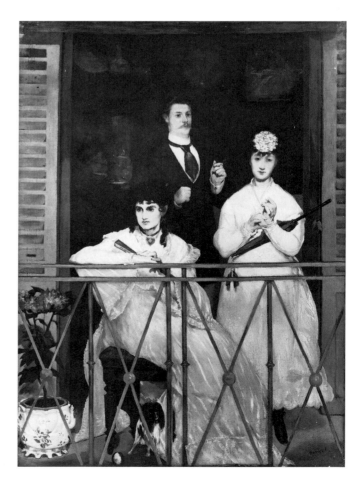

married to his brother. Except for her momentary jealousy of Eva Gonzalès expressed in a letter, no document reveals anything more than social compatibility and professional esteem. I have no revelations to make in this matter, except to repeat the undocumented report I have heard that critical portions of her unpublished diary covering the appropriate period are missing,[8] and to note that the letters, edited by her grandson Denis Rouart, are excerpted in such a way that *Repose* is nowhere mentioned, nor any reference to her posing for it.[9] As for Manet, certainly a warm appreciator of women in general though an apparently contented family man, it is anyone's guess. One does not even know where the posing sessions for *Repose* took place (the sofa seems to be hers, not his);[10] Adolphe Tabarant claims Morisot was chaperoned by her mother on these occasions;[11] in his somewhat fictional work, Henri Perruchot imagines there were times when her mother was unable to come along.[12] Whatever peccadillos may have enlivened Manet's life (and there are slight hints of some), he certainly was discreet, and the chances are that in Morisot's case social respect would have inhibited any overt amorous impulse, however compelling it might have been as an undercurrent. In some ways, I submit, the portrait known as *Repose* is probably the best piece of evidence we have regarding this question.

Manet had stored *Repose* in 1871 (it is generally dated 1870) when he left Paris after the German victory to join his family in the south. Thinking there would be an exhibition in May of that year, he wrote to Morisot's mother, asking for her permission to show the picture of Berthe, and assuring her that it had "none of the character of a portrait" and that he would give it the title *Etude*.[13] It says something about social conventions of the day that he made this request not of Berthe but of her mother, and that he needed to reassure Mme Morisot, in effect, that nobody would recognize her daughter, as though it would be unfortunate if they did. In the event, the Parisian civil war and the *semaine sanglante* intervened in Paris in May, and Manet did not show the picture until the 1873 Salon, after he had sold it to Durand-Ruel. By then the title had been established as *Repose*, and we might suppose that he again requested permission to show it. There is no word on why, of the several portraits Manet did of Berthe, only one small one was acquired by her

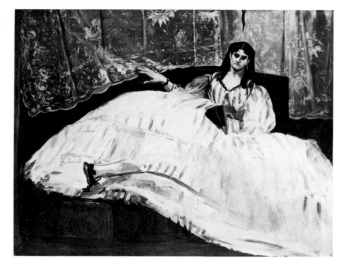

Figure 2-3

Edouard Manet, *Portrait of Jeanne Duval*, 1862
Oil on canvas, 90 × 113 cm (35½ × 44½ in.).
Szépmüvészeti Muzeum, Budapest

from Manet himself. When he sold *Repose* to Durand-Ruel, he gave Morisot a photograph of it.[14] In later collection sales, she did acquire three more of the small portraits, and attempted to acquire *Repose*, which had come up at auction. But owing to an error made by her bidder, she lost it.[15] Of the fourth, which she owned from the start, more will be said later. Clearly these works meant a great deal to her, all of her life.

Let us look at *Repose* in the context of portrait painting, first of all in Manet's own work, and let us note at once that Manet seldom painted a commissioned portrait. He painted friends, and men he admired in public life. Few portraits of women in his career have anything like the formality of, say, J.-A.-D. Ingres, or any of the more pompous Salon portraitists in the academician's wake, but though they tend to be informal, they are generally less so than many of Degas's. The one of the rival painter Eva Gonzalès, which he showed in the Salon of 1870, is certainly unexceptional in its iconographic manner of representation, though critics managed to disparage its technique. Later portraits of women are mostly half-length and far less monumental. Consider, however, the early works from his bachelor days, representing his friends' mistresses reclining on sofas: *Portrait of Jeanne Duval* (figure 2-3), Baudelaire's erstwhile mistress, and the *Young Woman Reclining in a Spanish Costume* (figure 2-4) dedicated to Nadar and

Figure 2-4

Edouard Manet, *Young Woman Reclining in a Spanish Costume*, c. 1862
Oil on canvas, 94 × 113 cm
(37¼ × 44¾ in.).
Yale University Art Gallery, New Haven,
Bequest of Stephen Carlton Clark,
B.A. 1903

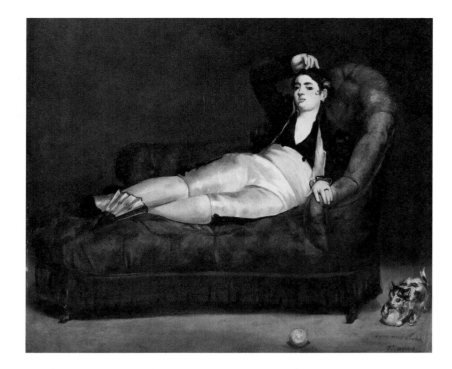

Figure 2-5

Edouard Manet, *La Femme aux Eventails*
(*Woman with Fans*), 1874
Oil on canvas, 113 × 166 cm (44½ × 65¼ in.).
Musée d'Orsay, Paris

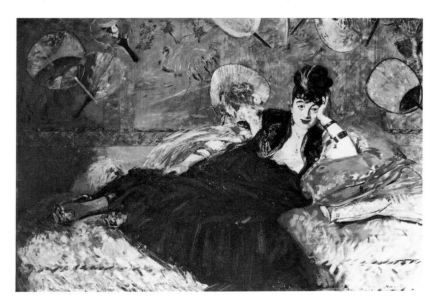

presumably painted for him, both of 1862. Both of these go rather far in the direction of casual pose, but on the other hand neither represents a respectable bourgeois woman. They are at best demimondaines, and more like what some wit called *le quart du monde*. Does *Repose* somehow resonate with a tradition of seductive, reclining females, simply because she is relaxing on a sofa? It is certainly hard to find a portrait of the kind commissioned by proper women or their families

that displays anything other than alert attention to the beholder, and it is even harder to find a portrait of one woman so much as seated on a sofa, let alone slouching with one leg drawn up.[16]

In the year *Repose* was shown, 1873, Manet began the large *Woman with Fans* (figure 2-5), a portrait of Nina de Callias, the estranged wife of the journalist Hector de Callias, fully reclining on a sofa in exotic North African costume. Was Nina de Callias a re-

spectable woman? An accomplished pianist and patron of the literary arts, she was the mistress of the poet Charles Cros, who introduced Manet into her circle. She later became both promiscuous and mentally unstable, but continued for many years to hold open house for a host of literary lights and their women, including Stéphane Mallarmé, Paul Verlaine, Anatole France, and, of course, Manet. But as Françoise Cachin has pointed out, it was Nina who had the fortune, and her lovers who were penniless poets; therefore she was the reverse of a demimondaine.[17] Moreover she maintained a household with her mother, a doting and indulgent woman whose presence nevertheless constituted chaperonage for her daughter in the eyes of society.[18] She was a renegade bourgeoise—a bohemian—a status unusual for an educated woman in those times. Hector de Callias, her erstwhile husband, on seeing mention of the portrait in a magazine where it was identified as Mme de Callias, wrote a note to Manet exacting a promise from him that it would never leave either her home or his studio. Manet promptly gave his word, and the portrait remained in his atelier.[19] It was never shown in the Salon, nor anywhere else until the memorial exhibition after Manet's death, where it was shown as *Woman with Fans*. It was purchased at the atelier sale by none other than Eugène Manet, Morisot's husband, and it hung in their dining room while their daughter, Julie, was growing up.[20] I shall argue that in this portrait Manet pioneered a daring format that was shortly taken up by others, and that *Repose* shared with this picture something from an iconographic tradition that had implications in the realm of propriety. In addition, it must be noted here that the small portrait of herself that Berthe had directly from Manet (figure 2-6) is a waist-length image, cut down from a full-length, of Berthe reclining, feet up, on a sofa. It was painted in 1873, the year of the *Woman with Fans*, and is probably the last one Manet did of her before her marriage to Eugène. There are no more after that.

The iconographic tradition of which I speak goes back to the eighteenth century. Before that, one will search in vain for any portrait in which the sitter is represented in anything but the most formal posture, either standing or "enthroned," as it were, on a straight chair. Indeed, until the eighteenth century the sofa was unknown to Western Europe. It was during the regency of the duc d'Orléans following the death of

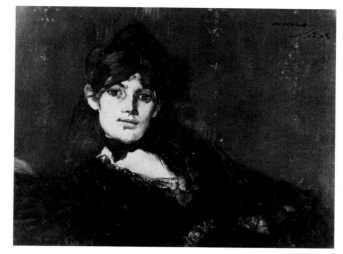

Figure 2-6

Edouard Manet, *Portrait of Berthe Morisot*, c. 1873
Oil on canvas, 26 × 34 cm (10½ × 13⅜ in.).
Private collection, Paris

Louis XIV, a time of libertinage and profligacy at court, that furniture began to acquire graceful lines and comfortable upholstery. And it was during this same period that among other sources of information the letters of Lady Mary Wortley Montagu with their descriptions of the harem of the Turkish court at Adrianople came to be known in France, along with the tales of Scheherezade. The sofa was imported from the Muslim East, and specifically from the women's quarters, a locale that, in the Western Christian mind, resonated with an exotic and illicit sexual morality of the greatest interest. *Sofa* is a Turkish word. It denotes a sort of dais raised some eighteen inches off the floor and surrounding the common lounging room in the harem, generally covered with soft and colorful cushions, on which the inhabitants reclined or sat, drank their coffee, smoked their hookahs, and, in the Western imagination, received the amorous attentions of their masters—or of illicit lovers. Many know of the novel *Le Sopha*, by Crébillon fils, which appeared in 1742 and went through twenty-five editions in the eighteenth century, but probably few of us have read it. Billed as "a moral tale" (*un conte moral*), it consists of the serial reminiscences of a personage of the Persian court who, under an enchantment, had been transformed into a sofa. He was to be released from his spell only upon witnessing an example of true love. He of course waited

a long time, and witnessed many other kinds of love, of which it is reported that Diderot, Laclos, and Stendhal all knew the juiciest passages by heart.[21] And while a contemporary evolution of the chair gave rise to the chaise longue, or daybed, a piece of bedroom furniture, the sofa came to be a standard feature of well-furnished rococo parlors and boudoirs. It imitated the shapes of existing chairs, but was wide enough to recline upon, and it assumed the connotation of a place for impromptu amorous activity in lieu of the more predictable and legitimate bed.[22]

Iconographic manuals for artists in the eighteenth century give formulas for the representation of lasciviousness as a woman reclining on cushions in immodest dress.[23] Another typical eighteenth-century image of a woman in relaxed posture on a sofa is of Oriental inspiration. In one of 1760 by Nicolas Boquet (figure 2-7), the sitter is Mme Favart, a well-known opera singer, in *Les Trois Sultanes*, an opera perhaps inspired by the famous book of Crébillon fils. Such a woman is generally represented as indulging in reverie, often induced in the Oriental case by the narcotic waterpipe, or, in the case of a Western woman, by a novel. The reverie is perceived, naturally, to be an erotic one, and the woman to be indulging in it in private. A work of this sort by Nicolas Lavreince is called The *Dangerous Novel* (Calouste Gulbenkian Foundation, Lisbon), although no book is in evidence. A 1781 engraving of it not only shows a discarded book, but makes the reverie more explicit by indicating the girl's hand in a conveniently placed pocket. It was because of such temptations that women were discouraged from learning to read, as in a line of Sir Anthony Absolute, the father of the hero of Richard Sheridan's *The Rivals*, who rants, "Had I a thousand daughters, by Heaven! I'd as soon have them taught the black art as their alphabet!"[24]

This kind of image was the prototype, in engraving, for a progressively more popular and less expensive imagery in lithography that came to be mass produced in the nineteenth century. A range of women reclining runs the gamut from simple repose to active coquetry, and from orientalist reverie to the European nude pinup (figures 2-8–11). The fully eroticized modern reclining nude of 1830, predecessor of Manet's *Olympia*, is successor to François Boucher's famous renderings of nude women in provocative postures on sofas, probably made for Louis XV. It was Gavarni who most specifically associated the sofa with the Parisian Lorette in a series of images published in *Le Charivari* on the kept women of the July Monarchy. The example reproduced (figure

Figure 2-7
Nicolas Boquet, *Madame Favart in "Les Trois Sultanes,"* 1760
Watercolor, 14 × 18.6 cm
(5½ × 7⅜ in.).
Bibliothèque du Théâtre national de l'Opéra, Paris

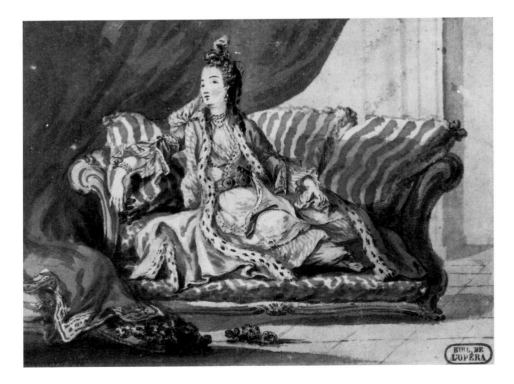

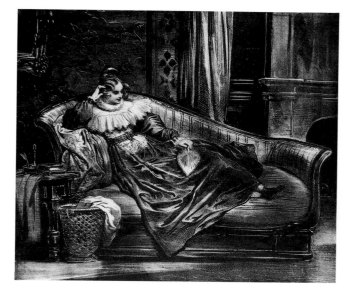

Figure 2-8

Achille Devéria, *Elle dort* (*Sleeping*), c. 1830
Lithograph.
Bibliothèque nationale, Paris

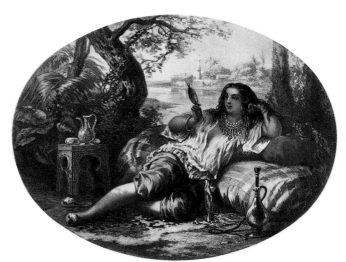

Figure 2-10

Claude Régnier, after François-Claudius Compte-Calix,
Constantinople, 1855–56
Color lithograph.
Bibliothèque nationale, Paris

Figure 2-11

Nicolas Maurin, *Europe*, c. 1830
Lithograph.
Bibliothèque nationale, Paris

Figure 2-9

Achille Devéria, *Coquetterie* (*Coquetry*), 1831
Lithograph.
Bibliothèque nationale, Paris

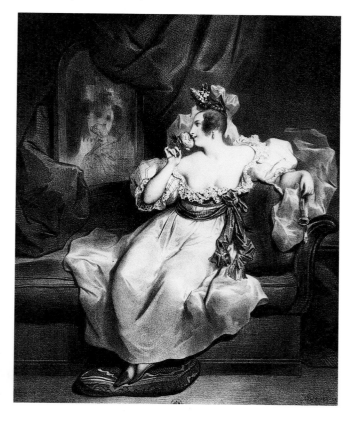

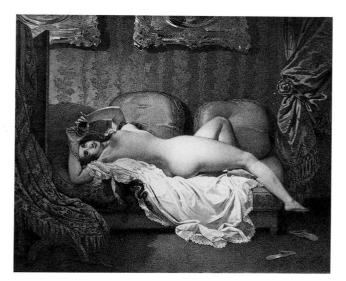

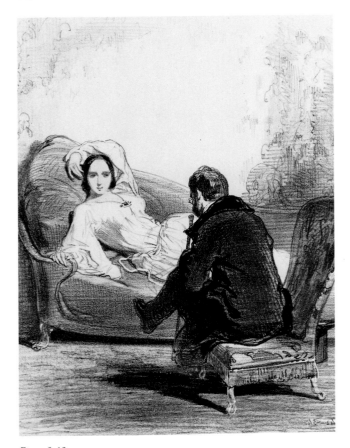

Figure 2-12
Gavarni, *Représentation à bénéfice . . . (Benefit performance . . .*), from *Les Lorettes*, 1843
Lithograph.
Bibliothèque nationale, Paris

2-12), if the male figure were removed, would be so close to Manet's portrait of Nadar's mistress as to suggest a direct connection. And in some images made for a less public audience one finds couples on sofas in scenes of seduction both of innocent women and of susceptible men. These involve an aspect of class interface common to all such subject matter, pointing up the iconographic hazards with which Manet was flirting. So much for the private uses of the sofa.

But what about proper portraits? The one of Mme Favart was of course a portrait of a performer in costume and in a role. This disqualifies the picture as a true portrait of an individual, but as we shall see, her profession tended to legitimize a representation that would not have been tolerated in a respectable family portrait. Moreover, it is only a small watercolor. The most familiar eighteenth-century example of a full-dress, reclining portrait that comes to mind is Boucher's *Mme*

de Pompadour (1756; Alte Pinakothek, Munich), who reclines in almost unbearable finery on a rococo sofa or daybed. But despite this famous example, it is very difficult to find others. There are certainly none of the legitimate Queen Maria Leczinska. It is as though a protocol were at work: the royal mistress; actresses; and one other category, it seems: artists' wives. A Boucher portrait of 1743 is presumed to represent Mme Boucher (figure 2-13), and the informality of her pose goes even further than Mme de Pompadour's: she really reclines with feet up. More research turns up *Mme Greuze* (an undated drawing in the Rijksmuseum, Amsterdam). And, appropriately, Manet's *Mme Manet on a Blue Couch* (1874; pastel, Cabinet des Dessins, Louvre, Paris) immediately following the de Callias portrait and the reclining one of Morisot. In a slight variation we also have *Portrait of Mme Claude Monet*, but painted by Pierre-Auguste Renoir (figure 2-14).[25] This breach of the protocol bespeaks a bohemian society in which artists shared the intimacy of their homes. Did Manet wish to represent Berthe as his wife in the small reclining portrait he gave her? Did he cut it up for artistic or for social reasons?[26] In Renoir's art in general one finds standing and elegantly seated sitters, but few recliners. When one is encountered, aside from Mme Monet, it is a sexy *Algérienne* (1870; National Gallery of Art, Washington, D.C.), clothed, to be sure, but evoking the odalisque of the harem in terms that will be inherited by Matisse.

There is also the case, isolated in Spain, of Goya's Majas, *vestida* and *desnuda*, reclining on a sofa or chaise longue, not a bed. They apparently represent some mistress of Prime Minister Godoy, for whom they were painted, and in whose collection they remained until his death in exile. They were never on public exhibition in the nineteenth century, and were known by word of mouth and by pirated replicas. The two pictures have been cited as possible sources for Manet's *Young Woman Reclining in a Spanish Costume* and for *Olympia*.

We have, then, in this format, portraits restricted to actresses, mistresses, and artists' wives, and nonportraits generally representing idealized harem women or their Western equivalent. We come now to an anomaly that presents a problem: Mme Récamier as painted by Jacques-Louis David (1800; Louvre, Paris). Similarly problematical is the marble sculpture of Pauline Bonaparte Borghese as *Victorious Venus* (1804–8;

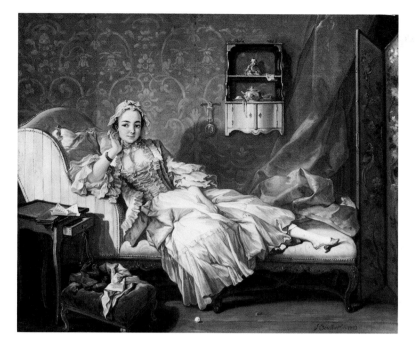

Figure 2-13
François Boucher, *Madame Boucher*, 1743
Oil on canvas, 57.2 × 70.8 cm
(22½ × 27⅞ in.).
Frick Collection, New York

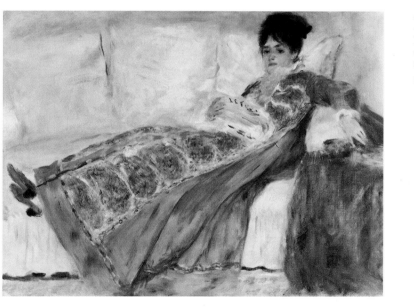

Figure 2-14
Pierre-Auguste Renoir, *Portrait of Madame Claude Monet*, 1872
Oil on canvas, 53.3 × 71.8 cm (21 × 28¼ in.).
Calouste Gulbenkian Foundation, Lisbon

Palazzo Borghese, Rome), in the nude. These may have been wives, but not of the artists who represented them. Nor were they light women. Mme Récamier shares Pauline Bonaparte's nudity only to the extent of her feet, and the fact that this feature was retained in her later portrait by François Gérard suggests it was her idea—though we may never know about that. Mme Récamier was married to a banker thirty years her senior upon her emergence from the convent, which means about age seventeen. She quickly became the center of an attentive social circle, largely on account of her ethereal beauty, and a fashion trendsetter because of her resulting social clout. Her virginal white clinging gown and blue headband, and her restriction of any precious ornament to pearls, consititued a symbolic flaunting of what Anita Brookner calls her "famous virginity," which she claimed to have maintained well into middle age despite her husband and the attentions of myriad suitors.[27] Let us face it: Mme Récamier was a tease. She herself commissioned her portrait by

David, at the age of twenty-three. Louis Hautecoeur says of this portrait that David wanted to make of her, as he did with his *Portrait of Mme de Verninac* (1799; Louvre, Paris), a figure "à l'antique."[28] Even though there is a vivid stylistic similarity, this comparison gets us nowhere, since it is the *pose* on which we want information. Mme de Verninac, Eugène Delacroix's older sister, is as properly and demurely seated as any lady of good social standing, though her costume obeys the extreme fashion that Mme Récamier's example commanded. But Mme Récamier's portrait has seemed to many to prefigure the *Grande Odalisque* of Ingres, who had actually worked on this canvas as a student of David.[29]

What are we to make of this anomaly, not to mention that of Pauline Borghese? There is little information on the Antonio Canova work of 1804–8. Though it is generally called *Victorious Venus*, the sculptor gave its head the features of Napoleon's sister, according to different accounts on orders either from the sitter herself or from her princely husband.[30] A legend has it that when she was asked whether it wasn't a bit uncomfortable posing thus before Canova, she replied cryptically, "The room was very warm."[31] The work is quite outside the norms of sculptured portraiture, but there is matter here for further study. In the case of both works the following speculations might be offered: first, that these women were independent, rich, and willful, and may well have commissioned their self-images as we see them, flouting the protocols we have hypothesized. The only argument against this is the knowledge that Mme Récamier preferred the Gérard portrait, and indeed had gone to Gérard while she was still sitting for David, which offended David and caused him to leave the famous canvas in its unfinished state.[32] She never claimed it, and it stayed in his studio until his death. Second, there is the possibility that such a flouting of tradition was somehow the result of concepts of freedom and equality born with the revolution —concepts that, particularly with reference to women, found expression not only in temporary freedom of fashion and temporary equality of a sort for women, and even temporary legalization of divorce, but also in the utopian thought of Saint-Simon and Charles Fourier. These portraits moreover bear witness to the complicity at least of two of the greatest artists of the time, David and Canova.

It is true that the Second Empire saw brisk acceleration in the revival of eighteenth-century style and subject matter, though I sometimes think as much of this came through the debased popular images of the Romantic period (which had eighteenth-century origins) as did directly from eighteenth-century art. It is also true that nineteenth-century Europe had absorbed a potent myth of non-Christian sexual freedom resulting from its contact as colonial dominator with Muslim culture in North Africa and the Near East. European women's demands for rights in their own society were effective enough in the early feminist movement to draw ridicule from the dominant sector in the form of cartoons. Anne Hanson quotes the caption of one in which a woman client in 1864 approaches an artist with these words: "I would like to have my portrait painted, but I would like something simple and gracious, for example, lying in a horizontal position on a divan, in the half light a ray of golden sunlight illuminating just my face, bringing out my attractions, and the smoke of a narghileh casting up a vague atmosphere provocative of dreams!"[33] Hanson offers this as a lampoon of popular "Turquerie," but it also contains reference to all the rest of the clichés we have detailed in the matter of portraiture, including horizontality, plus an obvious put-down of the intellectually fashionable woman who presumes to invade the world of male fantasy and sexual freedom on her own account.

In *Repose*, it is clear that Manet stepped slightly beyond the bounds of public propriety, and was publicly reprimanded for it. He did not go *far* beyond that boundary—instead of having Morisot really *recline* on the sofa as in the small, private portrait, he presented her frontally, so that her actual position is hard to read. Some of the critics noted this difficulty. The equivocal pose in conjunction with the distracted expression pushed the image away from "the character of a portrait," as Manet put it, but toward the character of an erotic fantasy piece with slightly immoral overtones. Not very far, but far enough to disturb a rigidly encoded protocol. After Manet's blatant flouting of such conventions ten years earlier, this is mild indeed, but Manet would not have wanted to plunge again into the public counter-discourse at the expense of this woman whom he respected and perhaps loved. Since he seems to have been aware of the rest of the portraiture protocols of his time, it is difficult not to see this

modest breach as deliberate. Perhaps he thought he could get away with a minor misdemeanor. I should like to think that he meant it as a tribute to Berthe, but owing to the bourgeois hypocrisies that he tried to combat throughout his career, it was seen as an insult instead. I do not think he miscalculated. He went as far as he dared in painting her as he felt she would like to be if society were a little different.

Morisot herself responded to the form if not the implications of this portrait and that of Nina de Callias. In 1874, the year in which Nina's portrait was completed, Morisot painted Mme Hubbard (colorplate 8) in a fully reclining position, close to that of Mme Monet as painted by Renoir in 1872. But the sitter reclines in a very stiff manner and seems sunken into the supporting bed. It is a real bed, not a sofa, with coverlet and pillows, and thus bespeaks a woman resting in her *intérieur* as seen by a friend of the same sex. There is nothing in this portrait to suggest the implications of the sofa. In a number of later works she pictured women on sofas or daybeds,[34] but none of these figures, whether portraits or mere sketches, can be read as sexual fantasy, although it is hard to assure oneself that one is not affected by the knowledge that the painter was a woman. No such image appears in her work earlier than 1874, the year of the de Callias portrait, except for a couple of totally domestic watercolors of her female relatives on sofas with their children.

There are other works in her repertoire that suggest she tried out subjects like those that preoccupied Degas in later life—bath and toilette—and that probably had their origins, in Degas's art at least, in popular imagery of a questionable kind.[35] But when Morisot did it, as in *The Bath (Girl Arranging Her Hair)*, 1885–86 (colorplate 19), what we see is again the women's *intérieur*, not the keyhole vision of the prurient male voyeur.

Others went on to paint portraits in the "brazen" format in Manet's wake: Emile-Auguste Carolus-Duran, who was a friend of Manet and could easily have seen his de Callias portrait, presented Mlle de Lancey (Alice Tahl, known as de Lancey), presumably an actress, in 1876 (Petit Palais, Paris), fully reclining on a sofa. And in the Salon that same year was the portrait by Georges Clairin of the divine Sarah Bernhardt (also Petit Palais, Paris) in her most voluptuous finery, exhibiting a certain artistic kinship with Mme Favart as a sultana one

hundred years earlier. These portraits are at one with the tradition, but they may be among the first large-scale, full-dress productions for public consumption, based on Manet's example, since Mme de Pompadour. Actresses, assumed to be women of easy virtue, could be portrayed with impunity as seductresses, punished as they already were with lack of respectability. Photographs of actresses and entertainers such as Adah Mencken or Rigolboche display a rich variety of informality. But, ironically, true *grandes horizontales* like Cora Pearl and Marguérite Bellanger were usually photographed with the utmost formality and propriety, making them indistinguishable, visually, from respectable women.[36]

What is to be learned from this minisurvey of an iconographic motif occasioned by Manet's picture *Repose*? I am not sure that it answers any questions, but it raises some. It may give us a slight insight into the emotional relationship between Manet and his model, and for students of these two artists that might be important, however unprovable. But beyond this biographical application of knowledge, it brings into question, for one thing, the nature of portrait painting in the nineteenth century and earlier. If this work has "none of the character of a portrait," and the features that make this so (the relaxed position, the air of reverie, the indirect gaze) relate it instead to the traditional representation of Oriental and erotic fantasy, then we confront the question of just how this kind of protocol and typology functioned in nineteenth-century culture, especially in its vanguard sector where one expects to find innovation rather than tradition. It would seem here that the "intense character of modernity" Banville saw was constituted in Manet's adoption of a traditional form for a new purpose: to render formal and decorous portraiture into something informal and intimate, thus flouting *another* tradition—an argument of the counter-discourse.

It also opens a window or two on matters concerning the social position of Berthe Morisot in particular and, by extension, nineteenth-century attitudes toward women in general. It ultimately links the idea of liberation for women with libertinage, or the fear of libertinage. A free posture means free morals. The freest of women in nineteenth-century civilization were those who had nothing to lose in respectability, just as the freest of men was symbolized by the ragpicker who had

nothing to lose in material goods or position, and could therefore speak his mind—the ragpicker-philosopher.[37] Perhaps this is why courtesans were in some way heroines in that time, not just fallen women, both to the male contingent that created them and to that portion of the female contingent that aspired to such estate. Morisot was embroiled, in Manet's portrait, with that freer, less circumscribed world to which he belonged and she did not. The picture balances on the edge between the two, leaving its original audience unsure about an appropriate response, and not quite knowing why.

Notes

1. Bernice F. Davidson, "Le Repos: A Portrait of Berthe Morisot by Manet," *Museum Notes: Rhode Island School of Design* 46 (December 1959), 8.

2. Ibid.

3. George Heard Hamilton, *Manet and His Critics* (New Haven, 1954), 163.

4. Ibid., 172.

5. Ibid. The passage in the original French is in Davidson, "Le Repos," 8–9.

6. Richard Terdiman, *Discourse/Counter-Discourse* (Ithaca, N.Y., 1985).

7. Eugénie de Keyser, *Degas: Réalité et métaphore* (Louvain-la-Neuve, 1981), 10.

8. Mina Curtiss, personal communication.

9. Denis Rouart, ed., *Correspondance de Berthe Morisot* (Paris, 1950).

10. Françoise Cachin et al., *Manet, 1832–1883* (exh. cat., Grand Palais, Paris, 1983), no. 121.

11. Adolphe Tabarant, *Manet et ses oeuvres* (Paris, 1947), 153.

12. Henri Perruchot, *Manet* (Cleveland, 1962), 200.

13. Davidson, "Le Repos," 6.

14. Cachin et al., *Manet*, no. 121.

15. Ibid.

16. Ibid., for an account of the drawn-up leg.

17. Ibid., no. 137.

18. See Tabarant, *Manet et ses oeuvres*, 228; also Albert de Bersaucourt, *Au Temps des Parnassiens: Nina de Villard et ses amis* (Paris, 1920), 27–30.

19. Tabarant, *Manet et ses oeuvres*, 239–40.

20. Cachin et al., *Manet*, no. 137.

21. Claude Prosper Jolyot de Crébillon (Crébillon fils), *Le Sopha*, preface by Jean Sgard (Paris, 1984), ii.

22. I am indebted to David Daiches for the remark of the actress Mrs. Patrick Campbell upon her marriage: "Oh, the peace of the double bed after the hurly-burly of the chaise longue!" Champfleury in *Vignettes romantiques* (Paris, 1883, 269) quotes on the subject this verse of Auguste Barbier: "Comment sur un sopha, sans remords et sans peur/Elle ouvre à tout venant et son jambe et son coeur."

23. H. F. Gravelot and C.-N. Cochin, *Iconologie par figures* (reprint, Geneva, 1972).

24. Act I, scene 2.

25. Renoir also painted *Mme Claude Monet Reading* (1871; Sterling and Francine Clark Art Institute, Williamstown, Massachusetts), and Monet himself painted *Mme Monet on a Couch* (1871; Musée d'Orsay, Paris). These and the Gulbenkian portrait are noted in connection with Manet's pastel of his wife by Cachin et al., *Manet*, no. 143.

26. See Denis Rouart and Daniel Wildenstein, *Edouard Manet: Catalogue raisonné* (Lausanne and Paris, 1975), no. 209: Morisot herself in a notebook indicates that the portrait was cut down from a full-length "couché sur un canapé." Rouart and Wildenstein offer the explanation that Manet was dissatisfied with the right portion of the canvas.

27. Anita Brookner, *Jacques-Louis David* (New York, 1980), 144.

28. Louis Hautecoeur, *Louis David* (Paris, 1954), 189.

29. Ibid.

30. According to Mario Praz, *Opera completa di Canova* (Milan, 1976), no. 165, it was commissioned by her husband. The alternative report is given in Giulio Carlo Argan a cura di Elisa Debenedetti, *Antonio Canova* (Rome, 1969), 133. Fred Licht (*Canova* [New York, 1983], 138–39) concurs with the latter report and even suggests that Canova was scandalized by the request. He concludes that the piece was intended to be viewed in the bedchamber and only by selected visitors (141).

31. Arrigo Pozzi, *Antonio Canova* (Ferrara, 1923), 76.

32. Brookner, *David*, 145.

33. Anne Coffin Hanson, *Manet and the Modern Tradition* (New Haven, 1977), 46.

34. See, for example, Marie-Louise Bataille and Georges Wildenstein, *Berthe Morisot: Catalogue des peintures, pastels, et aquarelles* (Paris, 1961), nos. 61, c. 1875; 434, 1877; 339, 1893; and 338, 1894.

35. See Beatrice Farwell, *The Cult of Images: Baudelaire and the 19th-Century Media Explosion* (exh. cat., University of California Art Museum, Santa Barbara, 1977), 13 and nos. 5–7

36. See photographs reproduced in Claude Blanchard, *Dames de coeur* (Paris, 1946).

37. Farwell, *Cult of Images*, no. 45.

TAMAR GARB

3. Berthe Morisot and the Feminizing of Impressionism

Dispersing, piercing those metaphors—particularly the photological ones—which have constituted truth by the premises of Western philosophy: virgin, dumb, and veiled in her nakedness, her vision still naively "natural," her viewpoint still resolutely blind and unsuspecting of what may lie beneath the blindness.

—Luce Irigaray, 1974

IN AN ARTICLE published in *La Nouvelle revue* in the spring of 1896, the year of the posthumous retrospective of Berthe Morisot's work, the prominent critic Camille Mauclair announced that Impressionism was dead.[1] It had become history. It was an art form that had lived off its own sensuality, and it had died of it. It was possible, now, in the 1890s, to detect the unsatisfactory and illusory principle on which it had been founded. For Mauclair, Impressionism was a style based on the misguided aim of restricting itself to the seizing of visceral sensation alone. It rejected all general and underlying truths in favor of the appearance of the moment. Its meagre resources were the hand and the eye. Like many of the supporters of Symbolism in the 1890s, Mauclair approved of the Impressionists' assertion of "subjectivity" ("nature seen through a temperament," in Emile Zola's words) and their rejection of old-fashioned beliefs in academic beauty, but he objected to their reliance on what he called "realism." By precluding from its orbit anything that was not to be found in the world of immediate experience, he claimed, Impressionism had destroyed itself. While understandably avoiding the excesses of idealism, it had lapsed into crass materialism.[2]

Although this view of Impressionism became prevalent in the 1890s, Impressionism had for some time been regarded as an art form of spontaneous expression, as a means of finding the self in the execution of

a painting whose very technique came to represent a direct and naïve vision, however hard won. For its supporters it could be defended in terms of its "sincere" and "truthful" revelation of the temperament of the artist, who filtered the world of visual sensation through the physical acts of making marks on a surface, approximating those sensations by inventing an appropriate technical language and thereby presenting a just and personal vision of the outside world. For many of its detractors, though, Impressionist painting could be construed as a thoughtless, mechanical activity, which required no exercise of the intellect, no regard to time-worn laws of pictorial construction, and involved simply the unmediated reflex recordings of sensory impulses, a practice that smacked of both decadence and superficiality.

It was, however, Impressionism's alleged attachment to surface, its very celebration of sensory experience born of the rapid perception and notation of fleeting impressions, that was to make it regarded in the 1890s as a practice most suited to women's temperament and character.[3] Indeed, Mauclair himself, while denigrating Impressionism at large, called it a "feminine art" and proclaimed its relevance for the one artist whom he saw as having been its legitimate protagonist—a woman, Berthe Morisot. In turn, Impressionism's demise is traced to its allegedly "feminine" characteristics: its sensuality, its dependence on sensation

and superficial appearances, its physicality, and its capriciousness.[4]

While the discourse that produced this apparently seamless fit between Impressionist superficiality and women's nature attained the level of a commonplace in avant-garde circles in the 1890s, those critics who read the art press had long heard Morisot's works discussed in terms that inscribed them as quintessentially "feminine."[5] In 1877 Georges Rivière had commented on her "charming pictures, so refined and above all so feminine."[6] When *Laundresses Hanging Out the Wash* was exhibited in 1876 and *Young Woman in a Ball Gown* in 1880, the works were praised for their delicate use of brushwork, their subtlety and clarity of color, their refinement, grace, and elegance, their delightfully light touch.[7] Her paintings were repeatedly praised for what was described as their "feminine" charm. Although many critics lamented the lack of finish in her work, some could still observe as Albert Wolff did that: "Her feminine grace lives amid the excesses of a frenzied mind."[8] She was seen, at worst, as the "victim of the system of painting that she has adopted."[9] On one occasion her lack of "finish" was attributed to a primordial feminine weakness. Paul de Charry, writing in *Le Pays*, asked, "With this talent, why does she not take the trouble to finish?" and answered himself, "Morisot is a woman, and therefore capricious. Unfortunately, she is like Eve who bites the apple and then gives up on it too soon. Too bad, since she bites so well."[10]

It is true that the qualities of "grace" and "delicacy" were on some occasions used to describe the techniques of the male Impressionists. Alfred Sisley was even credited with a "charming talent," and his *The Bridge at Argenteuil in 1872* was said to show his "taste, delicacy and tranquility."[11] Camille Pissarro on the occasion of showing his *Path through the Woods* (1877) was said to be gifted with a fine sensibility and great "delicacy."[12] But the analyses of work by men in these terms alone were few and far between. What is more interesting than such occasional applications of traditionally "feminine" attributes to individual male artists is the "feminizing of Impressionism" as a whole.[13]

The first critic to develop a sustained argument seeking to prove that Impressionism was an innately "feminine" style was the Symbolist sympathizer Théodor de Wyzewa, who, in an article written in March 1891, claimed that the marks made by Impressionist painters were expressive of the qualities intrinsic to women.[14] For example, the use of bright and clear tones paralleled what he called the lightness, the fresh clarity, and the superficial elegance that make up a woman's vision. It was, he wrote, appropriate that women should not be concerned with the deep and intimate relationships of things, that they should see the "universe like a gracious, mobile surface, infinitely nuanced. . . . Only a woman has the right to rigorously practice the Impressionist system, she alone can limit her effort to the translation of impressions." In his preface to the catalogue for her first solo exhibition, in 1892, Gustave Geffroy had called Morisot's a "painting of a lived and observed reality, a delicate painting . . . which is a feminine painting."[15] In the same year Georges Lecomte had claimed that Impressionism, with its "sincerity" and "immediacy," was more suited than any other mode of expression to allow "this delicate female temperament which no external influence alters or corrupts, to develop."[16] Writing in the *Revue encyclopédique* in 1896, Claude Roger-Marx felt able to assert that "the term Impressionism itself announces a manner of observation and notation which is well suited to the hypersensitivity and nervousness of women."[17]

These sentiments were echoed in a review of the work of women artists in Boston by the Parisian critic S. C. de Soissons, who stressed that the superficiality that attended woman's fitting restriction of her sensibility to the mimetic function central to Impressionism would be recompensed by her "incomparable charm, her fine grace and sweetness."[18] Arguing for the suitability of Impressionist technique to women's manner of perception, de Soissons wrote:

One can understand that women have no originality of thought, and that literature and music have no feminine character; but surely women know how to observe, and what they see is quite different from that which men see, and the art which they put in their gestures, in their toilet, in the decoration of their environment is sufficient to give us the idea of an instinctive, of a peculiar genius which resides in each one of them.[19]

Women artists, according to de Soissons and his colleagues, could give expression to their intrinsic natures by being Impressionists. What was peculiar to women were the sensitivity of their sensory perceptions and the lack of development of their powers of abstraction. What was peculiar to Impressionism was its insistence

on the recording of surface appearance alone. As such they were made for each other. A particular construction of "Woman" and "Impressionism," which becomes operative and meaningful within the political and aesthetic climate of the 1890s (although its formation can be traced back for decades and its influence can still be seen today), is at stake here. In the context of the Symbolist valorization of the imagination on the one hand and the resurgence of various forms of idealism on the other, Impressionism came to connote a relatively inadequate aesthetic model based on the filtering and recording of impressions, hastily perceived, of the outside world. "Woman" was the graceful, delicate, charming creature, nervous in temperament, superficial in her understanding of the world, dexterous with her hands, sensitive to sensory stimuli and subjective in her responses, who could most legitimately make use of this mode of expression. Berthe Morisot came to represent the happy fusion of these two constructions.

In order for the myth of Morisot's well-adjusted femininity to function as naturalized speech, however, her artistic practice had to be seen as the result of an unmediated outpouring. The condition of myth according to Roland Barthes is that it emerge "without any trace of the history which has caused it."[20] Implicit in much of the Morisot criticism during this period is the assumption that her painting was achieved without effort. Gustave Geffroy compared her hands to those of a magician. Her paintings were the result of "delicious hallucinations" that allowed her quite naturally to transport her "love of things" to an intrinsic gift for painting.[21] Moreover, her strength was said to reside in her feminine powers of observation that allowed for an intuitive filtering of the outside world, uncorrupted, in Georges Lecomte's words, by any learned system of rules.[22]

Morisot's success, the critic George Moore wrote, lay in her investing "her art with all her femininity," thereby creating a "style" that is "no dull parody of ours" (men's); her art is "all womanhood—sweet and gracious, tender and wistful womanhood."[23] But such gifts, necessarily, set her apart from other women artists. She had since the 1880s been compared with her female contemporaries whom she was said to outstrip in "femininity." The most famous casualties in such comparisons were Rosa Bonheur, Marie Bashkirtseff, and even Morisot's fellow Impressionist Mary Cassatt, described by Roger-Marx as "that masculine Ameri-

can."[24] None of these artists eschewed linearity, precision of execution, or contrived compositional arrangements. None of them was prepared to concentrate on color at the expense of line. All of them were accomplished at drawing. As such they were often seen to be reneging on their natural feminine attributes. The general mass of women artists were regularly described as imitative, sterile, and unconsciously derivative. They had, in the words of de Soissons, "a hatred for feminine visions; they make every effort to efface that from their eyes." They wished to usurp a masculine mode of seeing. Writing to his assumed male audience, he claimed:

Many even succeed in assimilating happily our habits of vision; they know marvellously well the secrets of design and of colors, and one could consider them as artists, if it were not for the artificial impression which we receive in regarding their pictures. One feels that it is not natural that they should see the world in the way in which they paint, and that while they execute pictures with clever hands they should see with masculine eyes.[25]

The slippage between seeing and representing is easily achieved. While vision is fleetingly acknowledged to be habitual and in that sense cultural, de Soissons quickly moves on to the conflation, common among his peers, of seeing with rendering. If women are constitutionally different from men, it follows that they should see differently. Art, in this discourse, is produced as the extension of a manner of seeing and is, in that sense, an extension of a process that is by nature sexually differentiated. Where Morisot's talent allegedly triumphed over her misguided female contemporaries was in her intuitive translation of perception through a natural ability to draw and harmonize color. Her work seemed, to her critics, to be untainted by any intellectual system of drawing or composition. She was praised, therefore, for not reneging on the characteristics intrinsic to her sex. As the *Journal des artistes* critic put it in 1892, she was praiseworthy for the appropriateness of her ambition, which, unlike that of other would-be women painters, propelled her toward an art "entirely imbued with the essential virtues of her sex," an art that was devoted to the idea of a *"peinture feminine."*[26] Her work managed, according to Théodore Duret, to escape "falling into that dryness and affectation which usually characterises a woman's workmanship."[27] Lecomte praised her for resisting the tempta-

tion of creating "an artificial nature, a man's vision." She managed to ignore the sentimentality and gratuitous prettiness to which most women artists fell prey.[28] According to Roger-Marx she "escaped the law which pushes women towards a sterility of invention, passivity and pastiche."[29] By being an Impressionist, Morisot was being, truly, herself.

If such claims are to make sense at all, it is crucial to appreciate the context within which these comparative assessments were made. Morisot, exemplary *haute bourgeoise*, a *"figure de race,"* as Mallarmé called her, came to represent for her admirers the acceptable female artist.[30] In her refined person and her secluded domestic life-style, she was seen to embody the dignity, grace, and charm regarded as the mark of a peculiarly French femininity. In comparison with the deviant women who threatened to disturb traditional social and moral values, the *femmes nouvelles*, focus of anxiety for numerous French commentators in 1896, the year of the large International Feminist Congress in Paris, Berthe Morisot, wife, mother, and elegant hostess, could be acclaimed as a suitably womanly woman. What was more, her wholehearted adoption of Impressionist techniques could express an intrinsically feminine vision at the very moment women were being accused of denying their unique qualities and adopting the perverse posture of the *hommesse*. Paris of the 1890s, characterized by fear of depopulation and a suspicion of the recently proven German military strength and growing industrial prowess, saw the collaboration of scientific populists, politicians, and social theorists to create a xenophobic defense of the notion of a "racial" Frenchness, centering on the traumatic Dreyfus affair at home and the attempts of the assimilationists in the colonies. It was to women that many of the commentators turned for salvation. If women did not renege on their natural duties, France's future would be assured.[31] Berthe Morisot's work and person came to symbolize for her supporters, therefore, the essence of a Frenchness under threat and of a femininity at risk.[32] It is not surprising that her paintings were embraced by many of her defenders as, in the words of the avid Francophile George Moore, "the only pictures painted by a woman that could not be destroyed without creating a blank, a hiatus in the history of art."[33]

The discourse on art and femininity that produced Berthe Morisot as its heroine must also be situated within the more specific debates on women's potential and actual contribution to art at their height in Paris in the late 1880s and 1890s. The mobilization of women in organizations to represent their own interests had resulted in the foundation and growth of the Union des femmes peintres et sculpteurs, formed in 1881, which by the 1890s offered a venue for the display of some one thousand works by women at its annual exhibitions.[34] This decade witnessed concerted campaigns for women's professional rights. Attention was focused on the protracted struggle of women artists, led by the leaders of the Union des femmes peintres et sculpteurs, to open tuition at the Ecole des Beaux-Arts to women, to end the male monopoly on the competition for the Prix de Rome, and to elect women to Salon juries and to the Académie française. Such initiatives and the Union leadership's policy to encourage the press to review the women's exhibitions catalyzed a public debate on women's relationship to artistic practice.

Discussion of women's art at the Union exhibitions was permeated with the same concerns evident in the Morisot criticism. But whereas many critics felt satisfied that Morisot's oeuvre in the 1890s adequately and appropriately expressed the femininity of its creator, such was not the case at the Union. Many of the critics were disappointed at the neutrality of the work, at its apparent sexual indifference. Besides the abundance of flower paintings that the critics expected from an exhibition of women's work, there was little in the art itself to prove it had been created by the hands of women. In a culture that constructed masculine and feminine subjects as intrinsically different, critics wanted art to provide a concrete instance, a visible manifestation, of difference. When that did not occur, women were accused of masculinization. Critics complained that women mimicked the work of their male teachers. Some, like Charles Dargenty of the *Courrier de l'art*, even contended that the overeducation of women was to blame. If only women would remain untutored and natural, their work would express their innate characters and not the lessons absorbed from their male mentors.[35]

Against such a background Morisot's apparent ability to harness the art of her time into a practice that expressed her femininity deserved the highest praise. While many critics commented on her indebtedness to Manet, most praised her for successfully transforming his art into one of grace and charm befitting a lady of her class and background. She translated his lessons

into "a language which is very much her own."[36] And it was not, as we have suggested, primarily in the subject matter of her paintings that Morisot's femininity was seen to be most evident. Although critics commented on the woman's world she pictured, her true femininity was seen to lie in her manner of perceiving and recording that world: "Close the catalogue and look at the work full of freshness and delicacy, executed with a lightness of brush, a finesse which flows from a grace which is entirely feminine . . .: It is the poem of the modern woman, imagined and dreamed by a woman," wrote one enthusiast.[37] Femininity in painting, according to these critics, was a question of technique, although to name it thus would have brought it into the realm of conscious choice rather than unmediated expression. To function ideologically, Morisot's adherence to a particular set of pictorial practices had to be viewed as an unconscious and happy expression of self and sex.

That certain kinds of mark making were regarded as masculine and others as feminine was by no means accidental. The debates on the relatives merits of *dessin* and *couleur* had been couched in gendered terms since at least the seventeenth century. In the seventeenth and eighteenth centuries, however, sexual difference provided one of many ways of conceptualizing the relative merits of the terms of this binary opposition and seems to have operated more on the level of metaphor than as a framework for the assessment of the pictorial practices suited to men and women. By the mid-nineteenth century, drawing, *dessin*, with its connotations of linearity and reason, and the closely associated design, *dessein*, with its connotations of rational planning and cerebral organization of the elements on the surface, were firmly gendered in the masculine. They were not only descriptive terms but indicators of a manner of perceiving exclusively suited to the male of the species. Color, on the other hand, with its associations with contingency, flux, change, and surface appearance, was firmly grounded in the sphere of the feminine.[38]

For late nineteenth-century students the gendering of formal language was most clearly expressed in Charles Blanc's widely used textbook *Grammaire historique des arts du dessin* (1867) with which most fin-de-siècle artists and critics were familiar. Blanc proclaimed the dominance of line over color, taking issue with the relative importance that thinkers like Diderot had attributed to color. "Drawing," he stated, "is the masculine sex

in art, color is its feminine sex."[39] Drawing's importance lay in the fact that it was the basis of all three *grands arts:* architecture, sculpture, and painting, whereas color was essential only to the third. But the relationship between color and drawing within painting itself, Blanc wrote, was like the relationship between women and men: "The union of drawing and color is necessary for the engendering of painting, just as is the union between man and woman for engendering humanity, but it is necessary that drawing retains a dominance over color. If it were otherwise, painting would court its own ruin; it would be lost by color as humanity was lost by Eve."[40]

Color plays the feminine role in art, "the role of sentiment; submissive to drawing as sentiment should be submissive to reason, it adds charm, expression and grace."[41] What is more, it must submit to the discipline of line if it is not to become out of control. A formal hierarchy is framed within an accepted hierarchy of gender that functions as its defense. The language of form and the language of sexual difference mutually inflect one another, creating a naturalized metaphoric discourse that operates on the level of common sense in late nineteenth-century parlance.

Such claims would not have made sense had they not drawn upon assumptions deeply embedded in nineteenth-century culture and legitimated across a number of discourses. Aesthetic theory was not alone in representing the world to itself in gendered terms. Indeed it provided only one site among many for the articulation of sexual difference. Where the nineteenth century's approach differed from previous centuries' was in its attempts to understand these differences scientifically, to prove them empirically and thus use them as the basis for social theory. What had been the stuff of religion, philosophy, and common sense became increasingly a matter for medicine, the new discipline of psychology, and social policy. Where the theologians and artists had used faith and metaphor to support these contentions, now the scientists offered "facts" and "evidence."

In the face of nineteenth-century feminist agitation, the conservative medical and anthropological establishments used science to corroborate the belief in the natural hierarchy of the sexes.[42] Scientists' overriding conclusion was that women were not equipped to deal with the superior mental functions, especially those for abstract thought. In organizing thoughts, synthe-

sizing material, and making judgments based on evidence, women and people from so-called inferior races were stunted. Such inferiority was physically determined and depended on differences in the structure, size, and weight of the human brain. Although the relevance of these factors in determining mental capacities was disputed and the findings of experiments often hotly contested, the discoveries of craniology, as the pseudoscience of comparative brain measurement came to be called, generally endorsed the contemporary view of men and women. What was controversial was not the belief in the superiority of European males itself but the craniologists' conviction that it could be proven through measurement and quantification. As each form of comparative analysis was shown to be inadequate because it failed to prove the known "facts," new and more complicated instruments and procedures were developed. There were, of course, social theorists who thought the scientists had got it all wrong, but they produced their own evidence based on evolutionary theory, social conditioning, or simple observation to support essentialist theories of sexual difference.[43] While not all spoke of women's inferiority to men, all were convinced of their difference. The manner of describing this difference and the values placed on it were what varied.

Science's findings by no means remained the preserve of the experts. Robert Nye has shown that medical theories pervaded everyday life in late nineteenth-century France and that doctors became credible mediators between laboratory experiments and society's problems.[44] Research findings were widely disseminated in popular scientific and general journals, the finer points of dispute and doubt often eradicated. A general reference book like the *Grande encyclopédie*, for example, drew heavily on current scientific knowledge in its entry for *femme*. Henri de Varigny, the author of the article, wrote that the differences between men and women could be explained through anatomical and physiological factors. The origin of woman's mental weakness was found in the structure of her brain, which de Varigny described as "less wrinkled, its convolutions . . . less beautiful, less ample" than the masculine brain. In men, he asserted, "the frontal lobes, in which it is agreed that the organ for intellectual operations and superior psychic functions are placed, are preponderant; they are also much more beautiful and voluminous when it is a question of the more civi-

lised races."[45] Men also, he added, were endowed with greater blood irrigation to the brain than women, which was presumed to help their capacity for thought. Theorists like Alfred Fouillée, favorite of Republican politicians, who were skeptical of such forms of explanation, nevertheless endorsed the belief in men's superior capacities for rational and abstract thought. Although he distanced himself from the evidence used by the well-known defenders of masculine superiority Gustave Le Bon and Cesare Lombroso, who were widely quoted during the period, Fouillée endorsed the universally held belief in women's intellectual inferiority. The cause of this he attributed to women's social role: "Woman's brain is now less capable of prolonged and intense intellectual efforts, but the reason is entirely creditable to her: her rôle in the family involves a development of heart-life and moral force rather than of brain force and intellectual life."[46]

The idea that women's mental capacities were necessarily stunted so that they could fulfill their maternal role was widespread. Pregnancy and menstruation were widely thought to lead to mental regression, and women's generative capacities were regarded as responsible for their innate nervousness and irritability. The development of women's intellectual capacities, it was feared, would result in the deterioration of their capacity to breed and to mother effectively. Women were thought, therefore, to stop developing intellectually at the onset of puberty when their constitutions became consumed with their reproductive functions.[47]

Women's intellectual deficiencies were compensated by capacities that were more highly developed in them than in men. According to de Varigny, in women it "was the occipital lobes [of the brain] which were the most developed . . . and it is here that physiology locates the emotional and sensitive centres." Although women were intellectually weak they possessed greater *sensibilité* than men.[48] And together with their heightened capacities for feeling, they were believed to possess a "more irritable nervous system than men," hence the claims, across a number of discourses, for women's "nervousness" and "excitability."[49] Some commentators believed women had a larger visceral nerve expansion and hence were endowed with greater visceral feeling than men. Women thus experienced the world more directly through their senses, acting upon the impulse of the moment. Whereas European men's responses to sensory impulses were delayed, complex, and

deliberate, the result of cerebral reflection, those of women, children, and "uncivilized races" were direct and immediate. Peripheral stimuli, in these groups, produced unmediated reactions. These groups shared a similar psychological makeup: they had short concentration spans; they were attracted indiscriminately by passing impressions; they were essentially imitative, their mental actions dependent on external stimuli; and they were highly emotional and impulsive. Their strengths lay in their highly developed powers of observation and perception.[50]

One hears echoes of the art critics here. Theirs was obviously not a discourse that was elaborated in isolation. Popular scientific theory of the late nineteenth century projected Woman as a person who was not quite in control. Hysteria was the extreme expression of the characteristics intrinsic to all women (and certain men). Prey to her sensory impulses, Woman could become excessive, dangerous. Like color, she threatened to overspill her boundaries, to corrupt the rational order of *dessin/dessein*. She needed to be disciplined, controlled by rational forces.[51] But she could not usurp that world of reason and make it her own. To do so would be to step outside the natural boundaries on which order and civilization were based, to destroy sexual difference—that is, the fundamental binary opposition, masculine/feminine, self/other, on which culture is founded. In the sphere of art practice and criticism, it follows that it would be laughable, even unnatural, for women to absorb academic art theory, to aspire to *la grande peinture* or to ambitious imaginative work. Such work called upon capacities that women did not possess. Their attempts could only amount to, at worst, crude pastiche, at best, skillful copying. Science had proved this and morality and social order demanded that it remain so.

Berthe Morisot's position within this nexus of anxieties is fascinating. A woman, lauded for demonstrating women's most appreciable qualities in her art: "sparkling coquetries, gracious charm, and above all tender emotion," she was also widely praised for the dignity of her person, her elegance, and her high breeding.[52] A delicate balance is struck. In Morisot, women's innate qualities are turned to the good. They are harnessed to a project that is seen as the fulfillment of her sex and as unthreatening to the social order. Her life, with its necessary domesticity, and her art, content to sing the praises of the surface, are exemplary. Only occasionally do we sense the fear that she will go over the edge, that she will live out her femininity too fully and become ill. One such instance was in 1883 when Joris-Karl Huysmans described Morisot's work as possessing "a turbulence of agitated and tense nerves," suggesting that her sketches could perhaps be described as *hystérisées*.[53]

But for the most part critics in the 1890s saw in Morisot's work the realization of a well-adjusted femininity. Her painting gave stature and dignity to a way of perceiving different from men's. For a man to be an Impressionist in the 1890s would have been to relinquish his powers of reason, of abstraction, and of deliberate thought and planning. It would have led to an art that was weak, an "effeminate" art. But for a woman to be an Impressionist made sense. It was tantamount to a realization of self. In the words of Roger-Marx, Morisot's practice proceeded "according to the logic of sex, of temperament and of social class." Hers was "a precious art, . . . which successfully employed the most vibrant and impressionable apparatuses of the organism, and a refined almost sickly sensibility, [which was] the hereditary privilege of the eternal feminine."[54]

Notes

I am grateful to Kathleen Adler, Briony Fer, Rasaad Jamie, and Paul Smith for their invaluable comments on an earlier draft of this article. The first art historians to comment critically on the conflation of Morisot's "femininity" with "Impressionism" were Rozsika Parker and Griselda Pollock, in *Old Mistresses, Women, Art and Ideology* (London, 1981), 41–42. It was this work that first stimulated my interest in the issue and I gratefully acknowledge it.

1. Camille Mauclair, "Le Salon de 1896," *La Nouvelle revue* 1 (May–June 1896), 342.

2. Mauclair supported a return to "abstract principles" so that "realism" would be tempered by "idealism." For a discussion of these debates, see Richard Shiff, *Cézanne and the End of Impressionism* (Chicago, 1984), 70–98.

3. Of course, this construction of Impressionist technique took no account of the efforts artists made to affect the appearance of spontaneity and immediacy in their works. The aesthetics of the *non fini*, the sketchiness of the surfaces of so many Impressionist paintings, and the apparent informality of their compositional structures allowed them to be read as unmediated records of visual appearance. A study of the technique of an artist like Claude Monet reveals how inadequate such an understanding of Impressionism is. For such a

discussion, see John House, *Monet: Nature into Art* (New Haven, 1986).

4. Camille Mauclair, "Les Salons de 1896," 342.

5. Many articles on Morisot's retrospective exhibition held in March 1896 at Durand-Ruel mentioned the fact that her work was little known at this time. See, for example, "L'Oeuvre de Berthe Morisot," *Moniteur des arts*, no. 2227 (20 March 1896), 125. Mallarmé also made this point in his preface to the catalogue: "Paris knew her little. . . ." Stéphane Mallarmé, *Berthe Morisot (Mme Eugène Manet): 1841–1895*, exh. cat., Durand-Ruel (Paris, 1896), 5. "Poor Madame Morisot, the public hardly knows her!" wrote Camille Pissarro to his son Lucien on the eve of her funeral on 6 March 1895. See John Rewald, ed., *Camille Pissarro: Lettres à son fils Lucien* (Paris, 1950), 371.

6. Georges Rivière, "L'Exposition des impressionnistes," *L'Impressionniste*, no. 1 (6 April 1877), reprinted in Lionello Venturi, *Les Archives de l'impressionnisme* (Paris, 1939), 308.

7. The Fine Arts Museums of San Francisco and National Gallery of Art, *The New Painting*, exh. cat. (Geneva, 1986), 182, 328.

8. Albert Wolff, *Le Figaro* (3 April 1876), quoted in Monique Angoulvent, *Berthe Morisot* (Paris, 1933), 54.

9. Charles Bigot, *La Revue politique et littéraire* (8 April 1876), quoted in *New Painting*, 182.

10. Paul de Charry, *Le Pays* (10 April 1880), quoted in *New Painting*, 326.

11. Georges Rivière, *L'Impressionniste* (10 April 1877), quoted in *New Painting*, 240.

12. Edmond Duranty, *La Chronique des arts et de la curiosité* (19 April 1879), quoted in *New Painting*, 288.

13. In 1877 Paul Mantz had already claimed that there was only one "real Impressionist" in the group, Berthe Morisot: "Her painting has all the frankness of an improvisation: it does truly give the idea of an 'impression' registered by a sincere eye and rendered again by a hand completely without trickery." *Le Temps* (21 April 1877), quoted in Monique Angoulvent, *Berthe Morisot*, 56. At the same time Philippe Burty wrote of her "double privilege of being both a woman and an artist," invoking the eighteenth-century pastellist Rosalba Carriera as her predecessor in "liberty and charm." *La République française* (25 April 1877), reprinted in Venturi, *Archives de l'impressionnisme*, 291–92.

14. Théodor de Wyzewa, "Berthe Morisot," in *Peintres de jadis et d'aujourd'hui* (Paris, 1891), 215–16.

15. Gustave Geffroy, *Berthe Morisot*, exh. cat., Boussod and Valadon (Paris, 1892), 12–13.

16. Georges Lecomte, *Les Peintres impressionnistes* (Paris, 1892), 105.

17. Claude Roger-Marx, "Berthe Morisot," *Revue encylcopédique* (Paris, 1896), 250. This thesis was later expanded in his "Les Femmes peintres et l'impressionnisme," *Gazette des beaux-arts* 38 (1907), 491–507. In keeping with the construction of Morisot as "intuitive Impressionist" who does not self-consciously adopt a style or working method, contemporary critics rarely, if ever, allude to changes or developments in her working practice. So, for example, the stylistic changes in her work in the early 1890s, such as her increased linearity, are not the subject of much discussion by her contemporaries.

18. S. C. de Soissons [Charles Emmanuel de Savoie, comte de Carignan], *Boston Artists: A Parisian Critic's Notes* (Boston, 1894), 75–78.

19. Ibid., 76.

20. Roland Barthes, "Myth Today" (1972), reprinted in Susan Sontag, ed., *Barthes* (Oxford, 1982), 111.

21. For an appreciation of Morisot's works in these terms, see Gustave Geffroy, *Berthe Morisot*, 6, 10. Geffroy's comments paradoxically inscribe Morisot as attentive to Edouard Manet's lessons and as an intuitive, untutored painter: "Mme Berthe Morisot, who heard and understood the good lesson in painting given during this period by Edouard Manet, has arrived totally naturally, by her love of things, to the development of the gift which is within her." Ibid., 10. The construction of Morisot as the intuitive painter has been perpetuated in the Morisot literature, most notably in the writings of Denis Rouart, who in 1950 declaimed: "It is essential to her nature to be a painter and everything is a pretext for painting. . . . She could not stop painting the people and the things she loved for with her to love was to paint. The way in which 'she lives her painting and paints her life' gives her work a special quality which Paul Valéry has rightly compared 'to the diary of a woman who expresses herself by colour and drawing.'" Denis Rouart, in Arts Council of Great Britain, *Berthe Morisot*, exh. cat. (London, 1950), 5. Even a cursory reading of her letters compiled by Rouart himself, which indicate both Morisot's struggle as an artist and her conscious indentification with certain painters and practices, undermines the reading of her work as an intuitive outpouring. See Denis Rouart, ed., *The Correspondence of Berthe Morisot*, trans. by Betty W. Hubbard, introduction and notes by Kathleen Adler and Tamar Garb (London, 1986).

22. Georges Lecomte, *Les Peintres impressionnistes*, 105.

23. George Moore, "Sex in Art," *Modern Painting* (London, 1898), 235.

24. Claude Roger-Marx, *Les Impressionnistes* (Paris, 1956), 39. Indeed, the comparison of Morisot's and Cassatt's styles in terms of what were thought of as intrinsic French and American characteristics had been around for some time. Not only were ostensible national character traits brought into play here, but an idea of a national construction of "femininity" had great currency at this time. For a comparison of

Morisot's and Cassatt's work in these terms, see C. E., "Exposition des peintres indépendants," *La Chronique des arts*, no. 17 (23 April 1881), 134. For a discussion of the peculiarities of French women as opposed to their Anglo-Saxon sisters who are described as excessively masculine, see Gustave Le Bon, "La Psychologie des femmes et les effets de leur éducation actuelle," *Revue scientifique* 46 (11 October 1890), 451.

25. S. C. de Soissons, *Boston Artists*, 77–78.

26. Raoul Sertat, "Berthe Morisot," *Journal des artistes*, no. 23 (13 June 1892), 173.

27. Théodore Duret, *Manet and the Impressionists*, trans. by J. E. Crawford Flitch (Philadelphia, 1910), 173.

28. Georges Lecomte, *Les Peintres impressionnistes*, 105.

29. Claude Roger-Marx, *Revue encyclopédique*, 250.

30. Stéphane Mallarmé, *Berthe Morisot*, 5.

31. For a discussion on the fear provoked by the *femme nouvelle*, see Debora Leah Silverman, *Nature, Nobility and Neurology: The Ideological Origins of "Art Nouveau" in France, 1889–1900*, Ph.D. dissertation, Princeton University, 1983.

32. For a general discussion on the atmosphere of gloom and the fear of degeneration that obsessed intellectuals in this period, see Eugen Weber, *France: Fin de Siècle* (Cambridge, Mass., 1986).

33. George Moore, "Sex in Art," 234. For another statement proclaiming Morisot the only woman to prove women's capacities in painting in the nineteenth century, see H. N., "Berthe Morisot," *Journal des artistes*, no. 10 (10 March 1895), 955.

34. For a broad overview of feminist campaigns and personalities in this period, see Jean Rabaut, *Féministes à la belle-époque* (Paris, 1985). For a discussion of the formation of the Union, see Charlotte Yeldham, *Women Artists in Nineteenth-Century France and England* (New York, 1984), vol. 1, 98–105. For a contextual analysis of the formation of the Union, see Tamar Garb, "Revising the Revisionists: The Formation of the Union des femmes peintres et sculpteurs," *Art Journal* 48 (Spring 1989), 63–70.

35. For a discussion of the criticism of the exhibitions, see Tamar Garb, "'L'Art Féminin': The Formation of a Critical Category in Late Nineteenth-Century France," *Art History* 12 (March 1989), 39–65.

36. The critic for the *Moniteur des arts* put it as follows: "Sister-in-law to Manet, it was under his direction that she made her first essays in painting, penetrating his ideas but not submitting to his influence and rendering her impressions in a language which is very much her own: modest, without working for a public but for herself, for the satisfaction of her artist's dreams, without care for fashion, without desire for fame." "L'Oeuvre de Berthe Morisot," *Moniteur des arts*, no. 2227 (30 March 1896), 125. For a representa-

tive example, see also Raoul Sertat, "Mme Berthe Morisot," *Journal des artistes*, no. 11 (15 March 1896), 1381. Morisot's femininity is seen to reside in her indifference to a public and the sale of her works; she is, therefore, suitably modest and withdrawn from the public sphere. Even the most cursory glance at her correspondence with its many allusions to sales, dealers, and public exhibitions exposes the myth of such a construction. The allusions are too numerous to itemize. See Rouart, *Correspondence*, passim.

37. "L'Oeuvre de Berthe Morisot," 125.

38. The link with makeup was already made in the seventeenth century by Roger de Piles. I am grateful to Katy Scott for her helpful comments in relation to the gendering of pre-nineteenth-century academic theory.

39. Charles Blanc, *Grammaire historique des arts du dessin* (Paris, 1867), 22. I am grateful to Jennifer Shaw for her discussions with me on this book. It is not surprising that Blanc became hostile to Impressionism, regarding its realist enterprise as trivial. For his views on Impressionism, see Charles Blanc, *Les Beaux-arts à l'exposition universelle de 1878* (Paris, 1878).

40. Charles Blanc, *Grammaire historique*, 23.

41. Ibid., 24.

42. For a discussion of the links between the discoveries of science and an antagonism toward feminism, see Elizabeth Fee, "Nineteenth-Century Craniology: The Study of the Female Skull," *Bulletin of the History of Medicine* 53 (Fall 1979), 415–33.

43. For a representative account of this type, see Alfred Fouillée, *Woman: A Scientific Study and Defense*, trans. by Rev. T. A. Seed (London, 1900), based on Fouillée's *Temperament et caractère selon les individus, les sexes et les races* (Paris, 1895).

44. Robert A. Nye, *Crime, Madness and Politics in Modern France: The Medical Concept of National Decline* (Princeton, 1984).

45. Henri de Varigny, "Femme," in *La Grande encyclopédie*, vol. 17 (Paris, 1892–93), 143. For a critical analysis of de Varigny's theories in the context of late nineteenth-century medical and psychological studies on women's intellectual capacities, see Jacques Lourbet, *Le Problème des sexes* (Paris, 1900), 63–72.

46. Alfred Fouillée, *Woman*, 48.

47. For a representative argument of this type, see Gaston Richard's review of Jacques Lourbet, *La Femme devant la science contemporaine* (Paris, 1896), in *Revue philosophique* 43 (1897), 435. See also Charles Turgeon, *Le Féminisme français* (Paris, 1907), 315.

48. Henri de Varigny, "Femme," 145. There were theorists who were reluctant to grant women a greater sensibility than men. Lombroso, for example, distinguished between *irritabilité*

and *sensibilité,* according the former to women, the latter to men.

49. Prof. M. Benedict, "La Question féminine," *Revue des revues* (August 1895), 182.

50. The most extreme proponent of such views in France was the scientific populist Gustave Le Bon, who likened women's psychological makeup to the uncontrollability of a crowd. The qualities shared were: "impulsiveness, irritability, incapacity to reason, the absences of judgement and of the critical spirit, the exaggeration of the sentiments." Quoted in Susanna Barrows, *Distorting Mirrors: Visions of the Crowd in Late Nineteenth Century France* (New Haven, 1981), 47. For a detailed discussion of his beliefs regarding the qualities intrinsic to women and their concomitant social roles, see Gustave Le Bon, "La Psychologie des femmes et les effets de leur éducation actuelle," 449–60. For a discussion of women's and men's capacities in these terms, see the much-quoted

H. Campbell, *Differences in the Nervous Organisation of Men and Women* (London, 1891).

51. In 1887 George J. Romanes compared women's emotions with men's, describing the former as "almost always less under control of the will—more apt to break away, as it were, from the restraint of reason, and to overwhelm the mental chariot in disaster." "Mental Differences Between Men and Women," *Nineteenth Century* 21 (May 1887), 657.

52. These are the qualities identified by Gustave Le Bon as women's great strengths. They are also the ones that frequently recur in the Morisot criticism. See Le Bon, "La Psychologie des femmes," 451.

53. Quoted in Claude Roger-Marx, "Les Femmes peintres," 499.

54. Ibid., 508.

ANNE HIGONNET

4. The Other Side of the Mirror

WHAT DOES SELF-PORTRAIT MEAN in Berthe Morisot's case? For any woman of her time, "self" meant something rather different than it did for the men who produced the immense majority of the pictures we recognize as "self-portraits." Nineteenth-century individualism in both its republican political and its romantic artistic manifestations secured an autonomous masculine self. Women's identities, however, remained shifting and permeable, deeply affected by specific relationships to their families and children, as well as, more generally, by their dependence on men. Morisot herself produced images that begin to clarify what "self" might mean in a feminine case. These meanings acquire even fuller dimensions when we compare them with images of Morisot made by her sister Edma Morisot and by her colleague Edouard Manet. The feminine self in Morisot's case was a self as much constructed by images as reflected in them, and as much constituted by the images of others as by her own.[1]

Morisot made her most conventional self-portrait in 1885, when she was forty-four years old (colorplate 17). The image seems to be of that unmediated confrontation between self and mirror we associate with the self-portrait. Morisot's handling of her medium corroborates an essentialist reading, for she conveys her message with the physical characteristics of pastel as well as by mimetic means.

Morisot's strokes sweep back and forth, emphasizing the evanescent nature of fragile pastel crayon marks. The sure touch of her execution and the sophistication of her color harmonies, characteristic of her best work, are here quickened to pathos. On the right of her divided face, the deep shadows at the corners of eye and mouth, the reddened rims of eye and ear, could express anxiety or exhaustion. The left side of her face, though, denies its own physical substance. Her left eye, a black smudge, bores into a dense black, cream, and brick red field, in which the face, amidst hair, background, and bow, appears as mere incident. Floating in the middle of a gray paper expanse, the image seems less constructed than in the process of being effaced.

But this was by no means the first image of Morisot's self.[2] Long before, when Morisot was approximately twenty-two, her sister Edma had painted her portrait (figure 4-1). It was an image of the artistic identity they forged together. Friends and family believed their devotion to art sprang from a vow they had made to each other,[3] and for twelve years Edma and Berthe Morisot certainly worked constantly side by side, each the other's most loyal advocate and trusted colleague. Such a supportive and productive relationship between sisters was not rare in the nineteenth century; the three Brontë sisters provide only one among many possible examples. Like other nineteenth-century women who achieved public stature, Berthe Morisot was initially

Figure 4-1
Edma Morisot (Pontillon), *Portrait of Berthe Morisot*, 1863
Oil on canvas, 100 × 71 cm (39⅜ × 27⁵⁄₁₆ in.).
Private collection

Manet's portraits of her more than ten years before her own self-portrait. Her public self was initially the object of a man's vision, her self-image a self-presentation to his gaze.

Manet painted eleven equally and differently brilliant portraits of Morisot. His 1872 *Berthe Morisot with a Bunch of Violets* (figure 4-2) conveys an admiration for his subject's character as well as her person. His portrait, like Morisot's self-portrait, differentiates the two sides of her face. But what was disjuncture in the self-portrait Manet represents as engaging, and engaged, subtlety. Manet passes from the luminous blond tone, the limpid intelligence of the wide eye, the decisive, relaxed brushwork of the left, to the tawny, reserved calm of the right, with its gently blended tones emerg-

appreciated and encouraged by her sister. It was Edma Morisot who first imagined her sister as a painter (see figure 4-1).

For Edma Morisot, Berthe Morisot is a woman absorbed in painting, staring intently at the image she is creating. At the very center of her image are her sister's hands holding the instruments of art, poised momentarily while she concentrates on work to be done. This portrait is one of the very few by Edma Morisot to have survived. When she stopped painting after her marriage in 1869, almost all her work was dispersed and has never been relocated. What remains for history is the vision she had of her sister's future.

Only when Berthe Morisot ventured outside family limits and joined the world of male painters did she become known as an artist. But the first appearance of this public self took a different form from the one her sister had imagined. Very soon after he met her in 1868, Edouard Manet asked Morisot to be his model. Her image passed into the history of painting as

Figure 4-2
Edouard Manet, *Berthe Morisot with a Bunch of Violets*, 1872
Oil on canvas, 22 × 27 cm (8¾ × 10¾ in.).
Private collection

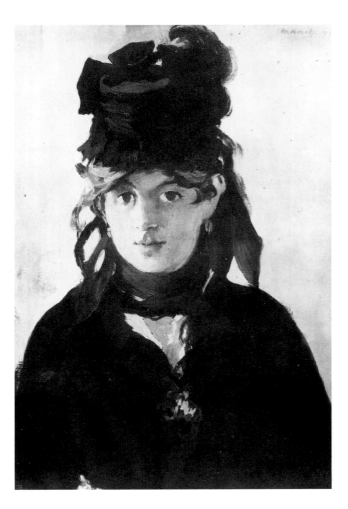

Figure 4-3
Edouard Manet, *The Balcony*, 1868–69
Oil on canvas, 169×125 cm (66½×49¼ in.).
Musée d'Orsay, Paris

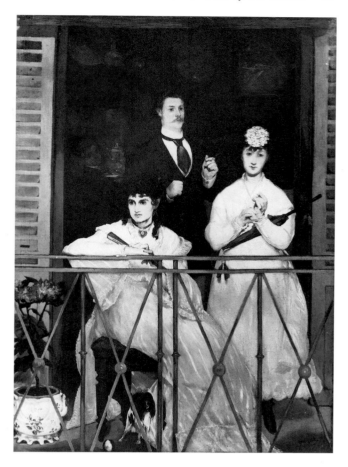

ing from still shadow. His image of Morisot is forthright and elegant; her jaunty hat combines with tendrils of hair and ribbon into a strong but humorous silhouette, clearly defined in a translucent space.

Manet's revelation of a confident, vital woman was not limited to one type. The pictorial and emotional variety of his eleven portraits, painted in a six-year span, depict the many facets of a complex personality.[4] Manet could recognize in his 1868–69 *The Balcony* (figure 4-3) Morisot's passionate intensity, perhaps her sexuality, at the same time as he represented its containment. Morisot's huge eyes, her curt fan, and her neck locket smolder as she twists against the flat green barrier of the balcony. A year later Manet would paint her in a gentler, more ladylike guise in his 1869–70 *Repose* (colorplate 24). Her expression furled like her skirt and fan, she reclines, reassuringly rounded, on a plump sofa, a picture for delectation like the painting depicted above her. It was Morisot, as well, who provoked one of Manet's most turbulent paintings, his 1874 *Berthe Morisot in a Mourning Hat* (figure 4-4). Heavy, slashing, flat brushstrokes convey an emotion comparable to Morisot's in her self-portrait, but this is a grief projected outward, into the swirls of black around the arm, the weight of the face against the fist, rather than an inward consumption.

Together Manet's eleven images of Morisot constitute an exceptionally discerning and sensitive tribute in paint. We might, even, seeing with contemporary eyes, think Manet's pictures a truer portrait of Morisot's self than Morisot's own self-portrait. And we would not, in a way, be wrong.

Not only do Manet's images present us with the self perceived by other contemporaries and corroborated by professional attainments, but his images are those destined for the public domain, while hers and her sister's remained private. While Morisot's 1885 pastel

Figure 4-4
Edouard Manet, *Berthe Morisot in a Mourning Hat*, 1874
Oil on canvas, 62×50 cm (24⁷⁄₁₆×19¹¹⁄₁₆ in.).
Private collection

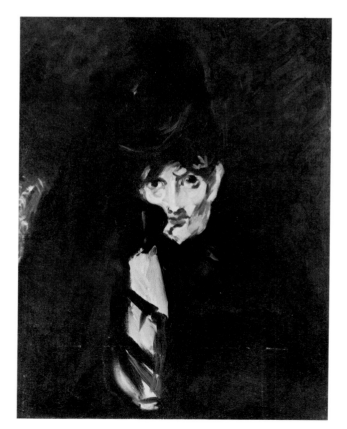

self-portrait was not exhibited publicly until 1961, several of Manet's portraits were conceived of for the Salon, that most public of all exhibition places in nineteenth-century Europe.[5] Long before she was known as a producing artist, Morisot became notorious in artistic circles. As she herself wrote after the opening of the 1869 Salon: "It seems that the epithet of *femme fatale* has made the rounds among the curious."[6] Her self-image had to pass through the avenues of masculine vision to become public knowledge.

The self-portrait as a genre expresses an individual physiognomy and psyche, but only on the conditions its culture allows. A codification of self, the self-portrait obeys the parameters within which privacy may, in a given time and place, manifest itself publicly.[7] It functions as both an act of self-revelation and an act of professional self-declaration (hence the great number of self-portraits with emblems of the trade). If the tension between the two imperatives can be great, one of the self-portrait's attractions is the promise it holds of releasing that tension, of reconciling, or at least assembling, disparate selves: inner and outer, private and professional.

In his portraits of Morisot, Manet took as his subject a person whose female condition posited an acute conflict between personal and professional selves.[8] It would be fair to suppose it was Morisot's intellectual attainments as well as her appearance that kindled his images of her. But Manet is a man who looks at a woman and makes paintings of her, and who does not have to face her conflicts. He can choose to see Morisot not as a painter, but as a feminine woman wielding a fan rather than a palette, as a woman who gives him visual pleasure. The year he met her, Manet wrote to a mutual friend: "I agree with you: the *demoiselles* Morisot are charming. It's too bad they're not men. Nonetheless, they might, as women, serve the cause of painting by each marrying an academician and sowing strife in the camp of those old fellows."[9]

For Morisot, however, the opposition between her culture's definition of femininity and its notion of high art was ineluctable. Women were offered many artistic outlets. Besides albums and amateur paintings, they were also encouraged to practice "womanly" arts consisting of needlework and interior-decoration crafts, supplemented professionally by miniature and flower painting. Any form of creativity consonant with domestic responsibilities was sanctioned.

Motherhood and artistic creation, moreover, were united metaphorically. Each was spoken of as a way of giving birth, both were miraculous processes of production, each perpetuated its author. No more evocative expression of the equation could be found than Zola's list of possible titles for his 1886 *L'Oeuvre*, a novel about an Impressionist painter. Among the titles he considered were (the untranslatable) *Faire un enfant, Faire de la vie,* and *Création, Créer, Procréer.*[10]

Zola's list is only a list of disparate terms. As soon as the terms are articulated into texts, the duties of wife and mother are diametrically opposed to the exercise of genius. The metaphoric bond between maternity and artistic genius must be distended into mutual contradiction for gender roles to be maintained. A binary bond remains, for the danger of women's artistic creativity is always posed in terms of a threat to their feminine roles, not only in novels, but also in countless etiquette books and family manuals. One such book, for instance, written by Catherine Parr in 1892 repeats the message of earlier novels in the story of "The Woman Who Wanted to Be an Artist Without Remaining a Woman," and includes the following warning: "Barely had she placed her hands on the sketch, barely had she imagined a yet unformed figure in her mind, than she thought she had the right to be no longer either woman or mother."[11]

The more prestigious the medium, the greater the menace. Nathaniel Hawthorne in his 1860 *Marble Faun* pits the morally corrosive sensuality of the oil painter Miriam against the redemptive purity of Hilda, copyist of the Old Masters. In Edmond and Jules de Goncourts' 1864 *Renée Mauperin,* the heroine, "*the modern young woman* produced by an artistic and boyish education," opens the plot by announcing to a man: "Just think! I myself work in oil; my family deplores it . . . I should only paint roses in watercolor," and closes the plot by dying, virginal, of a broken heart.[12] In novel after novel the cultural ban on women's artistic careers is given ideological structure.

These narratives are themselves a historically specific phenomenon, appearing at the end of the eighteenth century and disappearing in the first decades of the twentieth. Notable among the many are Honoré de Balzac's 1837 *The Unknown Masterpiece,* the Goncourts' 1876 *Manette Salomon,* and Zola's *L'Oeuvre.* These three texts represent a masculine genius drained or perverted by women. While they assign

artistic prowess to men, their narrative structure depends on a destructively binary relationship between masculine genius and feminine sexuality. Should, as happens in other texts, masculine genius occur in a woman's case, the consequences must be the termination either of her genius or of her life. Dinah Mulock Craik's heroine Olive in the 1857 novel of that name is a successful professional painter, but she is deformed, and she is only temporarily both an artist and deformed, for a man—the man who is to be her husband—saves Olive from a fire that destroys her studio, her canvases, and her desire to paint. As she learns to love him more than her art, her hunched back straightens. In Kate Chopin's 1899 *The Awakening*, Edna Montpellier, whose discovery of her physical and emotional desires parallels the increasing seriousness with which she paints, ends the story by drowning herself in the sea.

For Great Art to be made, women must conform to the social order. As wives and mothers, women enable art; as wanton mistresses or independent single women, they prevent it. In any case, a woman's sexuality must be sacrificed. More is at cultural stake in the denial of women's artistic careers than institutional elitism. The ideology articulated in texts to describe male artists cannot be separated from the place literature assigns to female artists. Considered together they reveal not only that female genius is unimaginable, but that male genius's price is women's sexual freedom. What began in Zola's list of title options as an equivalence between masculine artistic production and feminine biological production becomes, upon articulation, gender prescription. Men make art for culture. Women make babies for nature. Friedrich von Schlegel's 1799 *Lucinde*, in which a male writer meets a female painter, ends happily. They marry; she gives up painting; he writes a novel; she bears them a son.

So Morisot had no paradigms for the self presumed by the artist's self-portrait. The contradiction her culture decreed between feminine psyche and masculine genius operated on the social surface, but also as an intrinsic part of gender itself. Her identity as a woman painter was corroded by its very constitution; no alloy could be forged from her personal and professional identities; no self could emerge whole to be portrayed. Manet's portraits of Morisot are her self-portraits inasmuch as they define her self according to rules they both believe in. They are images of a woman as a man sees her, and as a woman identifies with a man's way of seeing her: as a wholly feminine woman (who is not an artist), therefore, as a woman whole in society's eyes. Morisot's 1885 pastel records another self, experienced within: a self disintegrating under ideological dictates, at once defined and undermined by the internalization of rules.

Yet our response to Manet's images of her becomes subtler and more constructive if we relinquish traditional definitions of self-portraiture. For the 1885 pastel is less a single image than one of three connected images made that year. In this tripartite investigation Morisot situated herself in a nexus of identities that escapes a binary pairing with Manet's representations of her; she pictured herself no longer only either as the image a man makes of her or as a female facsimile of the autonomous masculine artist, but as a mother. She identified herself with another woman who both is and is not herself, with her daughter, Julie Manet, her child by her husband, Eugène Manet, brother of Edouard.

In tandem with her pastel self-portrait, Morisot made a maternal self-portrait (colorplate 18). In both images Morisot's hair is arranged in the same way and she wears the same black neckpiece. As in the pastel, Morisot flaunts her pictorial skill, pushing her medium to its mimetic limits, using minimal means to establish her subject. But the two self-images put a similar style to very different purposes. In the small, fragile pastel Morisot denies her corporal self, while in the rather large (72 x 91 cm) and much more solid oil painting she asserts a physical presence. The canvas shows through everywhere, but a brazenly casual technique assuredly conveys its ample message. Stabilized by jutting elbows, the full forms of her arms and chest swell beneath a smoothly fitted dress. Torso and head meet securely at a high neckpiece that joins the rounded, plastic modeling of face and figure. Morisot dominates the picture, gazing out and obliquely past us, her head placed in relief against a dramatically brushed background. Next to Morisot, the merest sketch, but present nonetheless, is Julie.

It is in the context of these two self-images that a third must be understood. Morisot made a second "self-portrait" in 1885 (figure 4-5) that seems to accomplish everything the pastel shudders at. Morisot, dressed in the same way once again, presents herself martially erect, gazing straight out at us holding a palette. This could be the classic artist's self-portrait, were it not so closely paired to her maternal self-portrait.

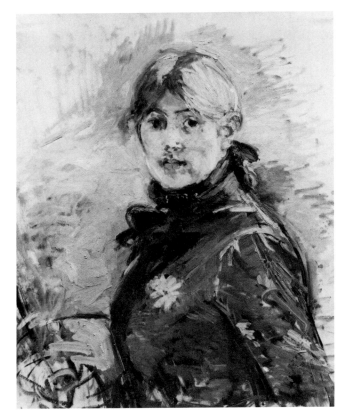

Figure 4-5
Self-Portrait, 1885
Oil on canvas, 61 × 50 cm (24 × 19¹¹⁄₁₆ in.).
Private collection

The two images of herself alone belong to the same conventional category of the "self-portrait." The two oil images, one of herself alone and the other with Julie, are alike in self-presentation as well as in medium. Morisot displays herself in both with the same technical and corporal vigor. Before the canvas of the maternal image darkened with age, the two oil pictures shared the same color relationships as well as scale, stance, and style. Morisot worked each of these pictures to exactly the same degree, noticeably unfinished by contemporary formal standards. She even left Julie in one picture and her palette in the other equally schematic in relation to each image of herself. We must assume that Morisot deemed these pictures finished enough for her purposes. They were left as reflections

of each other, with one difference—the exchange of daughter for palette. Daughter and palette can be interchanged, must be interchangeable, for each guarantees the other's validity. These two images are hinged at Morisot's equation of child and art. Through this equation she can imagine herself as not only body and mind but also a person who confronts the outside world with confidence. As she represents herself in 1885, the alternative to a double identity as mother/artist is the pastel image of her own effacement.

Morisot reiterated this conception of herself in a number of drawings made in the following years. In one 1888 drawing, Morisot shows Julie looking at her mother, who relays her gaze by looking in the mirror. In another drawing of the same year, Julie stands behind her mother's chair, looks over her mother's shoulder at the image her mother is making while she, Morisot, looks into the mirror. In yet another 1888 drawing (figure 4-6), Julie and Morisot lean their heads together to look at the image Morisot is making; Julie looks at the sketch pad, Morisot looks in the mirror.

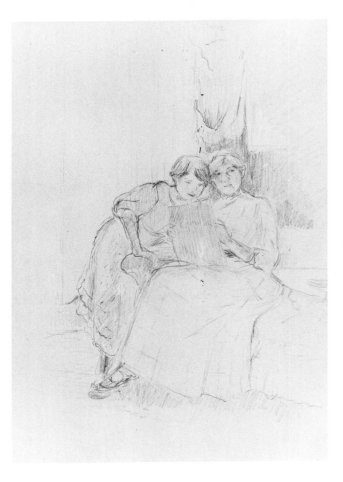

Figure 4-6
Self-Portrait with Daughter, 1888
Etching, 26 × 19 cm (10½ × 7½ in.).
Bibliothèque nationale, Paris

Her husband, Eugène Manet, and her friend Auguste Renoir also pictured her at various moments as the mother of Julie, her husband in both a pastel and a watercolor, her colleague in an oil and its pastel sketch. Elisabeth Vigée-Lebrun had adopted the same maternal persona in some of her self-portraits three-quarters of a century earlier. While they all imagine an exclusive bond between mother and daughter, Morisot explores a triangular relationship among self, daughter, and image making.

In representing herself simultaneously as painter and mother, Morisot was realigning professional and personal imperatives. The subject of woman-as-mother itself was banal; the artist's self-portrait-as-mother was a brilliant strategy. Of all feminine obligations, the most mimetic was supposed to be a mother's relationship to her daughter. A mother reproduced herself in her daughter. Doubly so, for according to the tenets of nineteenth-century feminine pedagogy, a mother inculcated in her daughter the roles of daughter, wife, and mother. This reproduction of ideology was intended to maintain women within domestic confines. Morisot celebrated maternity while claiming a professional and intellectual role, the role of artist. She conflated sanctioned with unsanctioned kinds of female duplication. The strategy was at once utterly daring and eminently defensible; daring because it accomplished the forbidden and defensible because it incorporated unassailable aspects of traditional femininity.

"Une ardente flamme maternelle, où se mit, en entier, la créatrice," wrote Mallarmé in his preface to Morisot's posthumous 1896 retrospective exhibition.[13] As usual, Mallarmé's (untranslatable) grammar conveys more than one meaning. A linear translation implies that Morisot put her entire creative self in an ardent maternal flame, which, being a flame, would have consumed whatever it touched. But Mallarmé also placed the syntactical juxtaposition of "en entier" (in its entirety) and "la créatrice" (the creator) in equilibrium with "the ardent maternal flame"; he thereby counter-implied that in maternity Morisot could situate the integrity of her imaginative gift.

In taking roles opposed to each other by her culture, Morisot agreed they exist in relation to each other, but rethought their relation. Like George Sand, Morisot did not construct herself as an artist despite or even in addition to her biological reproduction or her emotional bonds. Like Sand in her narratives of women's

creativity—*Consuelo* (1842), *Lucrezia Floriani* (1846), and *She and He* (1858)—Morisot imagined in her self-images an alternative creative impulse that united personal and professional motivations.

Morisot's art was able to evolve over the course of a forty-year career. Very few nineteenth-century women artists had the chance to develop their ideas so extensively, and so these rare instances are to be heeded all the more carefully. Like several of her fellow-Impressionists, Morisot became more self-conscious with time and her art more reflexive. Her art had always been introspective; the rigor of her thought had never entirely depended on a promise of public recognition. She herself exhibited none of her self-portraits. The first to be publicly displayed was the oil self-portrait with a palette in the 1896 posthumous show of her work at Durand-Ruel. There it amazed even her closest friends. Her daughter said, using the feminine gender, that it revealed her as "la grande artiste qu'elle était."[14] Mallarmé and Henri de Régnier used more masculine terms, Mallarmé likening the embroidered flower on her dress to a military decoration, Régnier concurring that Morisot looked "chevalresque" (chivalric).[15] Where had the picture been for the previous eleven years? Immediately after she made it, without showing it to anyone, Morisot had rolled it up and stashed it in a closet.[16]

Yet despite her extreme diffidence concerning its public life, this was the image that first led her to a self-conscious manipulation of self-portraiture. In 1886, a year after she made the oil self-portrait, she remade it in a fan-shaped watercolor called *Médaillons* (colorplate 21). She reinterpreted her *médaillons* image in the format of a carte-de-visite photograph, cornered as if for mounting. Now represented as the simulacrum of another medium, her self-portrait elicited its echo, Julie, who mirrors her mother on the opposite side of the image. Between a picture of herself, grasping palette and brushes, and one of her child, Morisot placed cameos of the Bois de Boulogne and flowers, linked by floral garlands. The image looks something like an album page and something like the masthead of a women's magazine. Twin photographs of herself and her daughter, feminine ornaments, her favorite "corner of nature" (as Zola would put it), these together make up Morisot's fan, the fan that, in nineteenth-century parlance, was termed the instrument of a feminine sign language.

This fan, in turn, leads us to the last, and cumulative, phase of Morisot's self-representation. This phase begins about 1891, around the time of her husband's death (in 1892), just as her earlier maternal phase had begun not long after Edouard Manet died. In these late years Morisot accomplished an exceptional feat in the history of art—the conscious revision of her self as it had been represented by or in others. Her images of herself as her daughter and of herself as the object of a man's vision set up *mises en abyme* that both recapitu-

late the social conditions of her identity and comment on its multiple constitution.[17]

Morisot appeared first in public as Edouard Manet's subject. At the end of her career she integrated his image into hers. In the upper right-hand corner of her 1893 *Julie au Violon* (colorplate 22), Morisot placed a sliver of Edgar Degas's portrait of Eugène Manet (figure 4-7). She did not give, however, enough information to any but the most informed viewer to identify her husband. He is passing out of the picture while she

Figure 4-7

Edgar Degas, *Portrait of Eugène Manet*, 1873
Oil on canvas, 81 × 65 cm (31⅞ × 25⁹⁄₁₆ in.).
Private collection

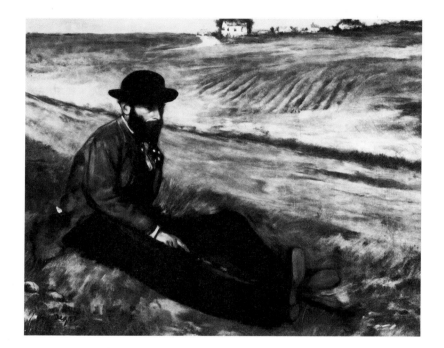

Figure 4-8

Edouard Manet, *Berthe Morisot Reclining*, 1873
Oil on canvas, 26 × 34 cm (10½ × 13⅜ in.).
Private collection

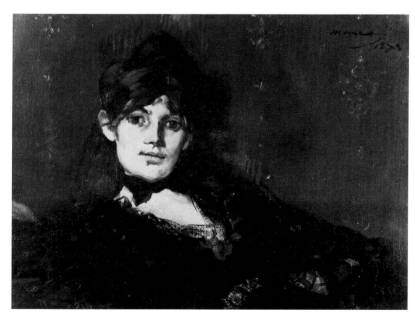

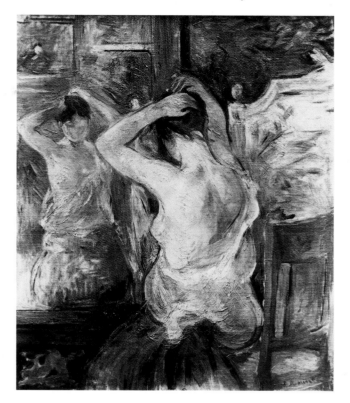

remains behind her daughter—in the ghost of yet another of Manet's portraits of her: his 1873 *Berthe Morisot Reclining* (figure 4-8). Wife and husband, in the avatars of portraits made at the same time, are coupled on either side of their child.

Having seen Manet's picture reproduced this way, we can identify one of the vague images in Morisot's 1891 *At the Psyché*[18] (figure 4-9), her most important painting of the female nude. It is once again Manet's *Berthe Morisot Reclining,* seen reversed in a mirror. If the noticeably center-parted hairstyle, the pale areas of face and tilted throat, and the dark, almost horizontal areas of bodice are insufficient to make this pictorial connection, the proportions of the frame that Morisot placed around the image, the same frame we see in *Julie au Violon,* settles any uncertainty.

This apparition of Manet's portrait of Morisot is uncanny indeed, in the sense that Freud defined "uncanny" in his essay of that name[19] and Neil Hertz refined it in his essay on Freud and the uncanny in "Freud and the Sandman": the imagined resurgence of one's past as one's double.[20] Spectral reflection of the artist who includes herself in her painting as the reversed trace of another's portrait, it is therefore three times over a mirror image. Morisot by the use of her portrait expresses her identification with, and yet distance from, the image she is representing.

At the Psyché initially appears to be an image of a nude model, seen twice, once as an ostensibly real figure and again as a mirror image. But the mirror image itself has a reflection, Manet's portrait. Morisot has flattened the hairstyle and eliminated the features of his portrait so that it resembles the face of the nude seen in the *psyché*. The frame of Manet's portrait, moreover, leads to the head of the reflected nude just as the mirror's frame pinions the unreflected nude. As Morisot represents them in the fictive spaces of her art, the three images of women are equated.

The female nude—passive object of a masculine sexual gaze—seen in the mirror is juxtaposed with herself seen by Manet, but, thus juxtaposed, Morisot can bring

neither into focus. Both are visions of a female self seen with masculine eyes, and neither, in Morisot's vision, can be resolved. They are the reminders of the contradiction between being the one who looks and being the one who is looked at, and remain as ghosts to haunt her paintings.

Only in an image diametrically opposed to the nude, only in her image of her daughter playing music, participating actively in culture, does Manet's portrait of Morisot right itself, escaping from the mirror's reversal, if not its spectral status. Morisot's identification with this image by Manet was repeated even after her death when her family and closest friends decided to use it as the frontispiece of her posthumous exhibition catalogue, for they agreed with her opinion that it was her best likeness.[21]

Another ghostly picture appears in the upper left-hand corner of Morisot's 1893 *Portrait of Jeanne Pontillon* (colorplate 23), one of Morisot's nieces who were like daughters to her. The faint image duplicates the only known picture of Morisot with Julie and Eugène Manet, a photograph taken of the family in the halcyon summer days of 1883 or 1884 at Bougival (figure

Figure 4-10

Photograph of Eugène Manet, Berthe Morisot, and Julie Manet
Private collection

Her one representation of her family identity was thus matched by an emblem of her professional success.

Like the many artists who have placed pictures within pictures,[23] Morisot chose which images to include in her work and how to use them. Her choices referred consistently not only to her past, but also to each other and to the image as a whole of which they were elements. All of these images were representations of herself in different ways: as a man's model, as a wife, as her daughter, as a painter. In this sense they are repetitions of each other, just as pictorially they are reflections of each other. An endless mirror game? Yet the images from her past are not exactly those of her present. The ghosts are in the background of Morisot's

4-10). Only in this spectral way did Morisot ever represent herself in the traditional role of wife and mother.

But Morisot has balanced her image of herself as part of a family with an emblem of herself as a professional by placing a picture of another niece, Alice Gamby, made about 1890 (figure 4-11, possibly a variant), in the opposite corner of Jeanne Pontillon's portrait. Morisot's choice is doubly artful. This picture-within-a-picture comments with two kinds of visual puns on the artifice and the mimicry of art: by repeating the foreground figure's orange dress in what had been a black-and-white drawing, and by turning the two figures, "real" and "represented," to face responsively toward each other. This drawing of Alice Gamby, moreover, was one of two illustrations to the only monographic article on Morisot's art published in her lifetime, Théodor de Wyzewa's, published two years before the painting of Jeanne Pontillon was made (figure 4-12).[22] It therefore cited the most important public acknowledgment Morisot knew of herself as a painter.

Figure 4-11

Portrait of Alice Gamby, c. 1890
Pencil on paper.

Figure 4-12

Portrait of Alice Gamby
Reproduced in Théodor de Wyzewa, "Mme. Berthe Morizot [sic]," *L'Art dans les deux mondes*, 1891.
Bibliothèque Nationale, Paris

work, while in the foreground she placed a new generation of women.

Object of masculine vision, divided personality, sister, artist, mother—Morisot had known all these selves. At the end of her life she could see them anew, put them into a context of her making, define herself overtly as an intersection of disparate yet inseparable selves. No one kind of portrait could suffice to understand this woman's conception of herself. It is the many—of a sister's faith, of inner conflict, of silent dependence, of eloquent pride, and of analytical citation—that together record Morisot's historical condition.

Notes

1. Beth Genné has also written about Morisot's self-portraits and compared them to Manet's images of her, in her "Two Self-Portraits by Berthe Morisot," *Psychoanalytic Perspectives on Art*, ed. by Mary Mathews Gedo (Hillsdale, N.J., 1987), 133–70. We cover some of the same material, but from different perspectives. Genné accepts the category of the self-portrait, and sees in Morisot's self-portraits the transcription of a fixed psychological and biographical reality, neither of which assumptions I share.

2. Louis Marin suggests in his comparative analysis of Nicolas Poussin's self-portraits: "Chercher d'abord, dans ce qui est vu, et non dans un dictionnaire ou un code des symboles, des significations qui ne sont pas immédiatement d'ordre iconographique: celles que présentent les figures en elles-mêmes et leur *collocatio*, dans le tableau et d'un tableau à l'autre; le dispositif sémantique de la figure du peintre et ses effets de sens. Variations." "Variations sur un portrait absent: les autoportraits de Poussin," *Corps Ecrits* 5 (1983), *L'Autoportrait*, 95.

3. Denis Rouart, ed. *Correspondance de Berthe Morisot* (Paris, 1950), 16.

4. *The Balcony* (1868–69; figure 3-3); *Berthe Morisot au manchon* (1868–69); *Repose* (1869–70; colorplate 24); *Berthe Morisot voilée* (1872); *Berthe Morisot au soulier rose* (1872); *Berthe Morisot à l'éventail* (1872); *Berthe Morisot with a Bunch of Violets* (1872, of which Manet also made two lithographs; figure 4-2); *Berthe Morisot étendue* (1873); *Berthe Morisot de trois-quarts* (1874, an oil and a watercolor version); *Berthe Morisot in a Mourning Hat* (1874; figure 4-4).

5. Notably *The Balcony* for the Salon of 1869 and *Repose* for the Salon of 1870.'

6. Rouart, *Correspondance*, 27.

7. See Daniel Arasse, " 'La prudence' de Titien, ou l'auto-portrait glissé à la rive de la figure," *Corps Ecrit* 5 (1983) *L'Autoportrait*, 112.

8. See Roszika Parker and Griselda Pollock, *Old Mistresses* (New York, 1981), 41–44. For a discussion of the differences between Manet's representation of Morisot and that of Eva Gonzalès, as well as with Degas's images of Mary Cassatt, see my *Berthe Morisot—Images of Women* (forthcoming from Harvard University Press).

9. Etienne Moreau-Nélaton, *Manet raconté par lui-même* (Paris, 1926), vol. 1, 105.

10. From Bibliothèque nationale, Département des manuscrits, Nouvelles Acquisitions Françaises, 10316, ff. 317–18, in Emile Zola, *L'Oeuvre*, dossier (Paris, 1974), 425–26.

11. Catherine Parr, *L'Usage et le bon ton de nos jours* (Paris, 1892), 259–63.

12. Edmond and Jules de Goncourt, *Renée Mauperin*, 1st ed. 1864 (Paris, 1875), 7, 10.

13. Stéphane Mallarmé, Preface, in *Berthe Morisot (Mme. Eugène Manet): 1841–1895*, exh. cat., Durand-Ruel (Paris, 1896); reprinted in Mallarmé's *Oeuvres complètes* (Paris, 1961), 535.

14. Julie Manet, *Journal* (Paris, 1979), 88.

15. Ibid.

16. Ibid.

17. Neil Hertz in his essay "Freud and the Sandman" gives this definition of *mise en abyme* so pertinent to Morisot's case: "There is no term in English for what French critics call a *mise en abyme*—a casting into the abyss—but the effect itself is familiar enough: an illusion of infinite regress can be created by a writer or painter by incorporating within his own work a work that duplicates in miniature the larger structure, setting up an apparently unending metonymic series. The *mise en abyme* simulates wildly uncontrollable repetition." In *The End of the Line* (New York, 1985), 112. On the possibility that maternity may induce an oblique or diffuse specular economy, see Julia Kristeva, "Héréthique de l'amour," *Tel quel* 74 (Winter 1977), 30–49, reprinted as "Stabat Mater," in *Histoires d'amour* (Paris, 1983), 295–327.

18. A *psyché* was a kind of mirror used for preparing one's appearance or costume while still in the privacy of the dressing room.

19. Sigmund Freud, "The Uncanny" (1919), trans. by Alix Strachey, in *Standard Edition of the Complete Psychological Works*, ed. by James Strachey, vol. 14 (London, 1954), 122–61.

20. Hertz's analysis of the uncanny is particularly relevant because he identifies the uncanny with *mises en abyme* like Morisot's: "The feeling of the uncanny would seem to be generated by being reminded of the repetition compulsion, not by being reminded of whatever it is that is repeated." Morisot—by situating her identity in the reflective pictorial play between Manet's representations of her and her representation of her reproduction of herself in her daughter in *Julie au Violon*, or between a photograph of her family and a drawing that was reproduced in an article about her in *Portrait of Jeanne Pontillon*—corroborates Hertz's argument that: "the irreducible figurativeness of one's language is indistinguishable from the ungrounded and apparently inexplicable notion of the [repetition] compulsion itself." "Freud and the Sandman," 101, 121.

21. Conversations by the author with Morisot's descendants, 1986–88.

22. Théodor de Wyzewa, "Mme. Berthe Morizot [*sic*]," *L'Art dans les deux mondes* 19 (28 March 1891), 223.

23. See Pierre Georgel, *La Peinture dans la peinture* (Paris, 1988).

SUZANNE GLOVER LINDSAY

5. Berthe Morisot: Nineteenth-Century Woman as Professional

THE LEGAL DOCUMENTS concerning Berthe Morisot's civil status—traditionally the weapon of truth against distortion and ignorance—make an assertion that instead seems grotesquely myopic before the facts of her distinguished career. Her marriage certificate of 1874 claims, despite a decade of exhibitions and two years of sales, that she was "without a profession."[1] So does the birth certificate of her daughter, Julie, of four years later, after her participation in perhaps the most contentious exhibitions and auctions of the time.[2] Worst of all, so does her death certificate of 1895, despite her thirty-year activity, the flurry of obituaries that reviewed her career, and the host of buyers who lent their Morisots the following year to her memorial show.[3] The sense of uncommon intransigence here only grows when Morisot's case is compared with others. Her negative designation was typical, but not automatic for women: during these years, these documents describe her own mother as veuve rentière (widow of independent means).[4] There was no problem with acknowledging the arts as an authentic profession: her brother-in-law Edouard Manet appears, in perhaps the greatest taunt to Morisot of all, clearly identified in her civil documents as an artiste or artiste-peintre.[5]

This is no archival arcanum. Morisot's champions claimed she was repeatedly denied her professional due in the public forum. The most powerful among them, Théodore Duret, attacked especially his fellow critics for dismissing her as a dilettante despite her proven professional credentials: her rigorous training, her profound commitment to her profession, the extraordinary quality of her art, and the circulation of her works within the commercial market, which he discussed at length by way of rebuttal.[6] Duret claimed that her professional reputation "continually" suffered from a special bias against her privileged social status, not just against her gender.[7] History supports him to a degree. Unlike the cases of the unmarried, bourgeois Mary Cassatt and the bohemian Rosa Bonheur, Morisot's pursuit of an artistic career in tandem with a conventional life of a bourgeois wife and mother only worsened her professional problems as a woman by making even her credibility suspect, especially since her art claimed to be aesthetically anticonventional.[8] However, the gender issue remains inescapable: the men among the avant-garde who, like her, were haut bourgeois (Edouard Manet, Edgar Degas, Gustave Caillebotte, and Duret, for instance) appear to have had no such problems.

Such disregard for women's professionalism should be stale fare by now in feminist studies. Yet despite the inroads made there and in studies of nineteenth-century patronage, and despite the fact that Morisot is one of the best-known women artists prior to this century,

her career remains poorly understood. Since her death, depictions of her professional persona have careened between two diametrically opposed concepts. On the one extreme is Stéphane Mallarmé's Morisot of 1896, his artistic paradigm of the purist who, except for exhibitions, abjured the hurly-burly of the mundane for creative solitude.[9] On the other is Germaine Greer's Morisot of 1979, an active entrepreneur who competed so successfully within the vulgar world that her work "consistently earned higher prices at auction" than that of her male colleagues.[10] Not surprisingly, more complex alternatives emerge when other sources are investigated.

This essay synthesizes such a preliminary scrutiny, focusing specifically on Morisot's interaction with the commercial forum. It proposes that, like her art, her career path evolved through her efforts to reconcile certain of her class values with her long-celebrated concern for artistic and institutional independence. The essay first considers her professional strategies and actions and what forces may have shaped them, as well as her accomplishment over thirty years, and concludes with the issue of her commercial success.

At the root of Morisot's career was her family. Far from being a hindrance, her parents actively encouraged Berthe and her sisters, Edma and Yves, in the pursuit of an artistic profession beyond genteel female dabbling. Tradition holds that they defied bourgeois respectability in doing so: Mme Morisot apparently escalated her daughters' training when their master, Joseph Guichard, warned her that making serious women painters of them could be "catastrophic" in their milieu.[11] M. Morisot contributed to the venture in his own practical way, despite the fact that he and Berthe were so incompatible that they otherwise avoided each other.[12] In 1864, apparently convinced of their talent and ambition, he built his daughters a studio in the garden of their rented home, an expense that preempted a family trip to Italy that year, his first, evidently, since his student days.[13]

Her parents had provided Berthe and Edma with exceptional resources for women of the time: private tutors instead of group classes and a relatively independent work space instead of the family hearth. Thus armed, the sisters embarked upon the standard courses of self-promotion for artists during the Second Empire —including those who were women. Judging by the Salon catalogue, Berthe and Edma were among about eighty women in the painting section alone when they made their Salon debut in 1864. They showed one or two works there regularly until Edma's marriage in 1869, considered entering minor suburban exhibitions,[14] and submitted to annual provincial exhibitions—they showed in Bordeaux, for instance, in 1867.[15] There is only one sign of a more unconventional strategy at this time: in 1867 Edma placed a painting at the shop of the publisher-engraver Alfred Cadart, who supported some new radical artists like Manet.[16]

However, to judge from the family correspondence, during the 1860s the sisters cared far more about the private ordeal of shaping their artistic vision than about public exposure. They scattered their drawings and canvases carelessly around their studio, often losing or damaging them and consequently limiting their options for exhibitions and sales.[17] Morisot's only outside interest was in the judgment of artists whom she respected, ideally sought in the safety of her own studio.[18]

The counterforce that drove her and Edma into the public forum seems to have been their mother, who battled repeatedly with her reluctant daughters on this point. Mme Morisot's correspondence reveals her as aggressively ambitious for her children, as an acid-tongued gadfly who was never satisfied. More important, she claimed, as did her husband, to be the formidable advocate for the layman, the ordinary public, whom, she alleged, her daughters scorned.[19] She firmly believed in the primacy of public opinion and, good bourgeoise that she was, in commercial achievement as the measure of professional worth. Above all, Mme Morisot sought financial, social, and emotional security for her daughters, which made her more than a little hostile to even the well-born eccentrics who flocked around them[20]—though she herself entertained them and went to their soirées. Mme Morisot was consistently driven by the impulse of social convention, affirming the established mores of her world instead of blazing new and risky paths. Thus, her putatively radical gesture of training her talented daughters as artists paradoxically obeyed the bourgeois mandate of a publicly acclaimed income-earning occupation. She was quite clear about these priorities in a tirade to Edma in 1871, where she fretted that her youngest daughter "has not the kind of talent that has commercial value or wins public recognition; she will never sell anything done in her present manner, and she is incapable of

painting differently. . . . I have become sceptical . . . my family is fairly distinguished, fairly gifted, but incapable of the efforts needed to reach certain rungs of the ladder."[21]

The closest she may have come to reconciling the warring views was much earlier, in 1867, when she urged both daughters to select replacements for Edma's unsold canvas with Cadart: "I am still wondering how artists who depend on selling their work manage to live. The successful ones are surely not those who like you want to pursue art solely for art's sake."[22] She suggested they provide a full range of their production for both the serious and the lay factions, invoking the advice of the dealer Detrimont: "'Why place at a *dealer's* only things that will not sell? The idea is to exhibit a little of everything—with some works one makes one's reputation among artists, with others one does business, if possible.'"[23]

Mme Morisot eventually succeeded somewhat, although it took the emotional crisis of Edma's marriage and departure in 1869 and the political upheavals of 1870–71 to clarify Morisot's shifting priorities. By the spring of 1871, Morisot announced to Edma that "I no longer want to work just for the sake of working. I do not know whether I am indulging in illusions, but it seems to me that a painting like the one I gave Manet could perhaps sell, and that is all I care about."[24] She was referring to *The Harbor at Lorient* (colorplate 1), which she had painted on a visit there with Edma in 1869 and had immediately given to Edouard Manet when he deemed it a masterpiece.[25] If that example is any measure, though, she felt she was compromising nothing artistically in producing works in this manner for the market.

As proof of her claims, the following year Morisot launched a broad-ranged program of submitting works to dealers and auction, as well as to Paris exhibitions. The actual number of objects that entered those forums was quite modest, but it triggered an immediate response from dealers and collectors. Her works were then carried far beyond her hands, either by admirers who hoarded them or by the tumbling currents of the art market. The case of the collector Ernest Hoschedé is a telling example. In 1873 he bought from Durand-Ruel Morisot's *View of Paris from the Trocadéro* (colorplate 5).[26] Two years later he acquired at auction her *Young Woman with a Mirror (Interior)* (1875; private collection) and a seascape in watercolor.[27] Finally, in 1877

he purchased her *Woman at Her Toilette* (BW 73; currently missing), also from Durand-Ruel.[28] He had sold all of them by the following year. Two went to auction in 1876.[29] One, the *View of Paris*, was bought by Georges de Bellio.[30] The others were auctioned in 1878 to collectors and dealers who were likewise in the process of buying their first Impressionist works—Victor Chocquet, Cassatt, and the dealer Georges Petit.[31] Judging by this group of Morisots circulating on the market, most works represented her independent style, what Mme Morisot complained was unsalable, and were sold to many of her most distinguished patrons. Her buyers continued to be drawn from this category of largely professional-class connoisseurs or intellectuals like Arsène Houssaye, Mallarmé, and Duret. They also included, as William Scott has observed,[32] fellow artists, ranging from the well-known Claude Monet to the less-known American William Merritt Chase,[33] to the highly unknown French landscapist Edouard Daliphard.[34]

Morisot's relations with dealers during the 1870s seem to have established the pattern for the following decades. In July 1872 Durand-Ruel bought his first documented lot of Morisots: three watercolors and a painting.[35] It represents quite a small number compared with the far larger quantities of Manets and Monets purchased by the dealer that year.[36] However, this tiny group of Morisots appears to have constituted the single largest lot she ever sold through dealers. Her works apparently passed through that channel in steady drops rather than a sporadic deluge, like Manet's.

Morisot met with limited success with Durand-Ruel that summer. He managed merely to give away one of the watercolors, but he sold the canvas, a seascape of Cherbourg entitled *The Jetty*, within the month.[37] That landmark sale, her first to be documented, may be Mr. and Mrs. Paul Mellon's *Harbor at Cherbourg* (colorplate 4), despite its only vaguely related subject, if Morisot followed through on her plan to sell a work similar to the one given earlier to Manet.[38] The ledgers reveal that it was bought by exchange by a previously unknown Morisot collector, a frequent customer of Durand-Ruel, the Belgian Barbizon painter Alfred de Knyff, a comrade of Morisot's Belgian friend Alfred Stevens.[39]

Durand-Ruel was Morisot's most consistent dealer, but never her exclusive agent. In 1875 she displayed work like *In the Wheat Field* (Musée d'Orsay, Paris), produced at Gennevilliers that spring, at the shop of a

certain, so-called Master Poussin.[40] That individual is probably Victor Poupin, a modest dealer at 8, rue Lafayette who later showed two paintings by Pierre-Auguste Renoir in the 1876 Impressionist exhibition and who dealt regularly in Barbizon works and Renoirs with Durand-Ruel during these very years.[41] Yet the waters teem with other, even more obscure agents with whom Morisot may have dealt herself: Durand-Ruel bought the *Toilette* that he sold to Hoschedé from a mysterious M. Jacque of an equally mysterious Munroe and Co.[42]

Morisot's works were in at least eight auctions at Hôtel Drouot during the 1870s, beginning with her own submission to a charity event for Alsatian émigrés in 1873 and followed by others from Durand-Ruel's stock or from private collectors like Hoschedé, as mentioned earlier.[43] Her works almost always sold there, implying the success of this strategy during these years for Morisot and others marketing her works.

The 1870s otherwise saw her celebrated shift from the normal exhibition forum of the Salon to the new, radical one of the Independents. It is well known that she remained among the most loyal to the Independent exhibitions, participating in all but one of them. Her courage in following her own counsel over the protests of her male mentors—Manet, Pierre-Cécile Puvis de Chavannes, and Guichard[44]—is part of our

quietly heroic image of Morisot. But new evidence reveals that her break with the Salon was initially not of her own choice. In 1874 she planned her entries in the Independent exhibition at the same time as she submitted works to the Salon jury, which refused them outright.[45] Nonetheless she emerged from that double-dealing as a recognized martyr of the entrenched powers in the art world. She was one of the Impressionists' *refusés* instead of one of the Salon successes who were included for safety.[46] In what was also regarded as a radical act at the time, she and three other Impressionists in 1875 submitted their own work at auction.[47] The mudslinging that accompanied that public sale on March 24—not to mention the drastically low prices—was a sharp contrast to the relative success of Hoschedé's auction the year before.[48] Unlike her comrades, Morisot sold all twelve lots, including new paintings like *Butterfly Hunt* (figure 5-1) and controversial works from the first Impressionist exhibition, like *Reading* (colorplate 7), bought by the obscure Daliphard, whereupon it apparently disappeared from public view until the twentieth century (see note 34).

Her mother's fears about the unsalability of this work were not entirely unfounded, however. Morisot's entries in the Impressionist exhibitions in Paris and London, which provoked sometimes penetrating critical discussion, only occasionally sold and only appar-

Figure 5-1

Butterfly Hunt, 1874
Oil on canvas, 47 × 56 cm (18½ × 22¹⁄₁₆ in.).
Musée d'Orsay, Paris

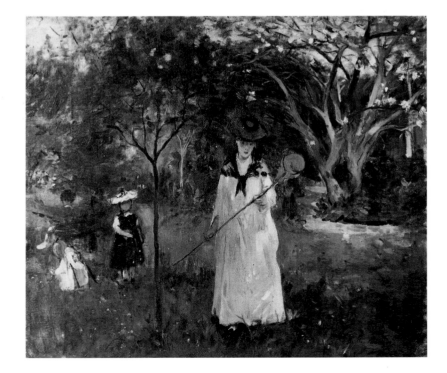

Figure 5-2
The Cheval Glass, 1876
Oil on canvas, 65 × 54 cm (25⁹/₁₆ × 21¼ in.).
Thyssen-Bornemisza Collection, Lugano, Switzerland

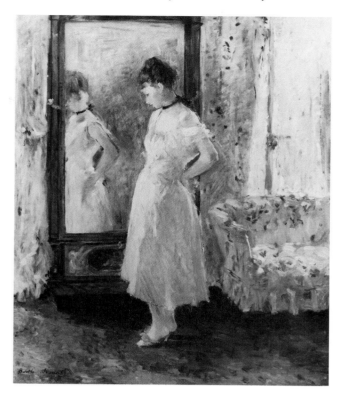

ently in Paris. She sold three out of her more than
sixteen entries in the 1876 exhibition to de Bellio: *At
the Ball* (Musée Marmottan, Paris), *Lunch on the Grass*
(BW 47; currently missing), and *Laundresses Hanging
Out the Wash* (colorplate 9).[49] In 1877 her *The Cheval
Glass* (figure 5-2) in the third Paris Impressionist exhi-
bition may have gone to the collector who released it
for auction three years later, in February 1880. He was
one of the Dutuit brothers, Eugène and Auguste, of
Rouen—not Count Doria, as Bataille and Wildenstein
allege in their provenance for the painting.[50] Eugène
and Auguste Dutuit were eminent bibliophiles and art
collectors whose holdings are now prominently fea-
tured at the Petit Palais in Paris. Their brief ownership
of this one Morisot represents their first known link
with Impressionism.[51]

Morisot passed another major threshold with her
marriage to Eugène Manet in December 1874. Unlike
Edma's case, her marriage and subsequent motherhood
seem to have been professionally more fruitful than
detrimental (figure 5-3). Though Mme Morisot consid-
ered Eugène to be crazy and as erratic as all his artist
friends,[52] he appears to have been an effective and em-
pathetic helpmate for his wife. Like his mother-in-law,
he continually urged Morisot to show her work, but,
unlike her, he apparently worked with her priorities of
independence instead of against them. Eugène and
Morisot shaped their lives and career strategies to ac-
commodate their mutual interests. They decided to
stay in Paris after considering moving elsewhere, par-
ticularly to that fertile ground for other French artists,
London. Morisot concluded that English taste was hos-
tile to her art, and neither she nor Eugène wished to
follow James Tissot's example and associate with fash-
ionable English society, which bored them, even to
attract its patronage.[53]

Morisot's wide-ranging efforts and the foment they
stirred during the seventies contrast startlingly with
her situation during the eighties. The only auction
including her work to surface during this decade is at
the very beginning—the Dutuit sale in February 1880.
Her sales were close to negligible, though not for lack

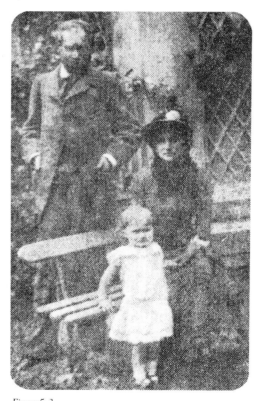

Figure 5-3
Photograph of Eugène Manet, Berthe
Morisot, and Julie Manet, c. 1882.
Private collection

of trying. Although she showed steadily and plentifully in the Impressionist exhibitions, she sold only a few works there, notably the *Portrait*, subsequently known as *Young Woman in a Ball Gown* (figure 5-4), sold on opening night in 1880 to the painter Giuseppe de Nittis. Her *Winter* (colorplate 13) in that same exhibition and her *Nurse and Baby* from the 1881 exhibition went immediately to the eminent connoisseur and critic Charles Ephrussi of the *Gazette des beaux-arts* who, by that year, owned at least three Morisots.[54] Morisot developed a professional relationship at this time with Alphonse Portier, a modest dealer of modern art whom painters trusted and respected.[55] He had superior stock and he sold successfully, but for anything but maximum profit—surprisingly with the artists' blessings. If Cassatt is to be believed, Portier's greatest asset was his clientele of serious collectors who cared little about the prestige attached to high prices.[56] During these years Portier took on at least a handful of Morisot's works; some new paintings that were placed in the Impressionist exhibitions, like the 1881 painting then called *In the Country* (BW 110; *After Lunch*, private collection); and some sold directly to Durand-Ruel or to private collectors like Edouard Brandon, who at the time of the 1881 exhibition bought her early pastel, *A Village, Maurecourt* (private collection).[57] Part of Morisot's problem during these years was a national economic crisis, a financial crash that unlike those of the seventies profoundly atrophied the art market in France for years afterward.[58] Like many investors, Durand-Ruel reduced his cash outlay. He continued to subsidize Monet and Alfred Sisley through purchase of their paintings,[59] but perhaps because she seemed a greater risk or less in need of his help he merely took Morisot's work on consignment to offer in a series of exhibitions—mostly abroad and apparently commercial failures for her. This was true even of the Impressionist exhibition in New York of 1886, from which her seven entries returned unsold.[60]

The 1890s did much to compensate for those disappointments. Morisot exhibited widely and sold more successfully with Durand-Ruel and Portier. The latter opened the decade by purchasing her early much-acclaimed *Figure of a Woman* and selling her *Girl with a Basket* (BW 218; private collection) to Paul Berard, one of his ultimately five Morisots, and *Parisian Woman* (BW 168; currently missing) to Maurice Leclanché.[61] She also opened a new relationship with the firm of Martin Camentron.[62] Most importantly, as is well established, this decade provided the final milestones to cap any artist's career. The first was her individual exhibition organized by the Boussod and Valadon gallery in 1892, perhaps her first and only such solo venture of her lifetime. This retrospective of more than forty-three works was drawn in part from at least twelve identified dealers and collectors, now including also Paul Gallimard, Berard, and Leclanché beyond her old collectors of the 1870s and 1880s. It was such a commercial success that Renoir teased her that the "fiasco she feared is itself a fiasco."[63] Beyond some watercolors and drawings that sold, Gallimard bought his second Morisot, his *Swans* (BW 225);[64] Monet bought *Girl with a Milk Bowl* (BW 251; private collection),[65] one of about four Morisots in his collection; the composer Ernest Chausson bought *On the Veranda* (colorplate

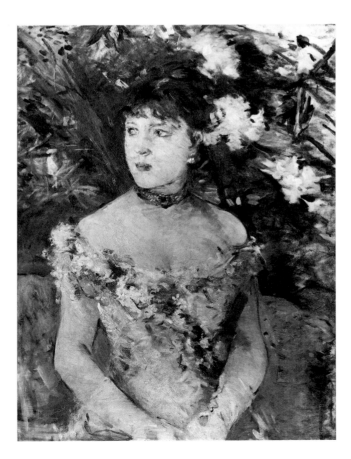

Figure 5-4

Young Woman in a Ball Gown, c. 1876
Oil on canvas, 86 × 53 cm (33⅞ × 20⅞ in.).
Musée d'Orsay, Paris

16),[66] and Denys Cochin bought *The View of the Bois de Boulogne* (National Gallery of Art, Washington, D.C.).[67]

Her final triumph came two years later, the year before her death: the French government bought one of her paintings for the prestigious museum of living artists at the Luxembourg Palace: her highly praised *Young Woman in a Ball Gown*, which her champion Duret had bought at de Nittis's death in 1884 and in turn sold to the government in his publicized distress auction of 1894 (cat. 30). The campaign to purchase this work for the government was prompted by Morisot's exclusion from the Caillebotte Collection bequeathed to the nation that same year.[68] However, according to Duret, the acquisition held an even more poignant meaning for Morisot: she apparently viewed this achievement as her official liberation from the painful amateur status in which the public had trapped her.[69]

Morisot began to withdraw from the commercial market during the 1890s, her interest in sales waning before her growing emotional attachment to her art as she faced the devastation of death in her life: by 1893, she had lost her husband and sister Yves to fatal diseases; she had been gravely ill herself; and she became increasingly preoccupied with the possible effect of her demise upon her sixteen-year-old daughter. Several of the works she deposited for display at Durand-Ruel in the spring of 1891 were marked "not for sale."[70] Consider also the case of *The Cherry Tree* (BW 275; figure 5-5). Morisot consigned this version to Camentron, but shortly before her death she demanded its return, even with a prospective buyer in hand for 1,500 francs. Once past the dealer's frustrated objections and his demand for his normal ten percent commission as compensation, Morisot was relieved, remarking to Julie: "I've done well to not sell it, I worked on it for so long at Mézy the last year your father was alive, I now possess it and you will see that after my death you will be very happy to have it."[71] Rather than measures of professional achievement, works like this had become cherished embodiments of a vanishing personal life. She herself was not far behind. Morisot died suddenly of respiratory complications of the flu in March 1895, at the age of fifty-four.

Morisot's vast memorial exhibition of 1896 at Durand-Ruel Galleries was drawn primarily from that legacy to Julie. But the exhibition was also testimony to Morisot's reputation among patrons since, to judge from the catalogue, no fewer than twenty-six lenders are identified

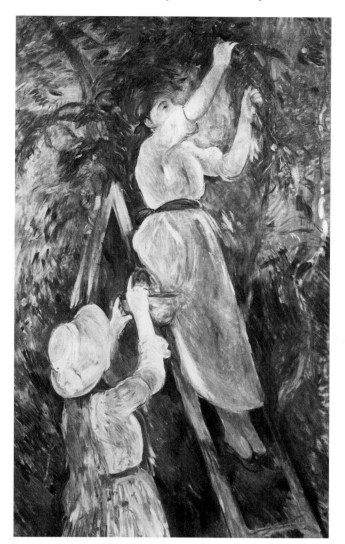

Figure 5-5
The Cherry Tree, 1891–92
Oil on canvas, 136 × 89 cm (53⁹⁄₁₆ × 35¹⁄₁₆ in.).
Private collection

beyond her daughter. Many of them were new since her 1892 retrospective, such as the dentist Georges Viau, the dealer Tadamasa Hayashi, and the connoisseur and jewelry expert Henri Vever. The retrospective thus revealed the public dimension of Morisot's achievement as well as the private vision that informed her work.

Her commercial success is a point that has been prominently mentioned but not fully examined to date. Under closer scrutiny the issue becomes more complex: the standards of measurement are not only infinite but problematic. Rae Becker stated that Morisot was "never commercially successful during her lifetime."[72]

That Morisot actually sold paintings is already clear. Beyond that, what constitutes commercial success? The number of completed transactions? By that definition Morisot failed since her attempts far outnumber her actual sales. But then she was in good company —Manet, Camille Pissarro, and others failed, as well, by that standard.

Do we measure by other artists' prices? Compared with the thousands of francs that Durand-Ruel paid and charged for the larger Manets and a few Monets and Degas in the 1870s, Morisot's prices, at that time in the hundreds, seem lilliputian.[73] But they were also the prices Durand-Ruel paid for most Monets: in 1872 the painter's most common selling price was three hundred francs, though the dealer would sometimes ask triple that amount or more.[74] In addition, during those years Morisot's own pricing scale was very low. In 1872 she thought five hundred francs per sitter for a portrait commission was "enormous."[75] By that standard she must have found her first sales to Durand-Ruel for from three hundred to seven hundred francs exhilarating.[76] Whether with Durand-Ruel or other dealers, Morisot's prices remained mostly in the hundreds for the rest of her career, though she demanded a thousand or more for her larger works in exhibitions in the 1880s.[77] But these works, as discussed above, did not sell, perhaps because of the high prices she put on them. Morisot's comparatively low price range might suggest a woman's conditioning to limited ambitions, just as the failure of her attempts at any higher prices might indicate the effects of a repressive market upon her competitive potential. However, given the patrons who typically bought at those prices, her male colleagues actually valued the range in the hundreds as the true connoisseur's bracket. Duret used this fact to console the idealistic, though eternally strapped Pissarro, who sold well at that level in the 1870s to the serious, if frugal, collectors,[78] but who failed thereby to cover the formidable expenses of his burgeoning household. In the 1880s these same prices drew Cassatt as a frequent buyer of Monets, Degas, Sisleys, and Pissarros for the emerging American collectors.[79] Morisot did see some expensive sales—albeit usually at a distance. In April 1891 Georges Petit sold her *Rising from Bed* (Collection Durand-Ruel, Paris) for 1,000 francs to Durand-Ruel.[80] Monet allegedly paid 1,500 francs in 1892 for the *Girl with a Milk Bowl*.[81] And the French government paid a stupendous 4,500 francs at the 1894

Duret sale for the *Young Woman in a Ball Gown*.[82] Proof of the old aphorism, her work began to command prices consistently over 1,000 francs only after her death.

The myth of Morisot's invariably higher prices at auction collapses under the facts. Her prices were instead always victims of the skittish vehicle of public sale. She did indeed command the highest price among the Impressionists at the famous Impressionist auction of 1875—for 480 francs to the extravagant Hoschedé. But in Hoschedé's own disastrous sale of June 1878, the highest prices, in the 800s, were for Manets and Monets; the highest bid for a Morisot painting was 95 francs, from the bargain-hunter Cassatt.[83] Even Morisot's highest lifetime price of 4,500 francs, at the spectacularly successful Duret auction, was nowhere near the top—again Manet and Monet shared that honor at three times that sum.[84]

Finally, adopting the most conventional standard of all, do we measure success by the artist's capacity to earn a living by her sales? Given her prices and the modest number sold, Morisot probably would have struggled, with or without dependents. Her best commercial year, apparently—1875—for which there are documentable figures, yielded little more than 2,100 francs before brokers' commissions—a mere twelve percent or so of the 17,000-franc salary that Mme Morisot deemed acceptable that year for Eugène, as master of a household.[85] Within the romantic mythology of the true artist, Morisot enters the coterie of the spurned genius. However, judging by her socioeconomic circumstances, her survival itself, like Corot's and Manet's, was not at risk. Only once did Eugène urge her to prod Durand-Ruel to sell more paintings—to finance a second home on the Riviera.[86] Given her gender, this ease of circumstance, as Duret suggested, subverted her lifetime professional reputation. Later, it was subtly explosive in her critical fortunes in the hands of modern scholars: it intensified her cavalier treatment in the landmark twentieth-century epics that heroicized especially the starving among the avant-garde.[87] How Morisot used her income from sales is not clear. Cassatt, whose father required that she pay all professional expenses from her own earnings, did so and much more.[88]

What, therefore, was Morisot's commercial motivation? A tantalizing clue emerges in her correspondence from 1872: she accepted Manet's suggestion that she demand high prices of a new client to gain his respect

for her as an artist.[89] The commercial idiom thus may have had less of a material than a symbolic value for her, giving artist and patron a common means of articulating professional worth. Applied to the broader commercial arena, a sale becomes, as it still serves the modern business community, a public expression of esteem apart from the material gain involved. In seeking this form of discourse Morisot was, like her mother, very much the bourgeoise.

This symbolic commercial idiom also strongly shaped the polemics supporting Morisot at the time. In 1878 Duret challenged Morisot's disdainful public by stating that she was among the radicals who were actually selling, and to important collectors, even if they would never become wealthy on their earnings.[90] And he emphasized the message of the price paid by the government for the Luxembourg Palace Morisot in 1894: the 4,500 francs was itself an extraordinary public tribute *because* it was higher than market value.[91]

Such interaction among artist, critic, and public on a monetary level is rich in meaning; this study only suggests its intense ideological and emotional charge for all concerned, including modern scholars. This complex exchange also affirms that Morisot, though shunned in some quarters and willfully secluded at times, actively engaged her world and moment. Mallarmé conceded this reality and its impact upon her closest colleagues: "Certain great originals . . . counted her as a comrade in the struggle, [whose] work is linked, exquisitely, to the history of painting, during one period of the century."[92] Her career confronted myriad entities in intricate and fluid association, not just adversaries and obstacles. Morisot enjoyed success, as well. The challenge is to move beyond the *Martyrologia* of women or geniuses to seek the nuances of her place within that rich matrix.

Notes

Key to abbreviations: BW/Bataille and Wildenstein: Marie-Louise Bataille and Georges Wildenstein, *Berthe Morisot: Catalogue des peintures, pastels, et aquarelles* (Paris, 1961). BW denotes catalogue numbers.

I wish to thank especially Caroline Godfroy and France Daguet for making the Durand-Ruel Archives, that vital cache for nineteenth-century French studies, available to me for research on Morisot. Their generosity was matched only by their enthusiasm, both of which were precious and deeply appreciated.

1. "Extrait des minutes des actes de mariage du 16e arrondissement de Paris. Année 1874," in Monique Angoulvent, "Pièces justificatives," *Berthe Morisot* (Paris, 1933), unpaginated. The full document is Actes de mariage, V4E 4661 no. 414, Archives de la Ville de Paris. Chittima Amornpichetkul has kindly provided this and all subsequently mentioned civil documents not in Angoulvent.

2. Actes de naissance, V4E 4682 no. 872, Archives de la Ville de Paris.

3. "Extrait des minutes des actes de décès du 16e arrondissement de Paris. Année 1895," in Angoulvent, "Pièces justificatives."

4. Morisot's marriage certificate, cited above, n. 1, as well as Mme Morisot's death certificate, V4E 4675 no. 1042, Archives de la Ville de Paris.

5. Morisot's marriage certificate, cited above, n. 1, and Julie's birth certificate, cited above, n. 2.

6. Théodore Duret, *Manet and the Impressionists*, trans. by J. E. Crawford Flitch (Philadelphia, 1910), 170–76.

7. Ibid., 175.

8. Linda Nochlin, "Women Artists after the French Revolution," in *Women Artists: 1550–1950*, exh. cat., Los Angeles County Museum of Art (New York, 1978), 57–58; Rae Becker, "Berthe Morisot," in ibid., 231; and Germaine Greer, *The Obstacle Race* (New York, 1979), 324–25.

9. Stéphane Mallarmé, Preface, *Berthe Morisot (Mme Eugène Manet): 1841–1895*, exh. cat., Durand-Ruel (Paris, 1896), 5–16.

10. Greer, *The Obstacle Race*, 111.

11. Reminiscence by Morisot's younger brother, Tiburce, in Armand Fourreau, *Berthe Morisot* (Paris, 1925), 11–12.

12. A feature that has never been remarked to date but is evident in the published correspondence dating from the 1860s. In the summer of 1869 Mme Morisot wrote the painter in Lorient, apparently astonished that her husband missed their younger daughter: "You hardly ever talk to each other, you are never together. Does he miss you then, as one misses a piece of furniture or a pet bird?" (Denis Rouart, ed., *The Correspondence of Berthe Morisot*, trans. by Betty W. Hubbard [London, 1959], 36.) Earlier that spring, Morisot herself described to Edma an encounter with her father that indicates how his prosaic, even dour vision of life crippled her own joyous sensibility: "I was admiring [the lilacs and chestnut trees] a little while ago; my father listened to me, then put an end to my enthusiasm by immediately forecasting the end of all these splendours." (Ibid., 30.)

13. Ibid., 20. As further evidence of the sustained distance between father and daughter, Mme Morisot claimed that year that an additional reason the trip was dismissed was because "the prospect of such a tête-à-tête would dismay you more than it would please you." (Ibid.)

14. Her onetime painting master Achille Oudinot allegedly selected works by both women for a lesser exhibition at Versailles, which he claimed was of little commercial interest; whether they were actually submitted is unknown. (Ibid.)

15. *Explication des ouvrages de peinture . . .*, exh. cat., Société des Amis des Arts de Bordeaux (1867); Morisot exhibited a still life (no. 414), as yet unidentified, and Edma, two landscapes: *Entrée de Dives* (no. 415) and *Etude (Fontainebleau)* (no. 416). Anne Higonnet kindly supplied this information.

16. Rouart, *Correspondence*, 21. For a recent general commentary, with updated bibliography, about artists and the nineteenth-century commercial forum in Paris, see Nicholas Green, "Circuits of Production, Circuits of Consumption: The Case of Mid-Nineteenth-Century French Art Dealing," *Art Journal* 48 (Spring 1989), 29–34.

17. Ibid.

18. Ibid., 39–41.

19. Ibid., 19.

20. Ibid., 66.

21. Ibid., 72.

22. Ibid., 23.

23. Ibid.

24. Ibid., 57.

25. Ibid., 37, 39.

26. Charles F. Stuckey with the assistance of Suzanne G. Lindsay, "Berthe Morisot" (hereafter known as Stuckey-Lindsay), in Charles F. Stuckey and William P. Scott with the assistance of Suzanne G. Lindsay, *Berthe Morisot—Impressionist*, exh. cat., Mount Holyoke College Art Museum and National Gallery of Art, Washington, D.C. (New York, 1987), 50.

27. Hôtel Drouot, 24 March 1875, cats. 22 and 29, in Merete Bodelsen, "Early Impressionist Sales 1874–94 in the Light of Some Unpublished 'procès-verbaux,'" *Burlington Magazine* 110 (June 1968), 333–36. For the identification of *Interior*, see Stuckey-Lindsay, "Berthe Morisot," 64.

28. Ibid., 68.

29. "Collection de M***, Tableaux modernes," Hôtel Drouot, 14 April 1876, cat. 42 (*Paris vu des hauteurs du Trocadéro*) and cat. 43 (*La Coquette*); see Stuckey-Lindsay, "Berthe Morisot," 70, n. 170. The latter may have been bought in, since it seems to have reappeared two years later in another anonymous auction that must have been Hoschedé's as well.

30. Remus Niculescu, "Georges de Bellio, l'ami des impressionnistes," *Revue romaine d'histoire de l'art* 1, no. 2 (1964), 265, no. 97.

31. Stuckey-Lindsay, "Berthe Morisot," 76. Petit bought cat. 116 (*Un Port [aquarelle]*) in the Hoschedé bankruptcy

sale in June (Bodelsen, "Early Impressionist Sales 1874–94," 335).

32. William P. Scott, "Morisot's Style and Technique," in *Berthe Morisot—Impressionist*, 187.

33. A Morisot painting entitled *Before the Mirror*, 31 × 24 in., was sold in Chase's auction at American Art Galleries, 7–11 January 1896, cat. 1093. The painting has long been identified as BW 84, *Woman at Her Toilette* (Art Institute of Chicago), without any firm documentary evidence. The dimensions of Chase's painting in fact accord in reverse with those of the Chicago canvas, and markedly differ from those of other known versions of the subject.

34. The buyer of *Reading*, cat. 24, in the auction of 24 March 1875 (Bodelsen, "Early Impressionist Sales 1874–94," 335), which corresponds in dimensions and title to what has been called until recently *The Green Umbrella* (BW 14), identified in Stuckey-Lindsay, "Berthe Morisot" (55–56), as the controversial painting in the first Impressionist exhibition (colorplate 16). Daliphard (1833–1877) was born in Rouen, studied with Gustave Morin and Joseph Quinaux, and lived, according to the Salon catalogues of the 1860s and 1870s, in Poissy. For a brief biography, see Thieme-Becker, s.v. "Daliphard, Edouard." The extent of his collection remains to be investigated.

35. Stuckey-Lindsay, "Berthe Morisot," 50.

36. Durand-Ruel bought one lot of twenty-three paintings from Manet alone in January 1872. (John Rewald, *The History of Impressionism*, 4th rev. ed. [New York, 1973], 272.) The year 1872 was unusually successful for Monet as well, who sold 12,100 francs' worth of paintings to numerous patrons, but the lion's share went to Durand-Ruel: twenty-nine paintings for a total sum of 9,800 francs. (Daniel Wildenstein, *Claude Monet: Biographie et catalogue raisonné*, vol. 1 [Lausanne and Paris, 1974], 62–63.) In both cases, however, Durand-Ruel was unable to sell most of those new acquisitions.

37. Stuckey-Lindsay, "Berthe Morisot," 50; no. 1765, 24 July 1872, Stock Book 1868 (1866)–73, Durand-Ruel Archives, Paris. The dealer gave one of the watercolors (stock no. 2047, *Femme seule sur un banc* [perhaps *Young Woman on a Bench*, 1872, National Gallery of Art, Washington, D.C.] on 7 November 1872) to a buyer named Kaufmann about whom nothing else is currently known (Journal, Année 1872, Durand-Ruel Archives).

38. For the identification of Mr. and Mrs. Mellon's harbor scene as representing Cherbourg, see Stuckey-Lindsay, "Berthe Morisot," 39. That source differs from the argument here, suggesting instead that the first painting sold by Durand-Ruel was *Harbor Scene* (BW 42; currently missing) rather than Mr. and Mrs. Mellon's painting. Both proposals are tentative, given the current lack of evidence.

39. Patrick and Viviane Berko, *Dictionary of Belgian Painters Born between 1750 and 1875*, trans. by Center of Transla

tion Service 9 (Brussels, 1981), 182. De Knyff (1819–1885 [Berko erroneously claims 1886]) painted sites in France favored by his French comrades Constant Troyon and Camille Corot such as Normandy and Mortefontaine. According to Durand-Ruel's Stock Book (1868 [1866]–73), de Knyff purchased landscapes by Théodore Rousseau and genre paintings attributed to Jan Weenix from Durand-Ruel beginning in the 1860s; *The Jetty* appears to be the only work by a future Impressionist to enter his collection.

40. Rouart, *Correspondence*, 93–94, 96.

41. His full name, address, and offerings ("Tableaux modernes, dessins, bronzes, et objets d'art") appear as the masthead on a sheet of his stationery glued in Durand-Ruel's Stock Book for 1876; for Poupin's dealings with Durand-Ruel, see especially the Brouillard (Daily Ledger) for October 1874–August 1878, Durand-Ruel Archives, Paris. See also Anne Distel, "Renoir's Collectors: The Pâtissier, the Priest, and the Prince," in *Renoir*, exh. cat., Arts Council of Great Britain (Great Britain, 1985), 21. This obscure figure, identified by Renoir as a dealer in "objets de Jérusalem" (ibid., n. 22), apparently was originally an artist or technician who worked in the studio of the sculptor Jean-Baptiste Carpeaux in the late 1860s (Louise Clément-Carpeaux, *La Vérité sur l'oeuvre et la vie de J.-B. Carpeaux*, vol. 1 [Paris, 1934], 25). Clément-Carpeaux recounts an anecdote that suggests Poupin lacked the traits of an effective studio assistant or dealer: he told her that, in his haste to move Carpeaux's studio to Auteuil, he threw out a quantity of the sculptor's sketches, most notably a large *projet* for the *Dance* (Paris Opéra) that differed significantly from the final composition.

42. No. 22320, Stock Book 1877 (Achats), Durand-Ruel Archives.

43. Stuckey-Lindsay, "Berthe Morisot," 50–54, 63–64; in addition to others mentioned elsewhere in the text, a *Paysage* (cat. 68) in "40 Dessins par Ribot . . . aquarelles par divers," Hôtel Drouot, 18 May 1875; *La Jetée* (cat. 65), "Tableaux, aquarelles et dessins modernes," Hôtel Drouot, 25 March 1879 (possibly BW 55, purchased perhaps at this auction by Chocquet).

44. As is the case typically with women artists, there was much debate, even during her lifetime, concerning Manet's role in her career, opinions ranging from her being his overly dependent student to his equally influential colleague. For evidence in the family correspondence alone of the involvement of the three male mentors in her professional activity at that time, see Rouart, *Correspondence*, 40–42, 77, 80, 95–96.

45. Stuckey-Lindsay, "Berthe Morisot," 54. In a newly discovered letter dated 7 April (private collection), Puvis expressed sympathy for the rejections Morisot had already suffered at the hands of the Salon jury, putting her in the company of other distinguished *refusés* that year, Manet and

the duchess Castiglione-Colonna (Marcello). He also expressed hope (futilely) for the better fortune of the watercolors she had also submitted but doubted the prudence of her participation in the Independent exhibition as well, which he considered ill conceived.

46. Rewald, *History of Impressionism*, 311; Rouart, *Correspondence*, 80; and Sophie Monneret, *L'Impressionnisme et son époque*, vol. 2 (Paris, 1979), 89.

47. This strategy may not have been as innovative as observers then (and now) believed (Rewald, *History of Impressionism*, 351), given the number of such auctions that emerge upon close study, beginning with the charity auctions in favor of the Alsatian émigrés that Morisot and Manet contributed to in 1873 (see above). Carpeaux made systematic use of that outlet to sell his work in Paris and abroad starting at least as early as 1870.

48. For a brief discussion of that auction, 13 January 1874, Hôtel Drouot, see Hélène Adhémar, "Ernest Hoschedé," in John Rewald and Frances Weitzenhoffer, eds., *Aspects of Monet* (Paris, 1984), 57–59.

49. Niculescu, "Georges de Bellio," 265, nos. 98 and 99; 276, no. 13; and Monneret, *L'Impressionnisme*, vol. 1 (Paris, 1978), 67.

50. The sale, at Hôtel Drouot, 11 February 1880, was entitled "Collection de M. D*** de Rouen." Corroborating Lugt's claim for Dutuit as the source, an annotated catalogue at the Frick Art Reference Library, New York, identifies the anonymous owner as Dutuit. The painting, *La Toilette* (cat. 57) [BW 64], is further described in a marginal note as "femme en peignoir blanc devant un psyché." The Morisot is the only work by an Independent in the sale.

51. For a brief biography, see Roman d'Amat, *Dictionnaire de biographie française*, vol. 12 (Paris, 1970), 940. The collection given to Paris in 1902 contains no Impressionist works at all.

52. Rouart, *Correspondence*, 66.

53. Ibid., 90–94.

54. Letter dated 5 December 1881 to Ephrussi from his protégé Jules Laforgue (Georges Jean-Aubry, ed., *Oeuvres complètes de Jules Laforgue*, vol. 4 [Paris, 1925], 41), which discusses these two in addition to an earlier pastel, *On the Grass* (Petit Palais, Paris). Bataille and Wildenstein allege that he also owned an early watercolor, *Woman and Child on a Bench* (BW 620; Louvre, Paris, Moreau-Nélaton Collection). Ephrussi's *Nurse and Baby* described by Laforgue ("une bonne avec son enfant, bleu, vert, rose, blanc, soleil") has not been identified to date. It is logically associated with *Nourrice et bébé* shown in the Sixth Impressionist Exhibition (cat. 57), currently identified as *Nursing* (BW 94; private collection; see colorplate 14). However, a description in a recently discovered critical review links the work more closely with *Nurse and Baby* (BW 102; private collection): ". . . et la

nounou, enlacée de ses rubans bleus, veillant sur le baby qui joue placidement auprès d'elle. . . ." (Ernest Hoschedé, "Les Femmes artistes," *L'Art et la mode* 9 [April 1881], 55.)

55. Rouart, *Correspondence*, 104–7, 112. Durand-Ruel and Portier passed Morisots back and forth beginning at this time (Durand-Ruel's Brouillard [Daily Ledger] 1874–78, 1879–91). For a recent biography and assessment of Portier, see Monneret, *L'Impressionnisme*, vol. 2, 135.

56. Suzanne G. Lindsay, *Mary Cassatt and Philadelphia*, exh. cat., Philadelphia Museum of Art (Philadelphia, 1985), 15.

57. Rouart, *Correspondence*, 114.

58. Rewald, *History of Impressionism*, 480–82.

59. Joel Isaacson, "The Painters Called Impressionists," in The Fine Arts Museums of San Francisco and National Gallery of Art, Washington, D.C., *The New Painting*, exh. cat. (Geneva, 1986), 377, n. 34.

60. Durand-Ruel's Brouillard (Daily Ledger) 1884–87, nos. 340, 415, 4674–78, 8 November 1886. An eighth painting listed in the New York exhibition catalogue (*Special Exhibition. Works in Oil and Pastel by the Impressionists of Paris*, New York, Academy of Design), *The Toilette* (cat. 141), may have come from an American source, Morisot's first known work in America. The New York dealer Moore and Curtis bought a Morisot *Femme à sa toilette* from Durand-Ruel in July 1881 (Durand-Ruel's Brouillard [Daily Ledger] 28 February 1881–5 October 1881, no. 826). It is probably the ambiguously described painting later offered for sale at their own gallery (*Catalogue of High Class Oil Paintings. The Recent Importations of Moore & Curtis . . . at their Art Galleries, 845 and 847 Broadway [between 13 and 14 Street]*, 1–2 December 1881, cat. 121: "Moeisat [sic] [B] Paris, An Impression. 34 × 24"). The dimensions approximate those of the Art Institute of Chicago's *Woman at Her Toilette*, in reverse order, but more closely echo those of Chase's *Before the Mirror* (31 × 24; see n. 33). Chase could have bought his Morisot during this time in New York, whether through Moore and Curtis (and perhaps lent the work anonymously to the 1886 New York exhibition) or out of the 1886 exhibition itself.

61. Letters dated 28 April 1890 and 5 June 1890 from Portier to Morisot, private collection.

62. Durand-Ruel bought *Sur la plage* from Martin Camentron (no. 2105, 15 April 1892, Durand-Ruel's Stock Book 1894 [sic]). She placed more paintings with him in November 1893 that remained unsold by the following year (Julie Manet, *Journal* [1893–1899] [Paris, 1979], 50).

63. Rouart, *Correspondence*, 170.

64. Bataille and Wildenstein, 20, allegedly for 1,500 francs. The prices given in this source depart so radically from Morisot's documentable sales prices that year that their reliability is not beyond question. See below, n. 66, for one identifiable discrepancy.

65. Ibid.

66. Manet, *Journal*, 88, for 300 francs. Bataille and Wildenstein, 20, claim he bought it for 3,000 francs.

67. Ibid., 92, for 700 francs.

68. Duret, *Manet and the Impressionists*, 175.

69. Ibid., 175–76.

70. Durand-Ruel's Deposit Book 1890–September 1892.

71. Manet, *Journal*, 84.

72. Becker, "Berthe Morisot," 233.

73. Rewald, *History of Impressionism*, 272; Wildenstein, *Monet*, 62–63; and Durand-Ruel's Stock Book 1868 (1866)–73.

74. Wildenstein, *Monet*, 62; Durand-Ruel's Stock Book (1868 [1866]–73). For example, the dealer purchased inv. no. 2573, *Effet de brouillard*, at 500 francs and asked 1,500 francs for it, and bought inv. no. 2578 (*Valle de Deville près de Rouen* [sic]) for 400 francs but asked 2,000 francs for it. These, like most of the Monets Durand-Ruel acquired in 1872, did not sell, perhaps because of the asking prices. The markup on Morisot's work was initially around one hundred percent.

75. Rouart, *Correspondence*, 77.

76. Durand-Ruel's Stock Book 1868 (1866)–73; Durand-Ruel's Brouillard (Daily Ledger) 1873–76.

77. Rouart, *Correspondence*, 110.

78. Ralph E. Shikes and Paula Harper, *Pissarro: His Life and Work* (New York, 1980), 114.

79. Lindsay, Introduction, *Mary Cassat and Philadelphia*, 12–15; Frances Weitzenhoffer, *The Havemeyers: Impressionism Comes to America* (New York, 1986).

80. Durand-Ruel's Brouillard (Daily Ledger) January 1888–91, no. 911, 16 April 1891.

81. See n. 64.

82. Duret, *Manet and the Impressionists*, 175.

83. Bodelsen, "Early Impressionist Sales 1874–94," 339.

84. Ibid., 344–46.

85. Ibid., 335–36; Rouart, *Correspondence*, 86.

86. Rouart, *Correspondence*, 125.

87. The most courtly is Rewald, *History of Impressionism*, 351.

88. Frederick A. Sweet, *Miss Mary Cassatt: Impressionist from Pennsylvania* (Norman, Okla., 1966), 36.

89. Rouart, *Correspondence*, 77.

90. Théodore Duret, Preface, *Les Peintres impressionnistes* (Paris, 1878), 9.

91. Duret, *Manet and the Impressionists*, 175.

92. Mallarmé, Preface, 16.

LINDA NOCHLIN

6. Morisot's Wet Nurse: The Construction of Work and Leisure in Impressionist Painting

Tant de clairs tableaux irisés, ici, exacts, primesautiers . . .
—*Stéphane Mallarmé[1]*

BERTHE MORISOT'S *Wet Nurse (Nursing)* (colorplate 14) of 1879 is an extraordinary painting. Even in the context of an oeuvre in which formal daring is relatively unexceptional, this painting is outstanding. "All that is solid melts into air"—Karl Marx's memorable phrase, made under rather different circumstances, could have been designed for the purpose of encapsulating Morisot's painting in a nutshell. Nothing is left of the clichés of pictorial construction—figure versus background, solid form versus atmosphere, detailed description versus sketchy suggestion, complexities of composition or narration—all are abandoned for a composition almost disconcerting in its three-part simplicity, a facture so open, so dazzlingly unfettered as to constitute a challenge to readability, and a colorism so daring, so synoptic in its refusal of nuance as to be almost fauve before the fact. But Morisot's *Wet Nurse (Nursing)* is equally innovative in its subject matter. For this is not the old motif of the madonna and child, updated and secularized, as it is in a work like Pierre-Auguste Renoir's *Aline Nursing,* or many of the mother-and-child paintings by the other prominent woman member of the Impressionist group, Mary Cassatt. It is, surprisingly enough, a work scene. The "mother" in the scene is not a real mother, but a so-called *seconde mère,* or wet nurse, and she is feeding the child not out of "natural" nurturing instinct, but for wages, as a member of a flourishing industry. And

the artist painting her, whose gaze defines her, whose active brush articulates her representation, is not, as is usually the case, a man, but a woman, the woman whose child is being nursed. Certainly, this painting embodies one of the most unusual circumstances in the history of art, perhaps a unique one—a woman painting another woman nursing her baby. Or, to put it another way, introducing what is not seen but what is known into what is visible, two working women confront each other here, across the body of "their" child and the boundaries of class, both with claims to motherhood and mothering, both, one assumes, engaged in pleasurable activity which, at the same time, may be considered production in the literal sense of the word. What might be considered a mere use value, if, say, the painting was produced by a mere amateur, the milk produced for the nourishment of one's own child, is now to be understood as an exchange value. In both cases—the milk, the painting—a product is being produced or created for a market, for profit.

Once we know this, when we look at the picture again we may find that the openness, the disembodiment, the reduction of the figures of nurser and nursling almost to caricature, to synoptic adumbration, may be the signs of erasure, of tension, of conscious or unconscious occlusion of a substantial and disturbing reality as well as the signs of daring and pleasure—or perhaps these signs, under the circumstances, may be

91

identical, inseparable from each other. In any case, the painting may turn out to be much more complicated and ambiguous than it seemed to be at first, and its stimulating ambiguities may have as much to do with the contradictions inscribing contemporary mythologies of work and leisure in the latter part of the nineteenth century and with the way that ideologies of gender intersect with these paired notions as they do with Morisot's personal feelings and attitudes.

Reading *The Wet Nurse (Nursing)* as a work scene inevitably leads me to locate it within the representation of the thematics of work in nineteenth-century painting, particularly that of the woman worker. It also raises the issue of the status of work as a motif in Impressionist painting—its presence or absence as a viable theme for the group of artists which counted Morisot as an active member. And I will also want to examine the particular profession of wet-nursing itself as it relates to the subject of Morisot's canvas.

How was work positioned in the advanced art of the later nineteenth century, at the time when Morisot painted this picture? Generally, in the art of the later nineteenth century, work, as Robert Herbert has noted,[2] was represented by the rural laborer, usually the male peasant engaged in productive labor on the farm. This iconography reflected a certain statistical truth, since most of the working population of France at the time was, in fact, engaged in farm work. Although representations of the male farm worker predominated, this is not to say that the female rural laborer was absent from French painting of the second half of the nineteenth century. Jean-François Millet often represented peasant women at work at domestic tasks like spinning or churning, and Jules Breton specialized in scenes of idealized peasant women working in the fields. But it is nevertheless significant that in the quintessential representation of the labor of the female peasant, Millet's *Gleaners*, women are represented engaged not in productive labor—that is, working for profit, for the market—but rather for sheer personal survival —that is, for the nurture of themselves and their children, picking up what is left over after the productive labor of the harvest is finished.[3] The "glaneuses" are thus assimilated to the realm of the natural—rather like animals that forage to feed themselves and their young—rather than to that of the social, to the realm of productive labor. This assimilation of the peasant woman to the position of the natural and the nurturant is made startlingly clear in a painting like Giovanni Segantini's *The Two Mothers* (figure 6-1), which makes a visual analogy between cow and women as instinctive nurturers of their offspring.

Work occupies an ambiguous position in the representational systems of Impressionism, the movement

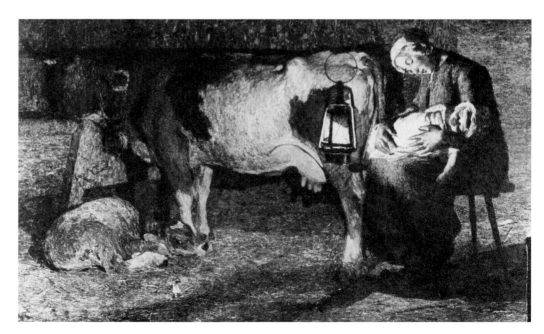

Figure 6-1

Giovanni Segantini, *The Two Mothers*, 1889 Oil on canvas, 163 × 300 cm (64¼ × 118 in.). Galleria d'Arte Moderna, Milan

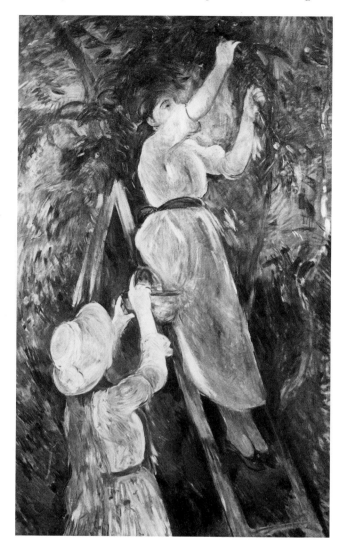

to which Morisot was irrevocably connected; or one might say that acknowledgment of the presence of work themes in Impressionism has, until recently, been repressed in favor of discourses stressing Impressionism's "engagement with themes of urban leisure."[4] Meyer Schapiro, above all, in two important articles of the 1930s, laid down the basic notion of Impressionism as a representation of middle-class leisure, sociability, and recreation depicted from the viewpoint of the enlightened, sensually alert middle-class consumer.[5] Now one could contravene this contention by pointing to a body of Impressionist works that do, in fact, continue the tradition of representing rural labor initiated in the previous generation by Gustave Courbet and Millet and popularized in more sentimental form by Breton and Jules Bastien-Lepage. Camille Pissarro, particularly, continued to develop the motif of the peasant, particularly the laboring or resting peasant woman, and that of the market woman in both Impressionist and neo-Impressionist vocabularies—right down through the 1880s. Berthe Morisot herself turned to the theme of rural labor several times: once, to the *Haymaker* in a beautiful preparatory drawing for a larger decorative composition, and again, to fieldwork in a little painting, *In the Wheat Field* of 1875, and a further time, more ambiguously, because the rural "workers" in question, far from being peasants, are posed by her daughter, Julie, and her niece Jeanne, to the theme of fruit picking in *The Cherry Tree* (figure 6-2).[6] Certainly, one could point to a significant body of Impressionist work representing urban or suburban labor. Edgar Degas did a whole series of ironers;[7] Gustave Caillebotte depicted floor scrapers and housepainters; and Morisot herself turned at least twice to the theme of the laundress: once, in *Laundresses Hanging Out the Wash* (colorplate 9) of 1875, a lyrical canvas of commercial laundresses plying their trade in the environs of the city, painted with a synoptic lightness that seems to belie the laboriousness of the theme itself; and another time, in *Woman Hanging Wash* (figure 6-3) of 1881, a close-up view where the rectangularity of the linens seems wit-

tily to reiterate the shape and texture of the canvas, the laundress to suggest the work of the woman artist herself. Clearly, then, the Impressionists by no means totally avoided the representation of work.

But to speak more generally, interpreting Impressionism as a movement constituted primarily by the representation of leisure has to do as much with a particular characterization of labor itself as it does with the iconography of the Impressionist movement. In the ideological constructions of the French Third Republic, as I have already pointed out, work was epitomized by the notion of rural labor, in the time-honored, physically demanding, naturally ordained tasks of peasants on the land. The equally demanding physical efforts of the ballet dancer, represented by Degas,

with its hours of practice, its strains, its endless repetition and sweat, was construed as something else, something different: as art or as entertainment. Of course, this construction has something to do with the way entertainment represents itself: often, the whole point of the work of dancing is to make it look as though it is not work, that it is spontaneous and easy.

But there is a still more interesting general point to be made about Impressionism and its reputed affinity with themes of leisure and pleasure. It is the tendency to conflate woman's work—whether it be her work in the service or entertainment industries or, above all, her work in the home—with the notion of leisure itself. As a result, our notions of the iconography of work, framed as they are by stereotypical notions of the peasant in the fields or the manual laborer, tend to exclude such subjects as the barmaid or the beer server from the category of the work scene and position them instead as representations of leisure, especially if the images in question represent women. One might even say, looking at such paintings as Edouard Manet's *Bar at the Folies-Bergère* or *Beer Server* from the vantage point of the new women's history, that middle- and upper-class men's leisure is sustained and enlivened by the labor of women—by entertainment and service workers like these represented by Manet.[8] It is also clear that such representations position women workers

—barmaid or beer server—in such a way that they seem to be there to be looked at—visually consumed, as it were—by a male viewer. In the *Beer Server* of 1878, for example, the busy waitress looks out alertly at the clientele, while the relaxed male in the foreground—ironically, a worker himself, identifiable by his blue smock—stares placidly at the woman performer, half visible—doing her act on the stage. The work of café waitresses or performers, like those represented by Degas in his pastels of the café concerts, is often, directly or indirectly, connected to their sexuality—what one might call the sex industry of the time—whether marginally or centrally, full-time or part-time. What women, primarily lower-class women, had to sell in the city was mainly their bodies. A comparison of Manet's *Ball at the Opera*—denominated by the German critic Meier-Graefe as a "Fleischbörse" or flesh-market—with Degas's *Cotton Market in New Orleans* makes it clear that work, rather than being an objective or logical category, is an evaluative or even a moral one. Men's leisure is produced and maintained by women's work, disguised to look like pleasure. The concept of work under the French Third Republic was constructed in terms of what that society or its leaders stipulated as good, productive activity, generally conceived of as wage-earning or capital production. Women's selling of their bodies for wages does not fall under

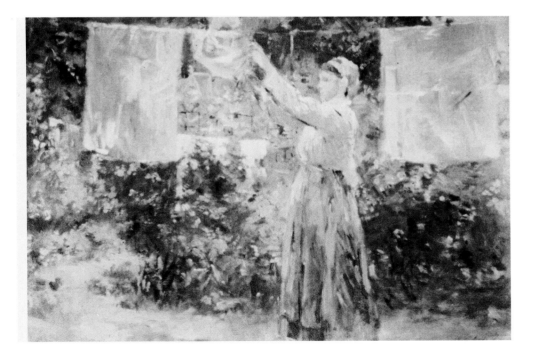

Figure 6-3

Woman Hanging Wash, 1881
Oil on canvas, 46 × 67 cm
(18⅛ × 26⅜ in.).
Ny Carlsberg Glyptotek,
Copenhagen

Figure 6-4
Edgar Degas, *Brothel Scene*, 1876–77
Monotype in black ink, 21 × 26.1 cm (8¼ × 10¼ in.) (sheet).

To understand Morisot's *The Wet Nurse (Nursing)*, one has to locate the profession of wet-nursing itself within the context of nineteenth-century social and cultural history. Wet-nursing constituted a large-scale industry in France in the eighteenth and nineteenth centuries. In the nineteenth century, members of the urban artisan and shopkeeping classes usually sent their children out to be nursed by women in the country so that wives would be free to work. So large was the *industrie nourricière* and so patent the violations of sanitation, so high the mortality rate and so unsteady the financial arrangements, that the government stepped in to regulate the industry in 1874 with the so-called Roussel Law, which regulated the wet-nursing industry, supervising wet nurses and their clients on a nationwide basis.[10] Members of the aristocracy or upper bourgeoisie like Berthe Morisot, however, did not have

the moral rubric of work; it is constructed as something else—as vice or as recreation. Prostitutes —ironically, today referred to colloquially as "working girls"—a subject often represented by Degas, are of course engaging in a type of commercial activity, like the businessmen represented in his *Members of the Stock Exchange*. But nobody has ever thought to call the prints from Degas's monotype series of brothel representations "work scenes" (figure 6-4), despite the fact that prostitutes, like wet nurses or barmaids and laundresses, were an important part of the work force of the great modern city in the nineteenth century and, in Paris at this time, a highly regulated, government-supervised form of labor.[9]

If prostitution was excluded from the realm of honest work because it involved women selling their bodies, motherhood was excluded from the realm of work precisely because it was unpaid. Woman's nurturing role was seen as part of her natural function, not as labor. The wet nurse (figure 6-5), then, is something of an anomaly in the nineteenth-century scheme of feminine labor. She is like the prostitute in that she sells her body, or its product, for profit and her client's satisfaction; but, unlike the prostitute, she sells her body for a virtuous cause. She is at once a mother— *seconde mère, remplaçant*—and an employee. She is performing one of woman's "natural" functions, but she is performing it as work, for pay, in a way that is eminently not natural but socially ordained.

Figure 6-5
Anonymous, *Wet Nurses,* c. 1900
Photograph.
Bibliothèque nationale, Paris

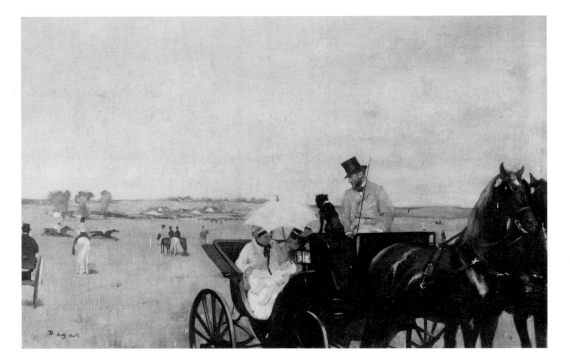

to resort to this "regulated" industry. They usually hired a *nourrice sur lieu*, or live-in wet nurse, who accompanied the infant, took it to the park, and comforted it—but was there mainly to provide the baby with nourishment.[11] The omnipresence of the wet nurse in the more fashionable purlieus of Parisian society is indicated in Degas's *Carriage at the Races* (figure 6-6), where the Valpinçons, husband and wife, are accompanied by their dog, by their son and heir, Henri, and by the veritable star of the piece, the wet nurse, depicted in the act of feeding the baby.[12] A foreign painter like the Finn Albert Edelfelt, when depicting the charms of Parisian upper-class life, quite naturally included the wet nurse in his scene of the Luxembourg Gardens (Antell Collection, Helsinki).

The wet nurse was considered, on the one hand, the most "spoiled" servant in the house and, on the other, the most closely watched and supervised: she was, in some ways, regarded more as a highly prized milch cow than as a human being. Although she was relatively highly paid for her services, often bringing home 1,200 to 1,800 francs per campaign—her salary ranked just under that of the cordon-bleu chef[13]—and though she was often presented with clothing and other valuable gifts, her diet, though plentiful and choice, was carefully monitored and her sex life was brought to

a halt—and, of course, she had to leave her own baby and other children at home in the care of her mother or another family member.[14] The wet nurse was always a country woman, and generally from a specific region of the country: the Morvan, for instance, was considered prime wet-nurse territory.[15] And in fact, wet-nursing was the way poor, or relatively poor, country women with few valuable skills could make a fairly large sum of money by selling their services to well-off urban families. The analogy with today's surrogate mothers makes itself felt immediately, except that the wet nurse was not really the subject of any moral discourse about exploitation. On the contrary, although some doctors and child-care specialists complained about the fact that natural mothers refused to take nature's way and breast-feed their children themselves, in general they preferred a healthy wet nurse to a nervous new mother, and few upper-class women in the later nineteenth century would have dreamed of breast-feeding their own children, while only a limited proportion of women of the artisan class, who had to work themselves or who lived in crowded quarters, had the chance to do so. Renoir proudly represented his wife nursing Jean not because it was so "natural" for her to do so, but perhaps because, on the contrary, it was not. But, of course, Renoir's wife was not of the same social class as Berthe

Figure 6-7

José de Frappa, *Bureau de Nourrices*, c. 1880s Oil on canvas, from Fanny Fäy-Sallois, *Les Nourrices à Paris au XIXᵉ Siècle* (Paris, 1980).

Morisot; she was a working-class woman. In any case, Berthe Morisot was being perfectly "natural" within the perimeters of her class in hiring a wet nurse. It would not be considered neglectful and certainly it would not have to be excused by the fact that she was a serious professional painter: it was simply what people of her social station did.

The wet nurse was frequently represented in popular culture and her image often appeared in the press or in genre painting depicting various aspects of her career, as one of the recognizable types or professions of the capital. José de Frappa, in his *Bureau de nourrices* (figure 6-7), probably from the 1880s, depicts the medical examination of potential wet nurses. Husband, mother-in-law, and doctor evidently participated in the choice of a candidate. Wet-nursing was frequently the subject of humorous caricatures right down to the beginning of the twentieth century, when sterilization and pasteurization enabled mothers to substitute the newly hygienic bottle for the human breast—and thereby gave rise to cartoons dealing with the wet nurse attempting to compete with her replacement (figure 6-8). With her ruffled, beribboned cap and jacket or cape, she was a frequent sight in fashionable parks, where she aired her charges, or in upper-class households. Her characteristic form could even serve to il-

Figure 6-8

Abel Faivre, "Oh, ces enfants!" *Le Rire*, September 14, 1901.

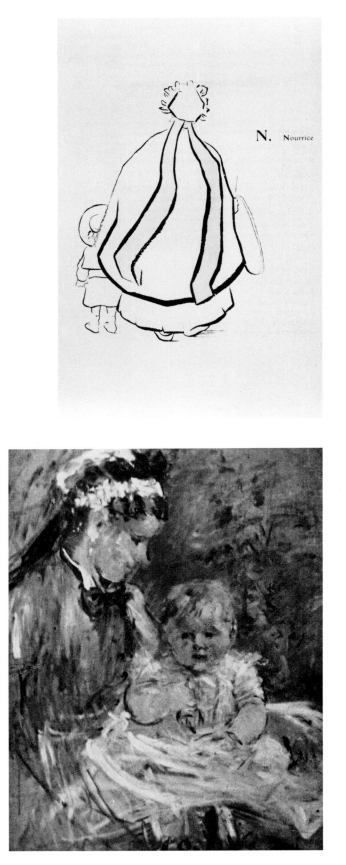

Figure 6-9
Anonymous, "N. Nourrice"
Illustration from French children's alphabet
book.
Bibliothèque nationale, Paris

lustrate the letter *N*—for "*nounou*" or *nourrice*—in a children's alphabet (figure 6-9).

In her paintings of her daughter and her wet nurse (figure 6-10), Morisot is not, of course, creating a sociological document of a particular kind of work, nor even a genre scene of some engaging incident involved in wet-nursing: both Julie and her wet nurse serve as motifs in highly original Impressionist paintings, and their specificity as documents of social practice is hardly of conscious interest to the creator of the paintings, who emphasizes visual qualities of color and brushwork, light, shape—or the deconstruction of shape—and atmosphere. Nor do we think of Morisot as primarily a painter of work scenes; she was, indeed, one of those artists of the later nineteenth century—like James McNeill Whistler and Manet, among others—who helped construct a specific iconography of leisure, figured by young and attractive women (colorplate 8) whose role is simply to be there, for the painter, as a languid and self-absorbed object of aesthetic contemplation—a kind of human still life.

We associate Morisot, quite naturally, not with work scenes, however ambiguous, but rather with the representation of domestic life, of mothers or, more rarely, fathers—specifically, her husband, Eugène Manet—and daughters engaged in recreation (colorplate 15). This father-and-daughter motif is, like the theme of the wet nurse, a most unusual one in the annals of Impressionist painting. Male Impressionists who turned, as Morisot did, to the domestic world around them for subject matter naturally painted their wives and children. Here is a case where being a woman artist makes an overt difference: Morisot, in turning to her closest relatives, paints a father and child, a rare theme in Impressionism, and one with its own kinds of demands.

Figure 6-10
Julie and Her Nurse, 1880
Oil on canvas, 73 × 60 cm (28½ × 23⅝ in.).
Ny Carlsberg Glyptotek, Copenhagen

Figure 6-11
Young Woman Powdering Her Face, 1877
Oil on canvas, 46 × 38 cm (18⅛ × 15 in.).
Musée d'Orsay, Paris

They are doing something concrete—playing with a boat and sketching, playing with toy houses—and with a vaguely masculine air.

Despite the fact that scenes of leisure, languor, and recreation are prominent in Morisot's oeuvre, there is another way we might think of work in relation to her production. The notion of the work of painting itself is never disconnected from her art and is, perhaps, allegorized in various toilette scenes (figure 6-11), in which women's self-preparation and adornment stand for the art of painting itself or subtly refer to it. A simultaneous process of looking and creating are prime elements of a woman's toilette as well as of picture making—and sensual pleasure as well as considerable effort is involved in both. One could even go further and assert that in both—maquillage and painting—a private product is being prepared for public consumption.

Painting was work of the utmost seriousness for Morisot. She was, as the 1987 exhibition catalogue of her work reveals,[16] unsparing of herself, perpetually dissatisfied, often destroying works or groups of works that did not satisfy her high standards. Her mother observed that whenever she worked, she had an "anxious, unhappy, almost fierce look," adding "this existence of hers is like the ordeal of a convict in chains."[17]

There is another sense in which Morisot was involved with the work of painting: the way in which the paintings reveal the act of working, are sparkling, invigorating, and totally uneffortful-looking registers of the process of painting itself. In the best of them, like *In the Garden (Women Gathering Flowers)* (colorplate 12), color and brushstroke are the deliberately revealed point of the picture: they are, so to speak, works about work, in which the work of looking and

registering the process of looking in paint on canvas or pastel on paper assume an importance almost unparalleled in the annals of painting. One might almost say that the work of painting was never to be so strongly revealed again until the time of the late Claude Monet or even of Abstract Expressionism, although for the latter, of course, looking and registering were not the issue.[18]

Even when she looked at herself, as in a *Self-Portrait* (colorplate 17) executed in pastels in about 1885, the work of painting or marking was primary: this is in no sense a flattering or even conventionally penetrating portrait. It is a working record of an appearance, deliberate in its notation, its omissions, its selective recording of a motif that happens to be the author's face. It is almost painfully moving. It is no wonder that unfriendly critics found her work too sketchy, unfinished, bold to the point of indecipherability. Referring to two of her pastels, for example, Charles Ephrussi declared: "One step further and it will be impossible to distinguish or understand anything at all."[19]

In her amazing late portrait of Julie (figure 6-12) with a dog and an empty chair, she dissolves the chair into a vision of evanescent lightness: a work of omission, of almost nothingness. Compared to it, van Gogh's *Gauguin's Armchair* (figure 6-13) looks heavy, solid, and painterly. Yet Morisot's chair is moving, too. Its ghostliness and disembodiment remind us that it was painted shortly after her husband's death, perhaps as an emblem of his absent presence within the space of his daughter's portrait. And perhaps for us, who know that she painted this near the end of her life, it is a moving yet self-effacing prophesy of her own impending death and, at the same time, perhaps unconsciously, a way of establishing—lightly, only in terms of the work itself—her presence within an image representing, for the last time, her beloved only child.

In insisting on the importance of work, specifically manual labor, in Morisot's production, I am not suggesting that Morisot's work was the same as the onerous physical labor involved in farm work or the routine mechanical efforts of the factory hand—nor that it was identical with the relatively mindless and constricted duties of the wet nurse. We can, however, see certain connections: in a consideration of both the work of the wet nurse and that of the woman artist the

Figure 6-12

Girl with a Greyhound (Julie Manet), 1893
Oil on canvas, 70 × 80 cm
(28¾ × 31½ in.).
Musée Marmottan, Paris

Figure 6-13

Vincent van Gogh, *Gauguin's Armchair*, 1888
Oil on canvas, 90.5 × 72 cm (35⅞ × 28⅛ in.).
Vincent van Gogh Foundation/
National Museum Vincent van Gogh,
Amsterdam

element of gender asserts itself. Most critics, both then and now, emphasized Morisot's gender; her femininity was constructed from an essentialist viewpoint as delicacy, instinctiveness, naturalness, playfulness, a construction implying certain natural gendered lacks or failures: lack of depth, of substance, professionalism, or leadership, for instance. Why else has Morisot always been considered as somehow a secondary Impressionist, despite her exemplary fidelity to the movement and its aims? Why has her very flouting of the traditional "laws" of painting been seen as weakness rather than strength, a failure or lack of knowledge and ability rather than a daring transgression? Why should the disintegration of form characteristic of her best work not count as a vital questioning of Impressionism from within, a "making strange" of its more conventional practices?

I would like to end as I began—with Karl Marx's memorable phrase: "All that is solid melts into air." But now I would like to consider the whole passage in the *Communist Manifesto* from which I (and Marshall Berman, author of a book with that title) extracted it: "All fixed, fast-frozen relations, with their train of ancient and venerable prejudices and opinions, are swept away, all new-formed ones become antiquated before they can ossify: All that is solid melts into air, all that is holy is profaned, and men at last are forced to face . . . the real conditions of their lives and their relations with their fellow men."[20]

I am not in any sense suggesting that Morisot was a political or even a social revolutionary—far from it. But I am saying that her strange, fluid, unclassifiable, and contradiction-laden imagery inscribes many of those characteristic features of modernism and modernity that Marx is, of course, referring to in his celebrated passage—above all, modernism's profoundly deconstructive project. Sweeping away "all fixed, fast-frozen relations, with their . . . prejudices and opinions" —this is certainly Morisot's project as well. And in some way, too, she is in *The Wet Nurse (Nursing)* being forced to face, at the same time that it is impossible for her fully to face, the real condition of her life and her relations with a fellow woman. Thinking of Marx's words, looking at Morisot's painting, these real conditions hover on the surface of the canvas, a surface as yet not fully explored, untested but still potentially threatening to "ancient and venerable prejudices and opinions"—about the nature of work, about gender, and about painting itself.

Notes

1. Preface to the catalogue of the posthumous exhibition of Berthe Morisot's paintings: *Berthe Morisot (Mme Eugène Manet): 1841–1895*, exh. cat., Durand-Ruel (Paris, 1896).

2. Robert Herbert, "City vs. Country: The Rural Image in French Painting from Millet to Gauguin," *Artforum* 8 (February 1970), 44–55.

3. See Jean-Claude Chamboredon, "Peintures des rapports sociaux et invention de l'éternel paysan: les deux manières de Jean-François Millet," *Actes de la recherche et sciences sociales*, nos. 17–18 (November 1977), 6–28.

4. Thomas Crow, "Modernism and Mass Culture in the Visual Arts," in *Modernism and Modernity: The Vancouver Conference Papers*, ed. by Benjamin H. D. Buchloh, Serge

Guilbaut, and David Solkin (Halifax, Nova Scotia, 1983), 226.

5. See Meyer Schapiro, "The Social Bases of Art," in *Proceedings of the First Artists' Congress against War and Fascism* (New York, 1936), 31–37, and "The Nature of Abstract Art," *Marxist Quarterly 1* (January 1937), 77–98, reprinted in Schapiro, *Modern Art: The Nineteenth and Twentieth Centuries* (New York, 1978), especially 192–93.

6. Mary Cassatt turned to apple picking at the same time, in a group of works related to her mural of Modern Woman for the Chicago World's Fair, which suggests women plucking the fruit of knowledge.

7. For a detailed discussion of Degas's ironers and laundresses, see Eunice Lipton, *Looking into Degas: Uneasy Images of Women and Modern Life* (Berkeley, 1986), 116–50.

8. For the role of the barmaid in French nineteenth-century society and iconography, see T. J. Clark, *The Painting of Modern Life: Paris in the Art of Manet and His Followers* (Princeton, 1984), 205–58, and Novalene Ross, *Manet's "Bar at the Folies-Bergère" and the Myths of Popular Illustration* (Ann Arbor, 1982).

9. For information about government regulation of prostitution, see Alain Corbin, *Les Filles de noce: Misère sexuelle et prostitution aux 19e et 20e siècles* (Paris, 1978); for the representation of prostitution in the art of the later nineteenth century, see Hollis Clayson, "Avant Garde and Pompier Images of 19th Century French Prostitution: The Matter of Modernism, Modernity and Social Ideology," in *Modernism and Modernity*, 43–64.

10. For the Roussel Law of 23 December 1874, see George D. Sussman, *Selling Mothers' Milk: The Wet-Nursing Business in France: 1715–1914* (Urbana, 1982), 128–29, 166–67.

11. For an excellent examination of the role of the wet nurse in the nineteenth century, focusing on the *nourrice sur lieu,* and including an analysis of the medical discourse surrounding the issue of maternal breast-feeding, see Fanny Faÿ-Sallois, *Les Nourrices à Paris au XIX^e siècle* (Paris, 1980).

12. I am grateful to Paul Tucker for pointing out the presence of the wet nurse in this painting.

13. Faÿ-Sallois, *Les Nourrices,* 201.

14. For the figures of the wages cited, see Sussman, *Selling Mothers' Milk,* 155, and for the salary of the live-in wet nurse and her treatment generally, see Faÿ-Sallois, *Les Nourrices,* 200–239.

15. Sussman, *Selling Mothers' Milk,* 152–54.

16. Charles F. Stuckey and William P. Scott (with the assistance of Suzanne G. Lindsay), *Berthe Morisot—Impressionist,* exh. cat., Mount Holyoke College Art Museum and National Gallery of Art, Washington, D.C. (New York, 1987).

17. Stuckey and Scott, *Berthe Morisot,* 187.

18. See, for example, Charles Stuckey's assertion that, in the case of *Nursing (The Wet Nurse),* "it is difficult to think of a comparably active paint surface by any painter before the advent of Abstract Expressionism in the 1950s." *Berthe Morisot,* 88.

19. Quoted in Stuckey and Scott, *Berthe Morisot,* 88.

20. Quoted by Marshall Berman, in *All That Is Solid Melts into Air: The Experience of Modernity* (New York, 1982), 21.

ANNE SCHIRRMEISTER

7. La Dernière Mode: Berthe Morisot and Costume

THROUGHOUT the Second Empire and early Third Republic, Parisian fashion and French art found a synthesis in the aesthetic program of avant-garde artists and critics in the painting of *la vie moderne*. Charles Baudelaire, who described modernity in terms that could also describe fashion, as "the transient, the fleeting, the contingent," defined the aim of the artist of *la vie moderne*: "to extract from fashion the poetry that resides in its historical envelope, to distill the eternal from the transitory."[1] For the Impressionist painters, the representation of modern dress and manners was at once a rejection of the art of the past and an embracing of the newly rebuilt city of Paris, the fashion and entertainment capital of the world, and of *la vie moderne*, which could only be experienced there.

In recent years, art historians have studied the iconography of *la vie moderne* at some length in articles, books, and exhibition catalogues. Focusing almost exclusively on the male Impressionists, especially on Edouard Manet, Edgar Degas, and Pierre-Auguste Renoir, they have cast the artist in the role of flaneur and investigated the iconography of public display, using the city of Paris as stage and pointing to the racetrack, dance halls, café concerts, masked balls, bars, the Opéra, and the holiday activities of boating, promenading, and dining in the surrounding chic suburbs and resorts. We have only recently begun to reexam-

ine the other side of the coin: the iconography of the private domestic sphere centered around home, family, and friends, painted occasionally by all of the Impressionists, but almost exclusively by Berthe Morisot.[2] An analysis of the costumes depicted by Morisot, especially when contrasted with those by her colleagues, will suggest how the painting of private domestic life can also answer the Baudelairian dictum to illustrate *la vie moderne*.

Berthe Morisot represented costume selectively. She did not paint the high-fashion Second Empire and early Third Republic costumes familiar to us through fashion plates, museum exhibitions, and the paintings of her academic colleagues James Tissot and Alfred Stevens. Nor did she paint the avant-garde fashions designed by the great couturier of her day Charles Frederick Worth, whose creations were worn by the high priestesses of fashion: the empress Eugénie and her court; the wealthiest members of the international aristocracy; and the high-profile actresses and courtesans who socialized with the elite of the new society. These fashion cognoscenti were highly visible public figures in a changing, upwardly mobile social order. They led active social lives that required elaborate and expensive wardrobes suitable for innumerable public events. At the Opéra or the racetrack, their toilettes were a part of the spectacle as much as the ballet dancer

or the race horse. Of great luxury and complexity, these costumes were described in minute detail in the fashion and society pages of daily newspapers and weekly journals devoted to fashion, art, or *le high life*. These dresses were intended to draw attention and comment from the crowd; many were designed specifically to be "read" and admired from a distance. Morisot's costumes, while fashionable and obviously luxurious, were designed primarily for a domestic existence and were thus not trend setting. The clothing she paints may illustrate what sociologists of dress refer to as the "trickle-down" theory of fashion:[3] couturiers created a few models of a style of great originality, novelty, and daring that were worn by the most visible and influential followers of fashion. These fashions were exhaustively reported and illustrated in the press and then reinterpreted by lesser couturiers, dressmakers, and, eventually, women sewing for themselves at home, in progressively cheaper fabrics and simpler trim, line, and detail. In Morisot's time, this process was aided by an increasingly fluid social order and by the eagerness of the bourgeoisie and affluent middle classes to associate themselves with the *haute bourgeoisie* and the aristocracy and, especially after the Commune, to disassociate themselves from the workers and artisans. Eventually, as in the case of the crinoline and the bustle, these fashions trickled down to the lowest classes and became "common," whereupon they were rejected by the upper classes who sought a new silhouette, only to have the process repeat itself.

In general, the costumes that Morisot painted were those worn by her family and friends, who, by and large, were members of the *haute bourgeoisie;* as such they illustrate the high end of the trickle-down process. In the fiction of Morisot's oeuvre, Parisian social life centered not around masked balls, café concerts, and beer halls, but around the home: the private salons of fellow artists and writers, the company of women paying calls, drinking tea, or reading together. Outdoor pastimes were equally secluded, taking place not at the racetrack in the Bois de Boulogne but in private gardens or parks or in a deserted Bois. The women Morisot painted, though highly fashionable, were discreetly, respectably, and often informally dressed. This is not to suggest that Morisot limited her range of costumes. Over the years she catalogued nearly all aspects of dress of the fashionable bourgeoise: peignoirs, morn-

ing dress, day dress, *trottoirs*, tea gowns, reception dresses, dinner dresses, ball gowns, outerwear such as coats and mantles, as well as a wide range of undress, including chemises, corsets, corset covers, petticoats, and nightgowns. Maternity clothes, fashionable baby and children's clothing, and nursemaid and maids' uniforms were also documented, as was the traditional garb of the French peasant.

Morisot differs from her Impressionist colleagues in the context in which she portrayed costume, but more importantly in her attitude toward dress. She treated the dress of her day with great discretion and with quiet good taste, as a practical feature of everyday life. Her approach was direct and unostentatious; elements of dress were formally and thematically integrated into her paintings. It is difficult to imagine Morisot renting an elaborate dress for a painting as her contemporary Claude Monet did.[4] In an age in which clothing was a heated moral issue, the focus of a debate on class, modesty, and propriety,[5] it is very rarely eroticized in Morisot's work, and women are neither spectacles nor on parade, neither exhibitions nor commodities. Only rarely does a dress serve to emphasize or heighten the sexual beauty of Morisot's sitters; never are her sitters simply clothes horses. Morisot's unjudgmental, realistic, and modern approach to clothing documents contemporary dress, but it also records the conventions of how dress was worn in daily life, adding significantly to the meaning of her paintings.

A survey of the dress Morisot painted—that worn by bourgeoises in the course of their daily domestic and social routine—suggests a possible source of inspiration for her treatment of fashion and interpretation of *la vie moderne:* the contemporary fashion plate. In his essay "The Painter of Modern Life," Baudelaire compared the fashion-plate illustrator to a poet, novelist, and moralist, stating that he is "the painter of the fleeting moment and all it suggests of the eternal."[6] Baudelaire emphasized that fashion plates not merely chronicled the evolution of style in dress, but also expressed "the moral attitude and aesthetic value of the time," portraying "bourgeois sketches of manners" and the fashionable scene.

Like much of Morisot's painting, fashion plates concentrated on a fairly restricted set of themes, frequently centering around the lives of women. Men and women are rarely shown together in plates, which tend to be

segregated by sex; there are many more fashion plates of women's than of men's fashion.[7] The subjects of fashion plates are most often the rituals of domestic existence, especially the social visit.[8] A particularly popular subject, the social visit permitted the illustrator to depict both indoor and outdoor clothing, street wear and tea gown, in the same plate. As in Morisot's paintings, women are usually at leisure: they read novels, embroider, drink tea, play a musical instrument, comb their hair, or entertain children who wear elaborate miniature versions of adult dress. Fashion plates, when not situated in a bourgeois interior, are set in nature, offering a background of greenery and flowers that helps to idealize the women. This nature was usually a private garden, indicated by the presence of statuary or furniture or a château in the distance, or, when identifiably public, a fashionable setting such as the boardwalk at a seaside resort or a spot near the racetrack in the Bois de Boulogne. In fashion plates and in Morisot's paintings, public places are never crowded, and the figures depicted are rarely strangers to one another. During and after the Second Empire, fashion plates reinforced the superficial and materialistic values espoused in the empire. In a time of generalized censorship by the popular press of the seamier side of life, fashion plates insisted that all was right with the world, stressing the official, progressive ideals of the French nation.

There is no question Morisot would have often seen fashion plates. Even if she were not to read fashion magazines, she would have seen the plates in the many weekly magazines that reviewed art and contemporary culture, for example, *Le Charivari* and *La Vie parisienne*. We can be certain that she read at least one fashion magazine, the short-lived *La Dernière mode*. This was written and edited by Morisot's close friend Stéphane Mallarmé, a fashion connoisseur whom she probably met for the first time in 1874, the year of the publication of his magazine.[9]

A comparison of Morisot's painting with contemporary fashion plates is fascinating in that it reveals which conventions and devices she did and did not adopt and how she interpreted those she did adopt. Fashion-plate illustration shares with caricature, another form of popular illustration, the exaggeration of the salient feature. The fashion plate often overstates what is, in effect, being "sold": the novelties of cut,

line, and trim, which are described in detail and with precision. Fashion plates were intended to provide descriptive and didactic information so that new trends could be understood and followed and, indeed, copied at the dressmaker's or at home. The body type of the figures was determined by the fashionable ideal of the period and was not individualized. Nor were heads, faces, and expressions individualized, as these, too, were deemed unimportant. The pose and stance of the figures were largely determined by the area of novelty in the costume; for example, in the 1870s and 1880s many fashion-plate figures were drawn in silhouette or from behind to emphasize the bustle and the increasingly complex and asymmetrical arrangement of drapery over and around it.

Morisot did not elongate her figures or diminish their waists, heads, hands, or feet to arrive at the fashionable body type of the plates. No dressmaker could copy the details of a flounced overskirt or the lace trim on a peignoir from her paintings. Among the Impressionists, her technique of broken brushstrokes and dissolving forms was least suitable for describing details. However, the fashion plate provided Morisot and other women of her period with a world view of the positive values of modern life. It was an important inspiration for Morisot's creation of an alternative, *vie-moderne* subject, as well as a source for her specific poses, for the character and arrangement of her interiors, and for her overall composition and format.

In Morisot's *Interior* of c. 1871 (figure 7-1), a woman in a fashionable, black silk afternoon dress with transparent sleeves and bodice sits on a gilded regency chair. Next to her is an identical, but empty chair, and, in the left-hand corner of the composition, a child is seen from behind. The little girl is attended by another woman who, by virtue of the simplicity of her dress, is probably the child's nanny; together the pair peers out through the curtains of the window. The subject of this painting, in which little happens, is the contrast in the attitudes of the members of the household awaiting a formal visit: that of the lady of the house, which is stiff and formal, and that of the child and her attendant, which is unabashedly eager. The social call, a frequent subject of fashion plates (figure 7-2), as noted, thus has a different tone in Morisot's painting. The figures in fashion plates are often separated to show up the individual dresses and emphasize the silhouettes; in

Figure 7-1
Interior, c. 1871
Oil on canvas, 60 × 63 cm
(23⅝ × 28¾ in.).
Private collection, Paris

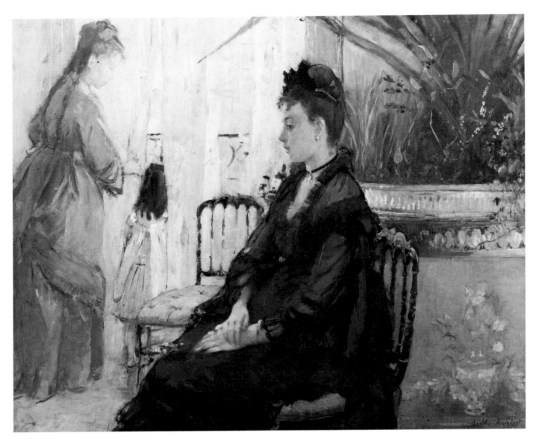

Interior the seated woman is isolated for psychological reasons. The sparse furnishing of the room also recalls the language of fashion plates, in which interiors are often shown nearly empty so as not to obscure or distract from the fashions. However, at the same time, the furnishings play an important supporting role in providing an approximate context for the clothing, as well as indicating the wealth and taste—and possibly the ancien-régime background—of the potential clients. Antiques, chandeliers, planters, elaborately carved and tasseled mantles, and luxurious curtains and passementeries are common (figure 7-3). The enormous gilt jardiniere in Morisot's painting signals a luxurious, upper-class setting, and the palm fronds, a trendy tropical plant of the day, suggest that it is also fashionable. Beyond the curtains, dissolved by light, is the railing of a balcony. Balconies were ubiquitous in fashion plates by the 1860s and during the 1870s and 1880s. They were common features of the new apartment buildings being constructed along the rebuilt boulevards of Paris by Louis-Napoleon and his prefect, Baron Haussmann,

and their modern character served to reenforce the up-to-date, upper-class message of the fashion plates. Balconies also provided an obvious solution to the problem of emphasizing the details of the back of a dress and the constantly changing shape of the bustle by giving the figures an opportunity to turn to look out a window or door.

In *Interior* we see that Morisot has absorbed the language of the fashion plate but transformed the conventions of setting, interior decoration, subject matter, and pose into a painting of enormous psychological resonance. The seated woman is separated, not to be better seen, but to carry the emotional weight of the painting.[10] Her toilette, far more elaborate than that of the other figures, emphasizes her isolation, as does her gaze, as she stares out blankly into the room. In an age of bibelots, the relative emptiness of the room and scanty selection of furnishings, familiar from fashion plates, reinforce this quality, as do the turned-away figures of the child and attendant. Such figures looking at distant views from a balcony become familiar

Figure 7-2
Fashion Plate. *Journal des demoiselles*, c. 1877
Lithograph, 21.5 × 28 cm (8½ × 11 in.).
Woodman Thompson Collection, Costume
Institute, Metropolitan Museum of Art,
New York

motifs in Morisot's art, appearing in *Villa at the Seaside* (figure 7-4) and *On the Balcony* (colorplate 6), with its distant view of the Parisian skyline from the heights of the Trocadéro. Morisot's use of these turned-away figures has been explained variously as a solution to the problem of posing bored children, as a means of adding spatial suggestion to compositions, as a metaphor for the innocent vision of children, and as a way to contrast the modes of visual experience of adults and children.[11] However, the restlessness of child models did not prevent Morisot's contemporaries, especially Mary Cassatt, from frequently portraying children frontally. And turned-away figures do not necessarily create a deep recession into space. Throughout her career, Morisot explored the complexities of the domestic world of women—which necessarily included children—and these back-turned figures are an important element in her creation of unposed, modern genre paintings, derived, however, from fashion plates.

In adopting the motif of the turned-away figure in *Interior*, Morisot transforms a staple of fashion-plate compositions to suggest a modern, psychological state of shared isolation. We are drawn into a sparsely furnished interior, curtained from the outside world, in which a woman, formally dressed and seated, is lost in reverie, and a child and nanny, simply dressed, and with contrasting attitudes of informality and eagerness, are sheltered from, but seem to yearn for the world of the boulevard. This dreaming and longing are suggested with great delicacy, intimating that mothers and children, so often depicted in art as a unit, can occupy separate spheres, moods, and thoughts, while occupying a shared domestic space.

In *On the Balcony*, Morisot's sister Yves Gobillard and her daughter Bichette look out over an iron railing at a view of the city of Paris. Dressed in a chic black walking dress with pink silk parasol, Yves leans casually on the railing in a three-quarter profile view

Figure 7-3
Fashion Plate. *Journal des demoiselles*,
November (1877?)
Lithograph, 21.5 × 28 cm (8½ × 11 in.).
Woodman Thompson Collection, Costume
Institute, Metropolitan Museum of Art,
New York

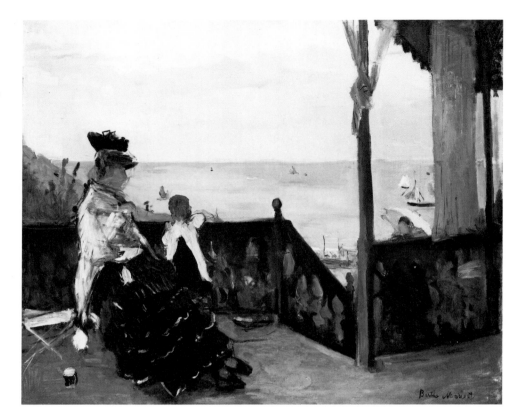

Figure 7-4

Villa at the Seaside, 1874
Oil on canvas, 51 × 61 cm
(19¾ × 24⅛ in.).
Norton Simon Art Foundation,
Pasadena, California

that outlines the form of her bustle and indicates the cascading arrangement of draperies from her waistline to feet. Bichette, also in day dress and pinafore, the standard uniform for children, is posed with her back to us, peering through the bars of the railing. A fashion plate published one year earlier, in 1870, in *La Toilette de Paris* (figure 7-5) also shows a woman and child in fashionable day dress looking out over a similar railing or fence at a distant view of a train.[12] Both Morisot's painting and the fashion plate not only illustrate fashionable dress but place the clothing in the context of a modish activity recommended by guidebooks: that of *la promenade* to scenic outlooks to admire nature, historic sites, or novelties. In Morisot's painting the figures admire a view combining historic Paris (represented by the Panthéon) with the newly rebuilt city, which is indistinct in the far distance. In the fashion plate a steam engine and train demonstrate modernity, progress, industry, and novelty. The woman in the fashion plate is also seen in profile to show to advantage the structure of her three ruffled overskirts and the shape of her bustle. She, too, leans on the fence in a jaunty pose. The little girl is shown from behind in order to emphasize the "cut away" of her bodice and its bow.

Back-turned and profile figures appear frequently throughout the 1870s and 1880s in fashion plates, especially with the increasing complexity and asymmetrical arrangement of draperies around the hips and over the bustle that provided much of the novelty in fashion; these fashion plates are the general source for Morisot's painting. In *On the Balcony* Yves looks down at her daughter, creating a connection between the figures; in general, the emphasis on the back view resulted in little communication or gesture between figures, a convention that Morisot exploited for its psychological qualities.

In *In a Villa at the Seaside* of 1874, the subject of the painting is social life in a rented villa or resort hotel.[13] A woman, perhaps Morisot's sister Edma, is perched on a folding canvas stool, dressed in hat and veil to protect her face from the strong afternoon sun and wind. The painting reveals the protocol and health habits at a seaside resort: the woman has wrapped her torso in a white shawl, totally shielding her arms and neck from exposure to the sun, and to the suntan or burn that was anathema to anyone with pretensions to being a proper lady. Her skirt is trimmed with at least four flounces edged in white piping, and her lavender

Figure 7-5

Fashion Plate. *La Toilette de Paris*, 1870
Lithograph, 19 × 27.3 (7½ × 10¾ in.).
Woodman Thompson Collection, Costume Institute,
Metropolitan Museum of Art, New York

Figure 7-6

Fashion Plate. *Modes de Paris*, *Journal des demoiselles*,
September 1875
Lithograph, 19 × 28 cm (7½ × 11 in.).
Woodman Thompson Collection, Costume Institute,
Metropolitan Museum of Art, New York

stockings, which peek jauntily out from her skirt, reveal casually crossed ankles.[14] On the floor by her feet is the cup of tea she has been drinking. By her side, again dressed in pinafore and seen from behind, is her child, leaning on the elaborately carved balcony railing, admiring the ocean, boats, and sky. As in so many of Morisot's paintings, the setting is a private one—a balcony enclosed by an awning, a sunshade, and vertical porch supports. In the right-hand third of the canvas, a woman climbs the stairs, a parasol shielding her head from the sun.

In a fashion plate from *Journal des demoiselles* (figure 7-6), the friend has already arrived to visit, and the women stand together admiring the view of sea, beach, and horizon. The setting is virtually identical to Morisot's, with carved balcony railings, vertical porch

supports, and awning. The illustrator of the fashion plate has emphasized the lushness of the vegetation, which, restrained in Morisot's work, here forms a green haze and climbs onto the porch and up the supports to the awning. The little girl, her mother, and the visitor are all seen from behind, the better to examine the complex ruching, ruffles, bows, flounces, and draperies of the backs of their dresses (by contrast, the fronts of these dresses were relatively restrained and narrow). The middle figure faces toward the child, isolating herself from and turning her back to the other.

Why did Morisot adopt these particular conventions of fashion-plate illustration? In terms of subject matter, fashion plates provided *vie-moderne* subjects accessible to a *haute-bourgeoise* woman artist. Fashion-plate illustrators chose the latest in interiors, settings, and

activities. Morisot's turned-away children do not share the fashion plates' devotion to the sartorial details of the backs of dresses. By placing women and children together in enclosed, private settings, but without contact or intimacy between them or with the viewer, she established a mood that is difficult to articulate. At times, as in *Interior*, the placement serves to isolate the mother from child; at other times, as in *On the Balcony*, there is a sense of separate reverie but shared experiences. This also seems to be the mood of *Villa at the Seaside* and may allude to the long hours of enforced "leisure" of the woman at home, who, musing or dreaming, gazes at distant views out windows or in her imagination. She goes about the domestic rituals of daily life, entertaining young children and a constant stream of visitors, reading, sewing, and drinking endless cups of tea. The many paintings of figures turned away—from other figures and from the viewer—to dream upon distant vistas—of the world of the city, the boulevard, stomping ground of the flaneur—may suggest the constraints of a sheltered bourgeois existence and privileged childhood. In short, these paintings, with their psychological disconnection (despite the bonds of familial relationships), are strikingly modern in tone and create, according to Baudelaire's dictum, permanent art from the ephemeral *vie moderne*.[15]

Thus Morisot manipulated some of the conventions of the fashion plate to construct daringly modern compositions and to establish subtle but highly evocative moods of disconnection and reverie. An analysis of how specific forms of dress—even individual dresses —function in her paintings also sheds light on the content, mood, and meaning of specific works, on her aesthetic program, on her attitude toward her sitters, and, ultimately, on her relationship to her art. This analysis also adds nuance and depth to the meaning of what we now vaguely refer to as the domestic sphere of women's art.

In *Young Woman at the Window (The Artist's Sister at a Window)* (colorplate 2) of 1869, Morisot painted her sister Edma during a visit to Lorient from June through early August, possibly during Edma's "confinement," although this is not evident from Edma's appearance or costume. Edma sits in a rounded, overstuffed upholstered chair that has been rolled on its casters in front of French doors opening onto a balcony. Again employing some of the conventions of the fashion plate, the room is quite empty except for the chair, upholstered in chic *style-anglais* chintz, sketchily indicated white curtains draped behind the door, the suggestion of a sideboard, and the gold and gray trellised wallpaper. Despite the inviting open view through the balcony railing to sunlight and bright green awnings, Edma ignores the window and, head tilted down, gazes abstractedly at the fan with which she is toying in her lap.[16] Of all fashion accessories, the fan is the most expressive and communicative, used to signal, greet, and flirt in social situations. In any study of the language of the fan, a closed fan is analogous to a "closed book" and toying with one's fan to talking to oneself.[17] Morisot's choice of the fan as accessory serves to emphasize not only Edma's aloneness, but also her self-reflection and self-absorption. The costume in which Morisot has chosen to portray Edma reenforces this reading of the painting. Edma is wearing what the French called a *robe d'intérieur*, also known as (depending both on the dress itself and on the occasion at which it was worn) a peignoir, an "at-home" dress, a housedress, a *matinée*, or a *saut-de-lit*. A form of *déshabillé* or semi-*déshabillé*, *robes d'intérieur* were worn exclusively in private settings in the company of intimates—family, friends, and lovers. Edma's peignoir is made of lightweight, transparent material, possibly cotton voile. Morisot has painted a tour de force of summer sunlight falling on sheer white fabric. The style of the peignoir is a popular one called *à la princesse*,[18] in which the bodice and skirt are cut from one piece of fabric without the constrictions of a waist seam and therefore without a tightly fitted bodice. These dresses usually had a vertical opening extending down the front from neck to hem, often closed by buttons and trimmed with lace or embroidery. The fullness of fabric, draped and falling in folds over the left arm of the chair, suggests the popular eighteenth-century-revival "Watteau pleat," a single, deep, wide, box-shaped pleat at the center of the back that fell freely to the floor, sometimes forming a demitrain. Edma's peignoir is trimmed with a ruffle or jabot at the neck and a long, pleated flounce at the hem. It probably had matching pleating or ruffles detailing the front opening, as is sketchily indicated by the highlit detailing visible at the knee.

There were two important distinctions between *robes d'intérieur* and day dresses. First, as noted, *robes d'intérieur* did not have a closely fitted bodice and were not generally worn with a corset and crinoline or bustle but only with a chemise and petticoat. Morisot

painted a number of *robes d'intérieur* during the 1870s and 1880s when this form of dress was rapidly and dramatically evolving into a more elaborate style that became known as the tea gown, at least partially in response to the constricting and severe sheathlike style of both day and evening dresses of the era.[19] Because they were amply cut, *robes d'intérieur* were worn by pregnant women indoors or in their gardens. Second, *robes d'intérieur* were worn only in private settings, thus retaining some of the intimate qualities associated with forms of undress such as underwear.[20] *Robes d'intérieur* were also associated with free and easy living; in England, where they were considered a French import, their rise in popularity was linked with the decline in public morality and the relaxing of the marital bond.[21]

In depicting Edma seated alone by a window in a white peignoir, Morisot established a familiar and intimate relationship between artist and subject and, by extension, between viewer and subject. Edma's peignoir, although obviously transparent, is painted to negate any erotic associations of *déshabillé.* The viewer is placed in the privileged position of intimate, indeed female, friend.

The use of the *robe d'intérieur* is one aspect of Morisot's creation of an isolated, private sphere in which the outside world is glimpsed only through open windows. The *robe d'intérieur* heightens our response to Edma's pose—head bowed, eyes lowered, withdrawn —and her gesture—toying with her uncommunicative fan—and reenforces the quiet, reflective, even brooding mood of the painting. Here, interior dress is a metaphor for a psychological state, for reflection, for reverie, for interiority. The viewer's empathy is implied and is part of the meaning of the work: we are admitted into a small, privileged world.

Edma's wearing of a peignoir in *Mme Morisot and Her Daughter Mme Pontillon* (colorplate 3) of 1869–70 emphasizes the emotional closeness between mother and daughter, and the contrast with Mme Morisot's correct black silk day dress (*robes d'intérieur* were never black) hints at Edma's pregnancy. Edma's loose, flowing tea gown in *Butterfly Hunt* of 1874 (figure 7-7), worn with a black shawl and straw hat to shield her face from the summer sun, establishes the setting as a private garden or park—as "home," as opposed to the Bois de Boulogne, or "nature." The subject in *Portrait of Mme Marie Hubbard* (colorplate 8), lounging on a

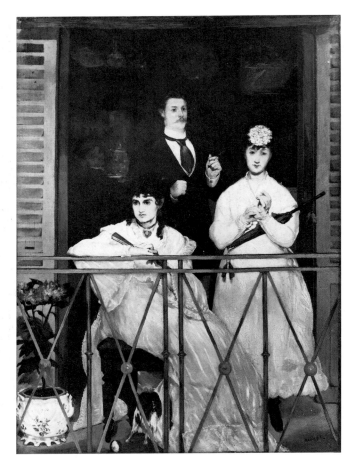

Figure 7-8
Edouard Manet, *The Balcony*, 1868
Oil on canvas, 169 × 125 cm (66½ × 49¼ in.).
Musée d'Orsay, Paris

daybed with her head propped on lacy pillows, wears a *robe d'intérieur à la princesse* of dotted Swiss voile with transparent sleeves and neck and mules, idly fanning herself with a painted silk fan. Her languid pose, bare ankles, informal shoes, and the transparency of her gown carry associations of *déshabillé* and the boudoir. The mood of the painting and the treatment of the costume look forward to Morisot's long series through the mid-1870s and 1880s of intimate studies of women at their toilette: combing their hair, dressing, gazing into the mirror—all attired in progressive stages of undress: *robe d'intérieur* in *Young Woman with a Mirror* (1875; private collection); chemise and slip in *Lady at the Toilette* (c. 1875; Art Institute of Chicago); nightgown and dressing gown in *Young Woman Powdering Her Face* (1877; Musée d'Orsay, Paris); chemise and slip in *The Bath* (1885–86; colorplate 19); nightgown

in *Getting Out of Bed* (1886; Collection Durand-Ruel, Paris). This series culminates in the late 1880s with paintings of complete undress: the series of nudes bathing.

Morisot was by no means unique in portraying *robes d'intérieur*. For an important earlier treatment we again turn to popular imagery: to prints of *Lorettes*, *Lionnes*, and the bluestockings of the July Monarchy who were painted in dressing gowns to emphasize their bohemian life-style and supposed easy sexual mores.[22] However, the most important and best-known earlier treatment of the dressing gown was made by her admired colleague and brother-in-law, Manet: the pink peignoir in *Woman with a Parrot* of 1866. Several years later, Manet posed Morisot, the violinist Fanny Claus, and the landscape painter Antoine Guillemet in the semipublic, semiprivate space of *The Balcony* (figure 7-8). Unlike Claus, who is dressed in correct street wear of walking dress supported by crinoline, gloves, hat, and *botines* (short walking boots), Morisot is portrayed in a Japanese-style peignoir with pagoda sleeves, without, of course, crinoline, her hair casually arranged around her shoulders, gloveless, with fan closed, and bearing a brooding, introspective expression. A similar mood exists in this painting and in Morisot's *Young Woman at a Window (The Artist's Sister at the Window)* (colorplate 2): that of the Morisot sisters' brooding, questioning, reflective, artistic temperament, expressed by their *robes d'intérieur*.[23]

Thus far we have considered Morisot's attitudes toward fashion and her appropriation of the fashion plate as a source of *vie-moderne* subject matter and composition. We have seen how one form of dress—the *robe d'intérieur*—may function as a metaphor for reflection, reverie, and intimacy. Without an understanding of the associations of a form of dress, Morisot's artistic intentions may elude us. By way of closing, we will focus on a specific dress to demonstrate how costume can hold the key to unlocking the layers of meaning in a painting. Ultimately, the analysis of dress may reveal Morisot's relationship to her art making.

By virtue of the elegance and refinement of its composition and costume, Morisot's *Figure of a Woman (Before the Theater)* of 1875–76 (colorplate 10), a full-length study of a woman in evening dress against an empty, dark, modeled background reminiscent of Manet and Francisco de Goya, is one of the artist's finest and most revealing works. Unlike other Impressionists, in-

cluding Mary Cassatt, who painted men and women at the theater and opera in private boxes, using opera glasses to survey the audience as well as the stage, Morisot has created a studio piece, probably staged in her studio at home. The lack of all details of setting—grand stairway, gilded mirror, opulent opera house—focuses attention on the splendid black dress, which becomes the subject of the painting. This evening dress, which leaves the arms and shoulders of the model bare, is a formal and fashionable costume. Its neckline is rounded and low cut and trimmed with ruching of the same fabric, most likely black silk, as the body of the dress. Festive ribbon streamers are tacked to the left sleeve with coquettish asymmetry, probably attached with a matching bow. The sleeves are minuscule, mere continuations of the line of the shoulder. The skirt consists of an underskirt and at least one overskirt, trimmed with artificial flowers, in the style *à la polonaise*, that is, looped up around the hips and arranged in complicated drapery over the bustle. This overskirt continues to the floor where it forms the short evening train we see in the right-hand corner of the painting. The model wears long, white silk evening gloves and carries opera glasses, which, given the occasion and the luxury of her costume, were probably made of ivory, mother-of-pearl, or gold. The overall effect of chic is heightened by the elegance of the pose of the model, who holds her opera glasses in one hand and elevates one side of her dress with the other, implying forward movement while revealing an elegant evening pump trimmed with a bow.

Morisot painted this same dress again the following year in *The Black Bodice* (colorplate 11), this time with the model seated in a chair and only the ornamented bodice of the dress visible. Here the model wears black evening gloves; either black or white gloves would have been correct with this costume. The model's white gloves in *Figure of a Woman (Before the Theater)* render her gestures of draping her skirt and holding her opera glasses readable against her black dress.

This refined, impeccably tailored, stylish evening dress was undoubtedly from Morisot's own closet and was the dress in which she chose to pose for her formal studio photograph (figure 7-9) taken the year before she painted *Figure of a Woman (Before the Theater)*. In this engaging, formal self-presentation, Morisot leans casually against a carved lectern, hands clasped together. In what was clearly the source for the pose and com-

position of the painting, Morisot's elbow is bent (revealing a small, corseted waist), one foot is thrust forward to expose an evening shoe decorated with a bow, and her train sweeps to the right of the image and beyond. The casual pose and cool gaze are an antidote to the formality of conventional studio portraits. This tension reenforces Morisot's self-presentation as *La Parisienne*, a female counterpart to the dandy and endowed with the dandy's strict elegance, rigorous composure and bearing, and au-courant wit.

A close comparison of the painting and photograph shows that Morisot changed several details of her costume. For example, in the photograph the skirt is ornamented with smocking trimmed with pleating at the bottom of the overskirt; in the painting, the form of the overskirt is indicated by punctuating its line with artificial yellow silk flowers. Morisot functioned not only as the artist of the work but as the *habilleuse*—

Figure 7-9
Photograph of Berthe Morisot
Private collection

choosing appropriate dresses and accessories for her mannequins—and also as couturier. In addition to fashion plates, contemporary fashion magazines published paper patterns and detailed descriptions and illustrations of the latest trends in *confection*: lace, ribbons, feathers, celluloid fruit, stuffed birds, tassels, passementerie, beads, and, especially, artificial flowers, one of the most popular forms of *confection*. Even very "upscale" magazines gave detailed advice on the latest *confection*, demonstrating how to update one's wardrobe or tailor it to special occasions by using the wide variety of *confection* available at department stores and *petits commerçants*. Nearly all women, except perhaps those few dressed exclusively by Worth, worked with their dressmakers in designing and ornamenting their dresses, creatively individualizing their wardrobes. In *Figure of a Woman (Before the Theater)*, Morisot has thus drawn an analogy between the creative act of the major art of painting and that of the minor art of dressmaking, acting as both artist and couturier.

Morisot's *Figure of a Woman (Before the Theater)*, in which she posed a model in her own dress and used a studio portrait of herself as the source of the pose, costume, and composition, can be seen as a self-portrait with the dress functioning as a surrogate of the artist. By virtue of her dress, Morisot presents herself not as the *femme au foyer*, but as *La Parisienne*—worldly, knowing, self-possessed, the epitome of chic and sophistication. This self-presentation, not as homebody, devoted wife and mother, or even artist, suggests a side of Morisot we know well from Manet's series of portraits but little from her own self-portraits or even letters. An especially telling detail is her choice of the model's accessories—a pair of jewellike opera glasses, a subtle visual pun reminding us that beneath this elegant presentation is the knowing vision of the artist.

Fashion, in its many facets, reveals aspects of the private world and working methods of Berthe Morisot. The dresses worn by her protagonists are often the clothing of home—an intimate domain. Similarly, fashion plates, perused and shared in domestic society, demonstrate Morisot's transfer of women's culture to professional life. These forces are also at work in her implicit equation of the creation of clothes with the creation of composition in *Figure of a Woman (Before the Theater)*. In all of these ways, Morisot exploits the ephemera of fashion to create incisive paintings that transcend the contemporary.

Notes

1. Charles Baudelaire, "The Painter of Modern Life," in *Baudelaire: Selected Writing on Art and Artists*, trans. by P. E. Charvet (Cambridge, 1972), 403.

2. See Charles F. Stuckey and William P. Scott (with the assistance of Suzanne G. Lindsay), *Berthe Morisot—Impressionist*, exh. cat., Mount Holyoke College Art Museum and National Gallery of Art, Washington, D.C. (New York, 1987); and the monograph by Kathleen Adler and Tamar Garb, *Berthe Morisot* (Ithaca, N.Y., 1987).

3. See Georg Simmel, "Fashion," *International Quarterly* 10 (October 1904), 130–55. The "trickle down" and other theories of the evolution of fashion are also discussed in Valerie Steele, *Fashion and Eroticism: Ideals of Feminine Beauty from the Victorian Era to the Jazz Age* (New York and Oxford, 1985), 19–20.

4. Monet may have rented a "gown of green satin" in Paris for a costume depicted in *Women in the Garden* and his *Déjeuner*. See Mark Roskill, "Early Impressionism and the Fashion Print," *Burlington Magazine* 112 (June 1970), 395, n. 22.

5. See Philippe Perrot, *Les Dessus et les dessous de la bourgeoisie. Une histoire du vêtement au XIXe siècle* (Paris, 1981).

6. Baudelaire, "The Painter of Modern Life," 394.

7. Berthe Morisot only rarely painted men, with the occasional exception of her husband, Eugène Manet, who appears in her work after their marriage, in 1874.

8. On nineteenth-century fashion plates and their illustrators, see Valerie Steele's "Art and Fashion," in her *Paris Fashion: A Cultural History* (New York, 1988), 97–132.

9. Morisot may have been aware of important precedents for borrowing from fashion plates: see Roskill, "Early Impressionism and the Fashion Print." Anne Higonnet's Ph.D. dissertation for Yale University, "Berthe Morisot (1841–1895): Images of Women," was unavailable at the time of writing as it was in press. Her work also deals with these issues.

10. Robert L. Herbert, *Impressionism: Art, Leisure and Parisian Society* (New Haven, 1988), 47–48, also notes the isolation of the seated figure; he believes the standing figure is the child's mother and the seated figure is a visitor.

11. Stuckey in *Berthe Morisot—Impressionist*, 45.

12. Anne Hanson has pointed out that in the years 1872–73, Manet painted *Gare Saint-Lazare* (National Gallery of Art, Washington, D.C.), which depicts a back-turned figure staring through iron railings at a railroad station with smoke rising dramatically from a locomotive engine. Manet displayed the neat arrangement of her coiffure, held in place with black ribbon, and the extravagant, pale blue sash of her white dress (Manet Seminar, Yale University, 1982). See also Stuckey in *Berthe Morisot—Impressionist*, 44.

13. Herbert, *Impressionism*, 280–81.

14. It is a myth that proper ladies never showed their ankles or calves or revealed stockings or petticoats as countless costume historians have asserted. Fashion plates are visual proof of this; the very structure of crinolines provides physical evidence: crinolines were constructed to sway back and forth as the wearer walked, revealing not only a glimpse of stocking but a well-shod foot. The evolution of underwear—especially during the second half of the nineteenth century—including colored petticoats and elaborately embroidered stockings also suggests that these were not hidden from view. There is no concrete evidence that revealing the ankle or foot suggested that the woman was sexually available.

15. See also Adler and Garb, "The Painting of Bourgeois Life," *Berthe Morisot*, 80–104.

16. Her fan may have been made of wood, bone, ivory, or silk. Fan painting was an amateur art form that ladies of the leisure class often practiced. By the 1870s, most fans were made of silk, and the fan as accessory was enjoying a revival.

17. See, for example, Louis Octave Uzanne, *L'Eventail* (Paris, 1882).

18. See Anne Buck, *Victorian Costume and Costume Accessories* (New York, 1961), 65–66.

19. The constricting style of dress of the 1870s and 1880s was widely regarded as less comfortable and more restrictive than the wide, bell-shaped crinoline-supported skirts of the 1860s. Buck describes the tea gown as a special form of dress: "At first it was only a bit more elaborate than the morning robes, but during the 1870s, it became less and less like a dressing gown and more and more like fashionable dress." Buck, *Victorian Costume*, 66.

20. Steele, *Paris Fashion*, 190.

21. See C. Willett Cunnington, *English Women's Dress in the Nineteenth Century* (London, 1937), 280. Cunnington quotes an unnamed source as stating that "the tea gown arose from the habit of ladies having tea in the hostess's boudoir and donning smart dressing gowns. [Now that gentlemen are admitted to the function] peignoirs have developed into elegant toilettes of satin, silk, foulard, etc." On the decline of public morality, see ibid.

22. Steele, *Paris Fashion*, 189.

23. By the 1890s, *robes d'intérieur* also had specifically artistic, bohemian, and fanciful connotations. See Steele, *Paris Fashion*, 190. However, neither Steele nor I have found evidence that they had these connotations as early as the 1870s.

Index

Works of art by Berthe Morisot are indexed by title; works of art are by Morisot unless otherwise attributed. Page numbers in *italics* refer to illustrations.

Photograph Credits and Copyrights

Archives Photographiques, Paris/S.P.A.D.E.M.: figures 2-5, 6-8

Courtesy of The Art Institute of Chicago. © 1986 The Art Institute of Chicago. All rights reserved: colorplate 17

Atelier 53, Paris, copyright: colorplates 15, 18, 21; figures 4-1, 5-5, 6-2

Bibliothèque Nationale, Paris: figures 2-8 through 2-12, 4-11

Georges Bodmer, Zurich: colorplate 23

Civiche Raccolte d'Arte, Castello Sforzesco, Milan: figure 6-1

Documentation R.S. Paris: figure 7-1

The Frick Collection, New York, copyright: figure 2-13

Giraudon, Paris: figure 4-2

Helga Photo Studio, Upper Montclair, N.J.: colorplate 20

Klaus Hönke, Bremen: colorplate 10

Jacqueline Hyde, Paris: figure 4-6

Service Photographique de la Réunion des Musées Nationaux, Paris: figures 2-2, 4-3, 5-1, 5-4, 7-7, 7-8

S. P. A. D. E. M.: figure 6-8

Statens konstmusser, Stockholm: colorplate 12

Studio Lourmel-77, Photo Routhie: figure 6-12

Szépművészeti Muzéum, Budapest, A. Szenczi Maria, 1989: figure 2-3

Ole Woldbye, Copenhagen: colorplate 8

Yale University Art Gallery, New Haven, Joseph Szaszfai: figure 2-4